D0016629

THE SCULPTURES OF THE PARTHENON

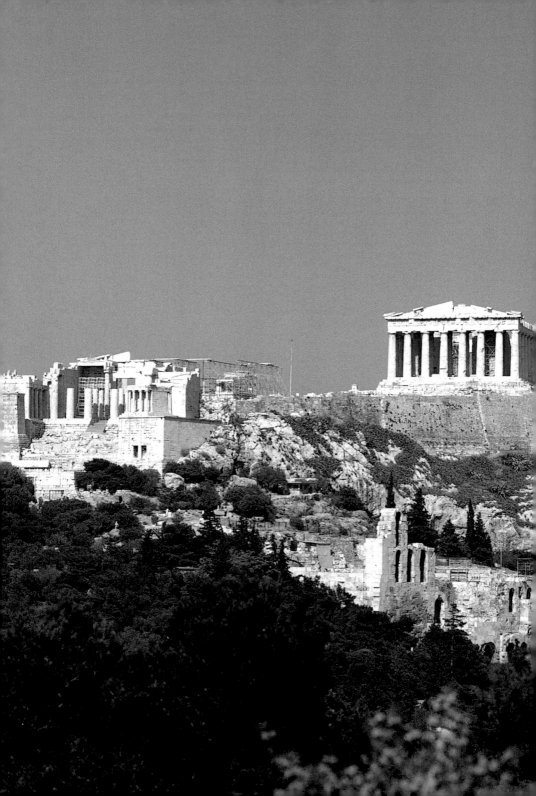

THE SCULPTURES OF THE PARTHENON

Aesthetics and Interpretation

Margaretha Rossholm Lagerlöf

2000
Yale University Press
New Haven & London

Translated by Nancy Adler

I (frontispiece): The Parthenon on the Acropolis Cliff in Athens.

Copyright © 2000 Yale University

All rights reserved. This book may not be reproduced, in whole or in part, in any form (beyond that permitted by Sections 107 and 108 of the U.S. Copyright Law and except by reviewers for the public press), without written permission from the publishers.

Set in Bembo by Best-set Typesetters Ltd., Hong Kong
Printed and bound by C S Graphics, Singapore

Designed by Mary Carruthers

Library of Congress Cataloging-in-Publication Data
Lagerlöf, Margaretha Rossholm, 1943–
The sculptures of the Parthenon: aesthetics and interpretation/Margaretha Rossholm Lagerlöf.
p. cm.
Includes bibliographical references and index.
ISBN 0-300-07391-7 (cloth: alk. paper)
1. Sculpture, Greek–Greece–Athens. 2. Parthenon (Athens, Greece) I. Title.
NB91.A7 L27 1999
733′.3′09385—dc21
99-047026

DAL
NB-
91
A7
L27
2000

CONTENTS

Acknowledgements

This work could not have been written without valuable financial support from the following institutions and foundations: the Swedish Council of Research in the Humanities and Social Sciences, Magnus Bergvalls Stiftelse, Konung Gustaf VI Adolfs Fond för Svensk Kultur, Helge Ax:son Johnsons Stiftelse, Stiftelsen Längmanska Kulturfonden, The University of Stockholm. I am deeply grateful for receiving so much substantial help.

I have benefited from discussions with many colleagues. I want to thank especially Charlotte Scheffer and Johan Flemberg at the Department of Classical Archaeology and Ancient History at Stockholm University – for reading the manuscript at an early stage, for encouraging me, making valuable suggestions and providing information – and Claes Petersson for allowing me to use his photographs.

The support of the Swedish Institute at Athens was important. I am grateful to Berit Wells, the Director of the Institute, for inviting me to Athens, and to Bodil Nordström for helping me to address the Greek authorities and for handling my photographic commissions with great efficiency.

I also want to express special thanks to my two teachers of classical Greek, Hans Ruge and Ove Strid. Without their inspired teaching I could not have grown familiar with Greek literature.

Ivor Kerslake of the Photographic Department at the British Museum has interpreted my intentions perfectly and made wonderful new photographs of some of the sculptures.

Nancy Adler has transformed my Swedish text into English with great subtlety – a tremendous feat for which I am truly grateful.

The reader from Yale University Press has contributed in a most

valuable way, with suggestions and criticisms, to the final version of the text. I am very much in debt to his reading.

My family has encouraged and supported me. They have all brought inspiration and happiness.

A note on the transliteration of Greek words

The system of transliteration applied here is not consistent. I have tried to stay close to the Greek idiom, but words and names very familiar in a traditional form to English readers have been retained.

A note on the numbering of the sculptures of the frieze

In this book I have used the numbers of slabs and figures introduced by Ian Jenkins of the British Museum, in his *The Parthenon Frieze* of 1994. I have also given the old numbers as alternatives, to make concordance possible. In June 1999 the old numbers are the ones on display in the British Museum.

Dimensions of the sculptures are given in note 1, p. 166.

I

APPROACH

The Parthenon temple is real, I can see it before me. It is surrounded by simple fencing and steel wire. Dandelions are pushing their way up between the cracks in the stone steps. Seen from below the capitals are blackened. The metope reliefs beneath the triangle of the pediment on the west side have been almost entirely obliterated.

Snatches of German and Dutch drift to me on the breeze. There is a smell of grass. The horsemen on the west frieze can be glimpsed behind the scaffolding.[1]

Most of the Parthenon sculptures, those known as the Elgin Marbles, are in London in the British Museum.[2] Others are in the Acropolis Museum in Athens.

Fifth-century Athens remains the source of much of our Western tradition — democracy, the sceptical and analytical lines of philosophical thought, a visual art which can rival reality and a drama which uncovers fundamental psychological patterns and reveals the limits of taboo can all be said to originate there.

Often, as I look at ancient works of art or read an ancient text, I encounter a spontaneous feeling of familiarity, of recognition which is reflected back to me from some place at the deepest or remotest level of experience. The work of art invites doubt about its own suggestion of reality. It is an art that is also its own extraneity, its own commentating voice; no place outside it is needed. And so it is indeed our 'home', our own old familiar doubt.

1

A sense of irresolution and uncertainty gave Plato the notion of an alternative to the domain of doubt, namely the world of immutable ideas. And so, doubting Plato and equally doubting the sense of recognition, I find myself between the extremes of certainty and doubt: some gaps can be filled more than others, some silences have a stronger echo.

It is tempting to try to escape from this familiarity, to seek persistently for all those aspects with which it is impossible to identify. It is tempting to undermine every attempt to imbue the figures and compositions with natural, obvious or immediately appealing meanings. It is much more difficult, however (and shows more respect for the initial sense of familiarity), to test the relative durability or fragility of the links between then and now, and to try to penetrate what is repressed.

The figurative sculptures on the Parthenon constitute an ensemble.[3] The subject of the east pediment was Athena's birth, and of the west pediment the struggle for Attica between Athena and Poseidon. Just below the pediments were the metopes, belonging to a Doric frieze along the outside of the temple, above the architrave. The metopes were figurative, rectangular images alternating with squares of equal size, but carrying the formal pattern of three vertical lines, the triglyphs. On the east side the metopes illustrate the battle between gods and giants (*gigantomacchia*), on the north side the destruction of Troy (*Iliupersis*), on the south the battle between Lapiths and Centaurs (surrounding a central section with unidentified motifs),[4] and to the west the Greeks' battle against the Amazons. The Ionic inner frieze of the temple with continuous figurative representations extended along the outside of the long cella-walls and along the outer walls of the porches of the cella. It was an 'inner' frieze in the sense that it was partly shadowed by the surrounding peristyle. This frieze, known as the 'Parthenon frieze', displays large groups of riders, chariots, a sacrificial procession, a group of men engaged in conversation and an assembly of gods surrounding a central scene with a woman accompanied by two girls carrying stools, and a man handling a mantle together with a third child. One aspect of the subject of the frieze, the Athenians participating in a cult ceremony, brings the living people into close proximity with the immortal gods.

The subject of the west pediment was a local Attic myth (or *aition*, a

myth which explains causes) about the country and the cult centres – about the olive tree and the salt water spring as tokens of the contention between Athena and Poseidon, sacred signs in this oldest and most venerated area of worship.[5] The subjects of the pediments and the metopes highlight Athena's special importance in a unified, traditional thematic; the spirit is mythic and Homeric, the main characters are Attic.

The theme, which sees order and intellectual discipline pitted against disorder and wild eruptive forces or 'female' fecundity, is the traditional meaning attached to all these struggles: the *gigantomacchia*, the battle between Centaurs and Lapiths and that between Greeks and Amazons. This type of clear duality – of a polemically driven meaning – probably conceals something far more subtle, a play of meanings revolving around the Greek identity and its conflicts.[6] The subject of the Fall of Troy frequently appears in Athenian culture, in tragedies and vase painting for instance, and Athena is the great protagonist: in the shape of the statue, the 'Palladion' at Troy, remaining unmoved by the Trojans' prayers and gifts; and as the protector of the Greeks.[7]

The Greeks probably saw a chain of connected meanings in the sculptural programme as a whole, ranging from the divine to the historical: the war against Troy was regarded as history, at least to judge from Herodotus and Thucydides.[8] The subject of the Fall of Troy seems to express an evocation of Greek unity. Thucydides writes: 'The weakness of the olden times is further proved to me chiefly by the circumstance, that before the Trojan war, Hellas, as it appears, engaged in no enterprise in common. Indeed, it seems to me that as a whole it did not yet have this name, either . . .'[9] It was in the course of the Trojan war that a Greek identity was first hammered out, contingent upon the joint struggle.[10]

In his analysis of the production of official Athenian art during the fifth century, David Castriota sees the overall theme of the Parthenon as reflecting the Persian war and the Athenians as defenders of freedom, self-discipline (*sophrosyne*) and social order. Castriota also interprets the whole building and its images as a structure of analogies: the Athenians and the Acropolis are to Athena as Athena is to Zeus and Olympus; the giants' attempt to conquer Olympus is an analogy of the Persians' recent attempt to destroy the Acropolis.[11]

The building and its sculptures encapsulate a theme connecting the gods' own defensive struggle, the mythical wars of a heroic past and human history. The sculptural images prefigure the war won by the Greeks making common cause with one another, and providing an ideal for preventing the threat of conflict. The creative and heroic force of the Greek mind (both represented and exemplified in the sculptures) comes from the gods and – by way of human confirmation and invocation – returns to them.

This may very probably have been the message, but to understand the images on the building in more existential terms (as expressing or responding to conditions of life), we must look at *how* (using what kinds of images) the Athenians chose to establish their relations with their gods.

So I will now attempt an interpretation of the Parthenon sculptures based primarily on how the sculptures convey their meaning, not so much through their subject matter as through the different modes of representation.

My method implies bringing relevant concepts or other kinds of imaginative thinking to bear on the images, applying them instrumentally to the visual worlds of the images and 'staging' these accordingly. This method differs from more traditional intentions that are geared to finding what is 'in' the picture itself. Here, instead, the pictures 'appear' first when the effects of the viewing instruments can be realised in an interpretation. The instruments chosen are inevitably subject to historical and epistemological contraints, and an interpretation is confirmed by the extent to which the instruments allow the work of art to 'appear'.

For decades there has been dispute about the identification of subject matter and the documentary value of the sculptures. But no 'script' can be reconstructed. The sculptures certainly cannot be read. Rather, they are shown or enacted, on display before the beholder, and they must be experienced visually. Iconographical identifications naturally affect perceptions of this display and of what is shown as happening. It is possible literally to see the body-language of a figure changing according to the particular interpretation: who the figure is, and what action or event is being presented. I will comment on different possibilities regarding subject matter below, but confirmation in this respect is elusive.

My method is based on the following assumptions:

The three kinds of sculpture in the original temple are different not only in the myths or events they represent and not only in their technical execution and their place on the building; they are different in kind, far beyond the mere difference between three-dimensional, full-scale sculpture (pediment), high relief (metope), and low relief (frieze). Rather, there is an expressive difference involving the way the subject matter is made visible in the chosen medium, at the chosen spot. The interaction between the levels is also interesting. Each one refers to the others' subject matter and representational method.

The system of interrelations between the three kinds of sculptural image is an indication of the possible meaning of the sculptures.

If the beholder's viewing experience – corresponding to the mode of the image – is essentially relevant to the understanding of the image, then a methodological problem of a general nature arises. The beholder is 'I' at time 'now', making conjectures about the classical world and about the beholders at time 'then'. Even if I may share certain conditions with those contemporary viewers in some basic human way, our mental frames are totally different.

I have to steer my way very carefully, making comparisons and conjectures, always bearing in mind that the Greeks are irrevocably remote from us. On the other hand, those who claim that they are concerned exclusively with a historical meaning in the ancient images are naïve or reductionist, since their own frames of reference will be hidden in the discourse but will linger under the cover of their alleged objectivity.[12]

Only by separating myself from the Greek creators of the work can I approach a historical understanding. However distant the present beholder is from the original viewers, I believe that this work – and the frieze in particular as a clue to the whole ensemble – cannot be understood unless it is experienced in a thoroughly visual way. The viewer must become involved, eyes and mind, in the appearance of the frieze. Why? Because the viewer, or the viewing, is part of what is shown.

To show how the parts of the ensemble function aesthetically, and how they differ from one another, I will concentrate in detail on the two extremes: the sculptures of the east pediment on the one hand and the

frieze on the other. The metopes will be considered only in the final synthesised approach, when a possible meaning for the whole ensemble will be explored.

The comparison between the frieze and the east pediment is based on two concepts of 'image': image as perceptual device and image as narrative. A third concept, namely the image as a 'symbol', will also be considered: in what ways do the sculptures witness about their causes, and how do we confront the damages time has created in the representaions, as we try to evaluate their expressive force? The word 'symbol' will be used here to denote that I am talking about reflections: the word refers to *thinking about* Greek society, not to Greek society itself which has disappeared from our present world except in the shape of fragments.

THE TEMPLE ON THE HILL

The decision to build the Parthenon was taken by the Athenian assembly, on the initiative of Pericles. The temple is, of course, a manifestation of the Athenian empire and its leader. However, it is not possible to distinguish a 'political' meaning from a 'religious' or a 'personal' one. In an elaborate intertwining of themes, and by incorporating the chain of earlier historical events, the building came to refer to the Persian wars, to victorious Athens, to the Athenian identity and to the roles and functions of the gods and their impact on human life. The Parthenon is situated where an earlier temple was under construction when it was burned down during the Persian sack of 480 BC; the Parthenon conformed to its predecessor's most sacred inner proportions, but its outer casing was extended and it was built entirely of Pentelian marble: thus the humiliation and defeat were transformed into triumph and self-reliance. The series of sculptured images are linked with themes established in the age of Kimon – Pericles' predecessor and the only person to rival his reputation as the ideal Athenian leader. Athens invokes her legitimacy in face of rebellious allies and Pericles 'usurps' for himself and for democracy the mythical apparatus Kimon had used to symbolise his achievements.

The temple was built on the southern edge of the rock (as was that burnt in the Persian sack),[13] unlike the archaic temple of Athena which was on the north side on a site long devoted to the worship of the gods.[14]

In the 'old temple', as it is generally called, was kept an ancient and particularly holy cult image of Athena made of olive wood.[15] This archaic temple was also largely destroyed during the Persian wars.[16] Parts of it survived for a while and were probably used in the cult, but it was replaced during the Peloponnesian war by the Erechtheion, the well-known irregular temple still on the cliff with its karyatid porch.[17]

The Parthenon cannot be said to have replaced the old Athena temple, since the buildings probably had different religious functions. However, as I have pointed out, the site of the Parthenon had already been chosen for a temple building before the Persian wars, but the remains of this early temple do not bear witness to traditions of specific religious functions.[18] Immediately after the wars it was decreed that nothing destroyed by the Persians should be rebuilt or repaired, but should remain as a reminder of the destruction brought about by war.[19]

There is no clear proof that the cult ceremonies for Athena, the goddess of the city, were conducted at or close to the Parthenon.[20] On the other hand, they are known to have taken place at the 'great altar' north of the Parthenon and in the 'old temple'. When Phidias' splendid statue of Athena was dedicated in 438 BC, it became one of at least four important statues of Athena on the Acropolis: the ancient and very holy figure carved in olive wood, which by Late Antiquity was being referred to as the 'Athena Polias';[21] a large bronze statue made by Phidias from material taken as booty after the Persian wars and later known as 'Athena Promachos'; a bronze statue which had been a gift from the Athenian colonists of Lemos, the 'Athena Lemnia' (a softer, more feminine Athena, probably placed near the Propylaea); and finally the colossal statue itself, made by Phidias of ivory and gold over a wooden core and known as the 'Athena Parthenos'.[22]

The old statue represented the presence and essence of the goddess, while the gold and ivory statue can be regarded as an expression of the people's supreme celebration of her greatness, an image treasured within the Parthenon as in a lovingly prepared casket.

The goddess as protector of the city is called 'Athena Polias', and the areas of the 'old temple' and of the Parthenon are both dedicated to her. She had her own priestess, and in religious terms represents a figure distinct from divinities such as Athena Nike and Athena Hygieia, who partly share her name but who have their own priestesses. These goddesses

certainly represent particular aspects of Athena but are still independent cult figures, not to be identified with the protector of the city.[23]

The name 'Parthenon' is not an official label. According to inscriptions it referred first to part of the temple (the space west of the cella and used as a treasury); the temple is then called *ho neos*.[24] The designation 'Parthenon' for the temple as a whole appears first in a speech by Demosthenes.[25] In purely grammatical terms this means the 'virgin's quarters' or 'the virgin's abode', which can be compared with 'the women's quarters' *gynaikon*.[26]

There is no evidence to suggest that the events shown in the frieze were ever staged at the Parthenon. However the documentary value of the frieze is considered, the sacrificial procession must be seen as the performing of a rite, and no such events can be proved to have taken place at the Parthenon. Nonetheless the idea of constructing a historical 'reflection' has a very strong appeal. The participants in the festival processions could thus see themselves 'in duplicate' immortalised in stone reflections as they walked past or round the temple, although the actions 'reproduced' there did not take place at the temple site and did not have the giant statue as their goal.

There may be an allusion, nevertheless, to the great festival of Athena – the Panathenaic festival. The festival of the Great Panathenaia was established – probably in 566 BC during the archonship of Hippocleides and possibly on the initiative of Peisistratos in connection with his assumption of power as 'tyrant' in 561/560 – as a recurring ceremonial event (it was a 'Penteteris', with four years between each occasion). The great festival continued for several days in the month of Hecatombaion (first month of the Athenian year corresponding to July–August), and its high point came with the sacrificial procession on the 28th day of the month, Athena's birthday.[27] A lesser Panathenaia had been celebrated every year from time immemorial, but the great festival represented a grandiose parallel to the festivals at Olympia and Delphi, emphasising the ambitions of the Athenians for a Panhellenism centring on themselves and adhering to their terms.[28] The religious motivation for the festival is far from clear.[29]

Plutarch, writing some 400 years after the Parthenon era, transmits the traditional opinion that Pericles wanted to gather the population together in a common endeavour, to keep them employed in the shared enterprise of beautifying their city; Athens demonstrated its power and all-

embracing superiority relative to its enemies, its neighbours and its allies.[30] Pericles and his advisors also wanted to ensure a financial resource for Athens which in case of need could be used in self-defence.[31] The allies paid Athens in return for her 'protection', and it was this resource which was exploited for building the Parthenon; once transformed into the building and its decoration, these remained as a city treasury, a kind of 'national bank'.

The exact use to which the temple and its decoration was put, is of decisive importance to any attempt at interpretation. In this book I regard the basic religious function as that of an invocation: a thanksgiving to the gods and a vision of coming closer to them.[32]

In religious terms the Parthenon, enveloping its gold-covered statue, was a vast votive gift, a token of gratitude from the population of the city to the goddess for the victories and domination she had granted them.

The Parthenon was a dominating ingredient of a greater whole, namely the Acropolis itself, whose symbolic value was determined by tradition and by the revolutionary events of the fifth century: the Persian wars and the establishment of democracy.

The Parthenon can be conceived as a 'treasury' on a colossal scale, that is to say a place for the safe-keeping of the valuable gifts rendered to a divinity by its worshippers. Seen in this light, there is perhaps an element of arrogance – almost of blasphemy – in the design and decoration of the temple. The human manifestations of piety compete with the glory of the gods; the borderlines become blurred.

The Parthenon can also be seen as a celebration and an assertion of Athens' position as a great power, just when that role was gradually being undermined. The temple was being built as the collapse of Greek unity was leading step by step to full-scale war between the Greek city states. The whole temple with its sculptures is informed by a matchless, dynamic synthesis between archaic features rooted in the past and entirely new modes of thought: the Doric temple order is profoundly traditional, the 'birth of Athena' motif refers back to an archaic taste in pictorial imagery, and the warlike themes of the metopes add a mythological dimension to actual victories and threats of war. But these archaic patterns are con-tained within forms that are altogether new: the conception of the Doric

temple has been fundamentally altered and combined with Ionic features; each traditional scene drawn from the storehouse of myth is represented as something happening now and never previously seen; myths without established visual tradition are chosen and given form (the struggle for Attica on the west pediment, for instance); scenes are introduced showing people engaged in the exercise of their religion in an imagery which draws upon the tradition of frieze processions, but which at the same time is also expressive of fundamentally new ways of thinking.

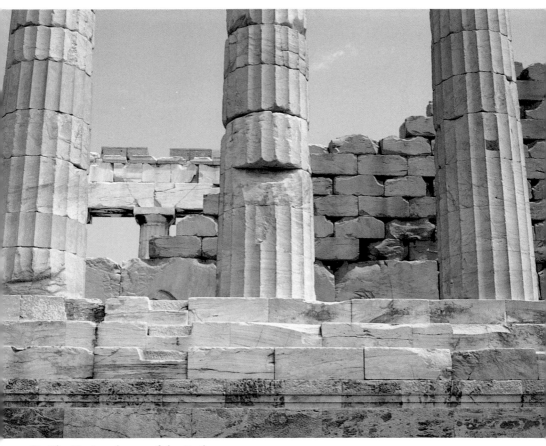

II. The Doric columns of the Parthenon.

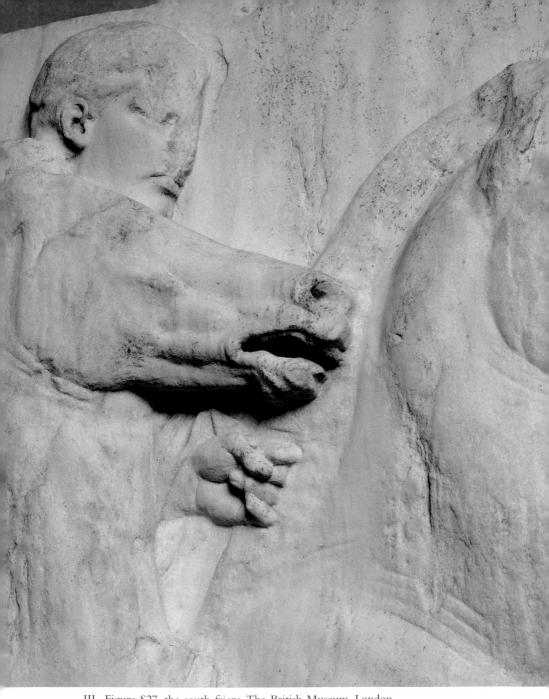

III. Figure S27, the south frieze. The British Museum, London.

II

ANALYSIS

DEPICTION

Assume that an image is a depiction of something actually seen. The figures constitute translations of what has been perceived; the artist's hand documents what the eye has observed.

Problems of depiction are not identical with problems of vision, but the concept of 'depiction' presupposes the notion of rendering perceptual experiences and is thus building on the presuppositions of what vision is. The notion that an image corresponds broadly to visual stimuli of its subject – the imprints in the mind through the eyes, as it were – is very strong and seems to originate in Greek thinking.

In art historical writing there have been occasional tendencies to let the analysis of art coincide with the analysis of vision. This approach was fundamental to Heinrich Wölfflin who tended in his *Kunstgeschichtliche Grundbegriffe* of 1915 to see a history of perception, or of perceiving, in the transformations of art; to him, styles are not arbitrary, as they are contingent upon an evolutionary status of human vision. E.H. Gombrich objected to this view, stressing cultural conventions in images; but he nevertheless explored how vision was supposed to be translated into representation. Gombrich argues that the Greeks were the first to create 'illusions' in their pictures, to 'tell' stories by illusionistic visual means, instead of substituting images for objects in a magical way.[1]

The interpretation of 'depiction' answers an ancient need, namely the desire to see into other times and to 'borrow' someone's eyes in order to enjoy a shared experience.

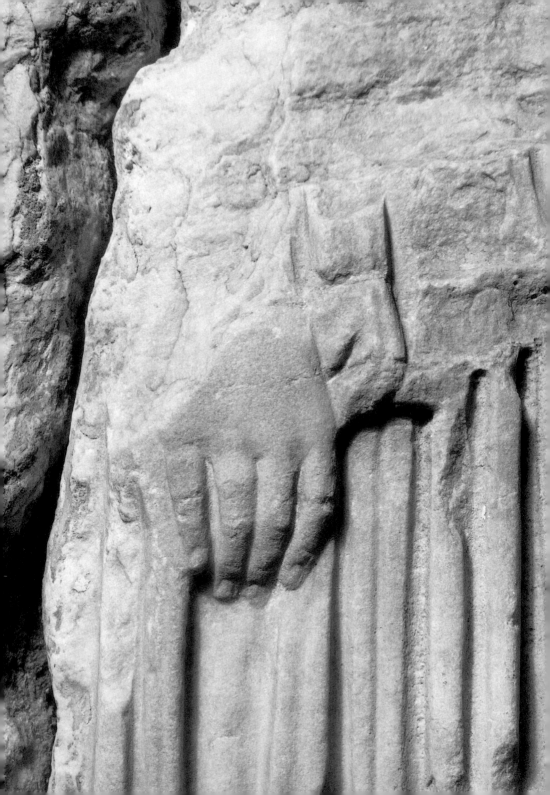

The eyewitness (depictor) encourages the observer to partake of the time which actually gave rise to the work of art and which is thus signified by it (if the work is interpreted as expressing its causes in some way): for a while the viewer is an initiate, a participant, seeing the same things that some of the main characters in history have seen, and in just the same way. The illusion appears to be guaranteeing that the viewer 'is there'.

The interpretation of art as retrieval of a perceptual image focuses upon the seeing that is relevant to survival, in other words that which identifies large forms, faces, groups, connections, distance and movement, corresponding to the outline or composition of an image. Again, the Greeks are referred to as prototypical. Classical Greek sculpture excelled in discovering positions of the body which, in characteristic schemata, make visible a movement or a whole succession of moments and actions. Such poised stances for capturing movement were known as *rhythmoi* and were associated with paradigmatic works of Polykleitos and Myron.[2]

In the Parthenon sculptures powerful patterns of movement of this kind are used, but the refinements and variations far exceed the more rigid structures typical of the earlier periods of Greek sculpture. In combination with these grand structures of movement, assuring visibility from a considerable distance, the Parthenon sculptures also display the minutest details: fingernails are carefully modelled, as are knuckles, veins, and hair-curls. Figures were executed in exquisite detail even in areas where they could not have been seen. How are we to understand this phenomenon? What kind of vision is being addressed and recorded in this huge span of distance, ranging from far away to a closeness inaccessible to any viewer when the sculptures were on the temple?

As a present-day beholder I can feel the challenge of these sculptures to every aspect of potential visibility. It puzzles me. Sometimes I get caught by the appeal of details and find myself developing and recognising aspects of vision that are simply not reached by the schematic patterns used by Gombrich and his followers to explain the relation between image and vision. This other vision, the hypnotised gazing at a single spot, involves a concentration of details that etch themselves on the mind, sometimes expanding, magically glowing and isolated from their context,

1. Figure E12, the east frieze. Detail of a hand. The British Museum, London.

and only returning later to a more structural form and an explanatory or revealing function.[3]

Is looking from a distance actually a different kind of vision compared with that involved in examining the magic of the detail? Were the Greek artists aware of a difference? If they were not, if they considered the one contingent upon the other, then their ideas about image and viewing differed from those of the theorists who built on their formulas, the theorists of classicism who have handed on to us many prejudices that steer our experiences of classical art. In such theoretical writings, mainly of the sixteenth to the nineteenth centuries, details are rarely the subject of justification; more often they are explained away, or removed from the rarefied atmosphere of 'high' art or the 'grand' manner and relegated instead to some lower artistic sphere.[4]

In order to try to understand the function of these sculptures, as they offer themselves to the eye and as they are conceived in terms of the retrieval of visual experience, I now turn to some of the ideas about image and vision in classical Greek thought.

Some Greek views on perceptual images

According to Aristotle in the *Peri psyches*, visual perceptions are an 'imprint' on the sight organ; the 'stamp' itself consists of the pictures of things. Thus, according to this metaphor, there is a clear analogy between mental and physical pictures.[5]

The Greek words for 'to paint', *zographein* and *skiagraphein*, imply elements of the imitation of visual images and illusionism. These are just the imitative impressions and deceptive pictures which Plato condemns in the *Republic*; pictures pretend to be the things which they represent, and are thus deceiving us.[6] The main reason for Plato's disapproval of two-dimensional images is that they depict visual impressions, not the real things themselves.

We know that this kind of criticism also pertained to the decoration of temples. From Plato's *Sophist* we learn that large-scale images were made with allowances for optical adjustment, so that the proportions would appear right to the beholder, even though this meant 'distorting' the actual measurements of the models.[7] In the Parthenon the metopes contain optical corrections adjusted to the distance for viewing from the

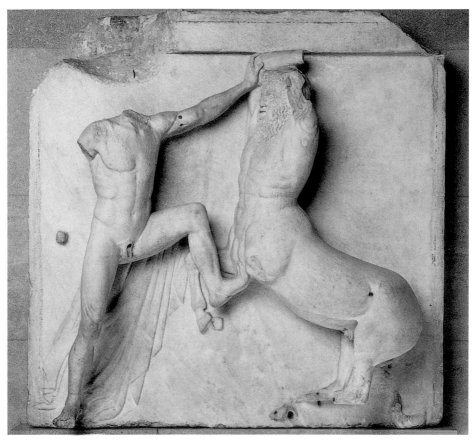

2. South metope 26. The man's leg is represented with optical correction. The British Museum, London.

ground (fig. 2), and in the frieze the depth of the relief is greater towards the top of the slabs; when we look at the riding men from a right angle and at eye-level, they appear somewhat larger than the appropriate size for the horses.[8]

This classical Greek conception of the pictorial may also have been inspired by Homer's description of the dead in the Underworld,[9] where the term *eidolon* (which is also used to refer to depictions) is employed to describe the tragic remains of a dead person's identity – a shadowy image unable to speak, without understanding, strength or substance, but

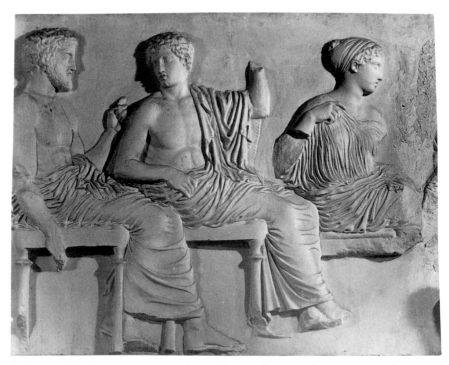

3. Figures E38, 39 and 40, the east frieze. The play between three- and two-dimensional devices is strong in the sculptural representation. The Acropolis Museum, Athens.

still clearly recognisable in shape and appearance. (In fact, for the sake of the emotional force and development of the story, the dead – the 'pictures' – in the *Odyssey* do speak, since Odysseus knows how to get them to do so by offering them a mixture of blood, wine, milk, honey, water and flour, and thus to regain their wits for a while.)

A sculpture is obviously different from a painting or drawing. A sculpture can stand more clearly for a living body. The Parthenon frieze was part of a sculptural ensemble, in which everything was painted, although the painting represented a surface treatment and was not strongly involved in the basic image-creation. Nonetheless the representations of the frieze are conceptually related to two-dimensional imagery. Visual foci such as heads and hands can assume something of the character of three-dimensional sculpture, but basically the figures are perceived in two-

18

dimensional terms, albeit the play of light and shadow fills out the flat shapes and enhances the illusion (fig. 3). According to Plato's condemnation in the *Republic*, it is the absence of 'sittability' which makes the pictured sofa worse than the real sofa which is its prototype; it is the absence of the functional dimension that reduces the value attaching to the representation. Thus three-dimensional sculptures are of greater cognitive value than paintings, which cannot depict actual bodies but only an impression of them. The Parthenon ensemble can therefore be said to reflect a value hierarchy, in which the free-standing sculptures of the pediments come highest, followed by the partially free-standing figures of the metopes and finally by the indirect and circumscribed figures on the frieze, in the medium which lies closest to painting.

To remain subject to an impression is at least to remain within the human condition, to confirm the indirect character of all human cognitions. This is a basic theme in Greek philosophy: the difference between 'seems to be' and 'be', and the impossibility, within the frame of biological life, of reaching out to the realities beyond the transient and particular, which is an inherent quality of impressions. Thus the choice of expressive mode for the frieze, within the ensemble, is particularly appropriate; here it is demonstrated in purely aesthetic terms that the representation belongs to the subject – the conditions of reality surrounding mortal Athenians as they approach their gods together. The more illusory the representation is, the lower is its cognitive value and the more human its character.

So, in Greek thinking there are strong ties between the notion of the image as recreating reality and the notion of the image as recording perceptions. These ties are also the source of problems: the threat of deception and the elusiveness of presence are implications of the image, along with its promises.

Obviously, the temple decoration was not only meant for mortal eyes. But the possibility of gods watching where humans could not, does not answer all the complexities of the representation. Rather, we are faced with a notion of vision that is perhaps different from our own: viewing from a distance is not essentially different from looking close up, and the two ways sustain each other. The reality-matching intention causes the Greek sculptor to fashion fingernails on his figures, because they must have such things in reality. And the urge to be truthful to impressions also leads him to fashion his figures in minute detail, so that they will look

convincing even from a distance: without such details, the overall impression will be weaker from further away. If the figure is really a visible thing, it must have all the qualities of visibility to be able to fulfil its purpose, its *telos*.

A religious motivation may also have been relevant to the sculptor, associated with the general function of the temple as being directed towards the gods. The gods could see, otherwise pictorial decorations would have had no purpose. In exploring, extending and sharpening their own powers of vision and discrimination, the humans could approach the gods in yet another more effective and enhancing way.

THE FRIEZE AS PERCEPTUAL IMAGE

Here I assume that the representations convey visual impressions of events. This assumption is greatly enhanced by the representation itself; it invites this kind of experience.

Construction of the depiction

In the frieze the procession appears to my eyes as stylised, coherent and organised. My attention swings in some way between the stone, and the representations in the stone. The marble glimmers in the light, shifting between yellowish white and grey. The original paint no longer enlivens the surface. Seen close to, the reliefs have a strange appearance. Now that some parts of the frieze are on display in the British Museum and others in the Acropolis Museum, we can constantly change our field of vision, and can capture the technical qualities of the carving (plate III).

The bodies are rendered mainly two-dimensionally, carved out of the surface and looking a little sunken into the surrounding figures, as though pressed into a slightly softer material (fig. 4). Thus, the figures depicted as further back in the picture-space, in the stone seem to swell out slightly around the front-figures. Fiction and representational means thus give contradictory impressions to a close examination. Technically the relief has no background; the plane surface of the relief is identical with the foremost level at the outer limit of the pictorial space: certain small details of the outermost surfaces of the reliefs constitute the remains of the original surface of the block.[10]

4. Figure N133, the north frieze. The figure appears to be sunken into the bodies behind, as though pressed into a softer material. The British Museum, London.

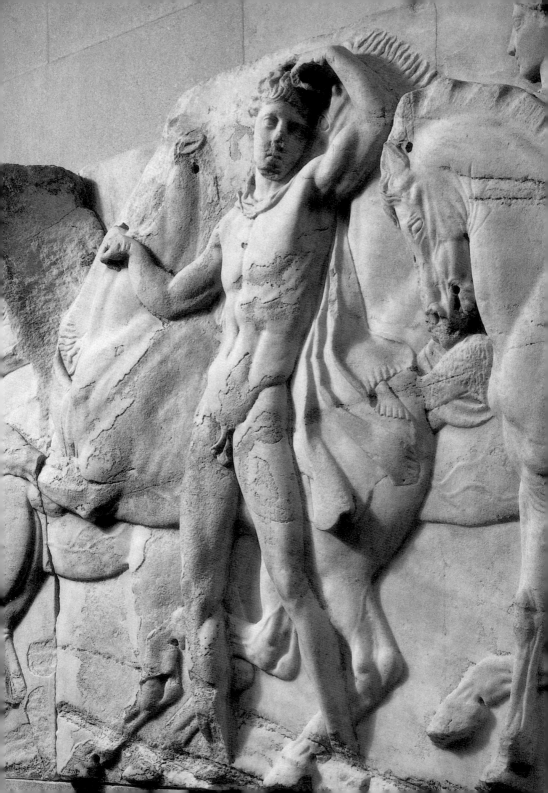

The represented bodies are seen as 'drawn' figures, albeit raised or filled out, so that they combine with the outermost surface of the fictive pictorial space.[11]

The artists must have worked rather like draughtsmen or painters who let their pictures take shape at the meeting of the plane surface with the hand holding the drawing pencil; the chisels and gimlets of the carver extend the action of the draughtsman's pencil, and the desired effects are achieved with the help of – and by calculating on – the mutations of light.

Some parts of these plastic 'drawn' figures are treated more three-dimensionally, particularly the faces and hands. Perhaps a desire to break free of the slab behind, to increase the impression of mobility motivated the method of gouging out a minute space between the background and details such as the profile or semi-profile of a head, leaving the face to cast its vivifying shadow. To an observer standing roughly on a level with the relief, such a face looks as if it is attached to its ground, undercut at the edges, thus forming a shadow faintly recalling a free-standing sculpture (fig. 5).

The treatment is not homogeneous, however: the heads which are turning round and looking back are shown with the fronts of their faces fully in the round; other frontally posed naked youths are like pictures of complete statues, or maybe like three-dimensional sculptures which have been 'flattened out'.

The Parthenon frieze thus exhibits a wide range of representational mechanisms: figures conceived two-dimensionally, endowed with shadows by the natural light, due to their raised surfaces; figures conceived two-dimensionally which have been undercut to recall free-standing sculptures; genuine free-standing details such as certain heads and hands; figures conceived three-dimensionally, in frontal pose, flattened to accord with relief carving. Perhaps it is significant that the Greek term for 'relief', *to ektypoma*, can also mean a clear impression received by the senses, as well as referring to the modelling effect of natural light.[12]

A singular balance between deviation and repetition creates the impression of bodies in motion. I perceive the balancing elements in the composition not as 'harmony' or the 'synthesis of opposites', but as markers in a processual schema: the figures seem to me to 'envisualise' an ongoing movement; something in every figure's physical pose is still in some way

5. The north frieze, slabs XLIV and XLV. The profile heads have slight undercuttings to provide the impressions of mobility. The British Museum, London.

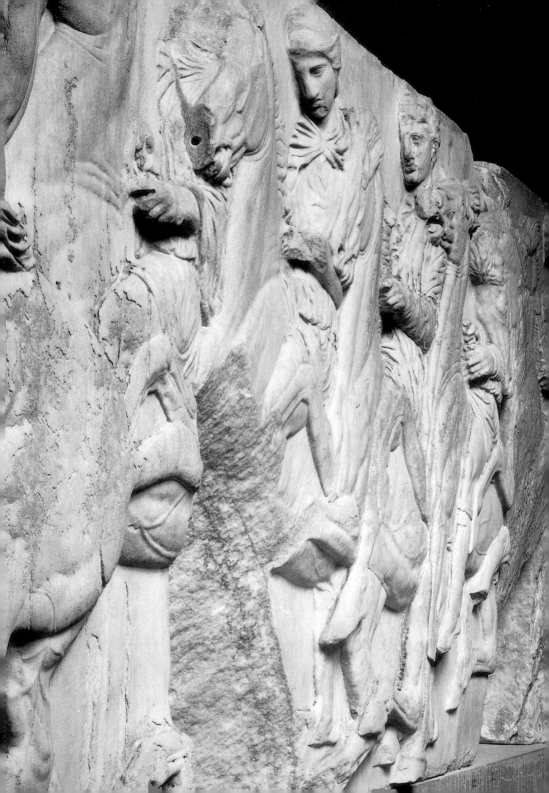

open to the immediately preceding state, represented by a neighbouring figure, while it is also moving on towards the next state as envisualised in the figure before it.

The movement alternates between contraction and relaxation, as human muscles do. The gradual differentiation of the groups from one another is an important element in this perception. Originally the differences were probably more evident and emphasised by colour and distinctive attributes, as well as by the similarity of posture and behaviour within the individual groups.

The reliefs are adapted to an observer looking up from below and placed at a slightly oblique angle to the direction of the movement. Every group is thus first perceived in relation to its 'sequel'.

The frieze depicts a procession, but the procession is conceived as a choreographical sequence, in which men and animals seem to be 'dancing' their roles. The Parthenon frieze has often been interpreted as a piece of music transposed into a pictorial medium.[13] Rhythm can be expressed in either music or dance. But here the emphasis on body language throughout the frieze makes the analogy with dance seem more apt, as does a comparison with other areas of Greek culture in which dance is essential to the performance. I am thinking of the choruses of Greek drama, of military drill as a display of dancing at the feast of Dionysos,[14] or of certain elements in many cults. According to a recent interpretation it seems that Athena herself appears dancing on the prize amphoras awarded at the Panathenaic festival.[15]

Time and events

The temporal character of the events portrayed can be intuitively grasped in two conflicting or, possibly, complementary ways: on the one hand everything seems to be accessible to us at the same time in a single comprehensive sweep, while, on the other, events succeed one another from the preparations in the south-west corner to the front of the procession and the culminating scenes of the east side.

Acts like 'fixing a sandal' and 'adjusting a dress' belong to the start of the festivity during the preparations down in the town, if the scenes are taken to refer to a Panathenaic procession. The scenes on the west frieze

6. Figure W1, the west frieze. The British Museum, London.

and in the western corner of the north frieze thus acquire the character of events at an early stage in a long-drawn-out process. Assuming that every figure represents a 'moment', then more space between the figures denotes a pause or a slower tempo; similarity in movements and a closing-up in space suggest more rapid progress.

The intuitive impression of simultaneity in the composition as a whole, however, has led some scholars to see the entire action in the frieze as occupying a single fairly brief period. Since the scenes of preparation cannot be read in any other way and must therefore be a beginning, these

scholars have chosen to locate everything at the moment just before the start of the procession.[16]

The impression conveyed by the frieze that we are witnessing an event which continues right round the temple is confirmed by the 'joints' at the corners: they are composed in such a way that the links between the action in the different sections are clear, although the corner figures also mark a pause in the rhythm by the static position of their bodies.

But what above all militates against the reading of the frieze as a single moment in time, is the position of the observers when the frieze was still in place on the temple. It was not possible to perceive the continuum at a single glance. On the contrary, moving round the building was part of the act of observation, during which the frieze was apprehended bit by bit with breaks in between. The progression round the temple confirms the similarity between the people in the relief and the observers on the ground, and thus too the similarity between the passing of time in the frieze and the time and the movements demanded of those viewing it.

Aesthetically the frieze seems to be promising a possible experience which cannot be concretely perceived: a continuum that was carved up into sections. The frieze comes very close to giving mortals what hitherto only the gods have possessed: simultaneity combined with successiveness, that is to say a paradoxical construction embodying the different modes of time.

The Greeks themselves were accustomed to envisaging past time as something they had before them: what had happened was 'visible' since they knew what it contained, whereas the future lay concealed behind their backs.[17] Thus a kind of residually instantaneous visibility attaching to what has passed in time was a natural conception for the sculptors of the Parthenon. Past events were thus visible, and historical as well as mythical, distant and near could become present through images.

According to John Boardman there is a 'safe view' in interpreting the events depicted in the frieze – namely that the sculptures represent a Great Panathenaia in a stylised and selective way.[18] However, this 'safe view' may allow for differences when it comes to the duration of what is depicted: it could be a question of a sequence or of longer stretches of time (even general time developing into particular), or of a vividly depicted situa-

tion. This view has come to be regarded as the probable solution by most scholars, with the rare exception of a few who seek to establish the belief in a mythological or heroic theme.[19]

John Boardman himself argued in favour of a heroic meaning by identifying the riders as the Greeks who died at Marathon, footsoldiers transmuted into heroic horsemen at the glorious moment of their death. Another attempt to alter the Panathenaic reading was made by Chrysoula Kardara who saw the *peplos* scene as the enactment of Attic foundation myths – with Erichthonios, Kekrops with his daughters and the earth-goddess Ge as the key actors.[20]

Recently Joan B. Connelly has reinterpreted the subject matter along the following lines: what we see on the central scene of the east side in the *peplos* scene is actually the preparation for a human sacrifice – the young daughter of Erechtheus and Praxithea is about to be killed to save her country in the war against Eumolpos, who attacked Attica with a horde of Thracian invaders.[21]

If the main subject is a heroic self-sacrifice for the preservation of the state, the frieze accords more closely with the function of the temple. Further, the main eastern side will not be essentially a mere heralding of the ceremonies and objects of the cult, but will be more a question of recounting the brave actions in a common heroic past.

Given Connelly's interpretation the characters of the central east scene will no longer include any subsidiary or secondary roles, inappropriate to such an important position. Rather, the three youthful figures turn out to be crucial characters performing the culminating acts of the frieze.

The Erechtheus theme also contains references to the west pediment, where the struggle between Athena and Poseidon for possession of the territory was depicted; this battle of the gods was reflected in the war between Erechtheus leading the Athenians, and Poseidon's son Eumolpos leading the Eleusinians and seeking vengeance for the loss of land.[22]

By presenting a sacrificial scene focusing on Erechtheus' family and on a war ending in victory (though costing the lives of Erechtheus' daughters as well as his own), the theme lends coherence to the underlying pattern of meaning in the whole sculptural ensemble, and it also testifies to the deep-rooted links between Athena and Erechtheus; the *Iliad* tells us that they were worshipped at the same spot.[23] The story can function here as an *aition* for the way Erechtheus merged with the identity of

Poseidon in the religious life of the Athenian people, just as Eleusis had become part of Athens.[24] The identification of this story as the main subject matter is also supported by the presence of sheep among the sacrificial animals of the north frieze, since according to Homer sheep and bulls were what the Athenians sacrificed to Erechtheus.

Athena and Poseidon were both needed as protectors by the Athenians. By addressing the themes of the original hostilities between the gods in terms of struggle, sacrifice and victory, the Athenians could explain the joint cult praxis to themselves, invoking the special protection of the sea-god (the god of naval victories) through Erechtheus as the mediator between Athena and Poseidon.

The forces of Athena and of Poseidon are portrayed equally in the images of the young horsemen of the frieze; both were worshipped as protectors of horse-taming and horsemen.[25] As an appropriate choice of subject matter the riders then fit very nicely into this interpretive frame, while as documentary evidence of Panathenaic procedures or as a political memento of a reorganised cavalry, they raise serious problems.

In the Erechtheus theory the elements of the frieze are no longer strictly tied to the evidence of the festival. Furthermore, the cross references to the rest of the sculptural decoration clarify the message of the ensemble, namely the great heroic task of the Athenians, the genealogical and civic identity of the Athenian people, and the invocation of divine powers.

But is not the *peplos* scene too peaceful to be showing the preparations for a human sacrifice? In reply to this one need only recall the staging of one of the pediments at the Zeus temple of Olympia where the story of the hero king Pelops' deceitful victory over his opponent Oinomaos is represented and no dramatic action reveals what the scene is actually about: contest, deceit, and a fate involving imminent violent death.

Why then should Athens focus on a 'barbaric' habit such as the sacrifice of humans, on her finest monument? The ritual killing of humans was certainly no longer a religious practice, and in fact was even regarded as alien and archaic.[26] But a tendency on the scholars' part not to 'allow' the Athenian official mentality to include heroism of the kind present in this theme, would be like dismissing Euripides from the stage of the Athenian *polis*. Such attempts have actually been made by referring to Euripides' insistence on the idealism of the human sacrifice as 'ironic'.[27] On the contrary, I think we must judge all parts of the sacrificial theme

28

as serious, as a demonstration of the conflicts and terrors surrounding an event that culminates in a sublime expression of human spiritual superiority. Only through the acceptance of inviolable common values can individuals disregard their own preservation; this is the essence of heroism. In every case the point is not the 'savage' appetite of a god who permits and enjoys the spilling of human flesh and blood, but the act of free will on the part of the 'victim'. The attitude of the protagonist transforms a situation of necessity and violence into one of 'freedom' and 'victory'.

The many horses and riders fit loosely into a context concerned only with the relevant cults, and they have a natural role in a political manifesto, either a documentary one as cavalry or a symbolical one referring to Athenian vigour and strength. But they are more strongly motivated in the Erechtheus reading, freed from the documentary function and appropriate for visualising the civic and genealogical identity of the Athenians. Furthermore, they can allude to Erichthonios, the hero fostered by Athena and often associated with Erechtheus.[28]

The chariots raise other questions. The feature in the frieze that most obviously pertains to the Panathenaia is the presence of these chariots with their drivers and their *apobatai*. The *apobatai* (*apobates* in the singular) were hoplites who jumped in and out of the chariots at speed, or jumped off at the end of the course and ran on foot to the goal in a race that was part of the sacred games. The chariots thus seem to settle the issue in favour of the great festival with its races and combats. The *apobates* race did not take place as part of the culminating sacrificial procession, but certainly belonged to the festival. But this feature is also connected with Erichthonios as the inventor of the chariot and as the first hero king to stage a Panathenaia.[29]

Even if it is identified as a scene of human sacrifice, the central scene still highlights an object − the *peplos* − that was also the symbol of the culmination of the festival and certainly recognisable as such by contemporary Athenians. Many of the circumstances of the events depicted in the frieze must have been perceived as allusions to contemporary ritual behaviour, no matter how profound the mythic structure might be. The beholders could recognise the chariot-race, the musicians, the marshals, the processions of tray-bearers and water-carriers, as well as the ceremonial riders at different stages of preparation and parade.

The most telling point in favour of the events being simultaneous with

the act of viewing, is the mode of representation itself. The frieze on this monument behind its row of columns must have entailed a sense of 'presentness', a feeling among the beholders that as they progressed past the columns they were also, in a way, viewing the reflections of ongoing, contemporary movements. This impression is particularly strong in the section with the riders and the procession arranged by marshals.

Why could there not be just one situation, why could it not all 'happen' simultaneously, with the gods simply being present and enjoying their own supernatural ease? The representation certainly suggests the possibilty of complete coherence in time and space. Yet there are very fine distinctions in the mode of representation, which together with the changes of subject matter define ontological barriers within this essentially human realm.

The gods appear next to the people, but act as if they are unaware of them; the gods are also represented in a slightly different manner, and not only in scale. The separateness of the gods is marked in such a way that the humans depicted here have no apparent contact with them, not even with the patron goddess who clearly receives nothing from the procession. The contemporary onlooker thus differs from his stone replicas in that he can look at this assembly of the gods – their visibility being a function of his craft and his devotion – while also recognising the ontological separateness of the divine beings.

The frieze offers the viewer four dimensions of reality:

the procession (contemporary, but maybe with different degrees of generality and echoing meanings from ancient myth and history);
the talking men (personifications of civic institutions and functions);
the assembly of the gods (non-temporal being, pure individuality);
the central scene (a singular event in the heroic past, also alluding to behaviour in contemporary cult practice and to an object – the *peplos* – as an *agalma* (a thing of splendour, presented to the gods), charged with symbolical power.

The west frieze

The events of the west frieze are framed by two static standing figures, who provide still points in the flow of movement, or rather a beginning and a pause.

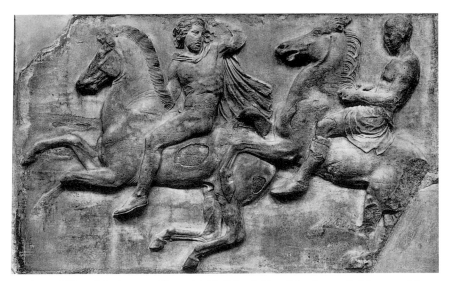

7. Figures W2 and 3, the west frieze, slab II. Pair of riders. The Acropolis Museum, Athens.

8. Figures W18 and 19, the west frieze, slab X. Pair of riders. The Acropolis Museum, Athens.

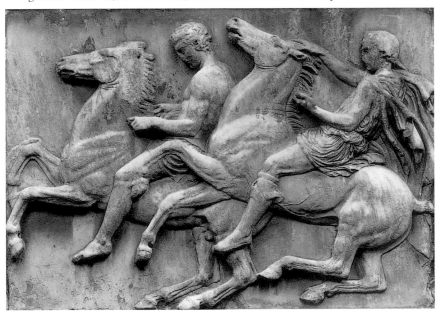

The clearest impression to emerge is one of pulsating motion. This impression has been created first by the similarity in the bodies and postures of the men and horses who are the main actors; the pattern is then broken by recurring variations and interruptions – mechanisms that give the impression of real action, full of the accidental occurrences and deviations attaching to life itself when some more general purpose (a pattern, a plan) is being realised.

Various devices are used to suggest that a flow of movement has been slowed or checked: single figures may turn against the stream, or stand passively instead of riding on, or pause to curb a frisky horse. Signs of movement, on the other hand, include rearing horses with front legs wide apart to suggest rapid motion, or a horseman's mantle billowing out behind him in the breeze.

The signs of movement intensify towards the middle of the west frieze: slabs II, IV, half of VI, VII, IX, X and XI all show riders and horses in motion; their speed has a certain discipline, however, as the horsemen ride together in pairs (figs 7 and 8). These compact speed-signifying groups yield to the sudden greater space round the single horse-tamer on slab VIII; here the movement is violently expansive but also controlled, as the standing man is just managing to curb a horse apparently intent on breaking away (fig. 9).

Scene VIII occupies the centre of the west frieze, thus also representing a powerful accent in the composition of the section as a whole.[30] But no movement is without its echo – not even this horse-tamer motif, which recurs on slabs XIII and XIV (fig. 10). In the second of these a horse is going in the 'wrong' direction, not participating in the main flow but acting as a check on it, although the impression is that the horse could be made to turn and join the bevy which is beginning to form itself into a procession. The repetition of the taming theme is thus modified by marked formal differences, so that the singularity of scene VIII is reinforced, as it becomes the main scene in this section of the frieze.

The groups of horsemen reveal a subtle interplay between like and unlike. The likenesses are general, the differences particular. In fact these horsemen seem to exemplify the very idea of 'similarity'. 'Similarity' requires some deviation. No figure adopts a stance that recurs exactly in any other; not even the pattern of variation within one pair reappears in any other. The play of small graded differences suggests some form or

32

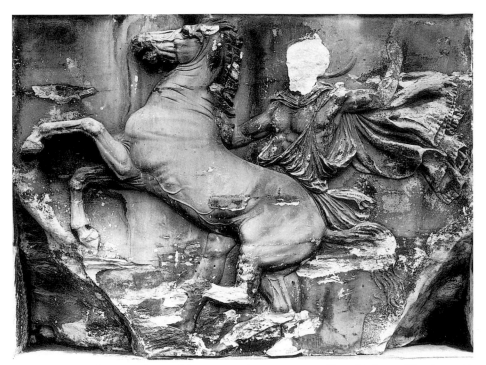

9. Figure W15, the west frieze, slab VIII. Standing man controlling his horse. The Acropolis Museum, Athens.

principle capturing the stage of coming-into-being. The representation, the aesthetic sign, seems to be saying: this is happening, this is what it looks like as the event unfolds. The 'accidental' variations all serve to stress the dynamism of the pattern, like a muscle swelling beneath the skin as an arm tenses itself against a counter-pressure.

The play of like and unlike is most intense in the groups of horsemen in motion. On slab II the horses are well separated; the head and forelegs of the one behind are higher, and it has a thicker mane; otherwise the two animals are more or less duplicates of one another. The men on the other hand are quite different, with the rider in front turning round and gesturing backwards, his face in three-quarters profile breaking with the forward direction of the general movement. On slab IV the horses are closer to one another, but their bodies are more clearly distinguished (fig.

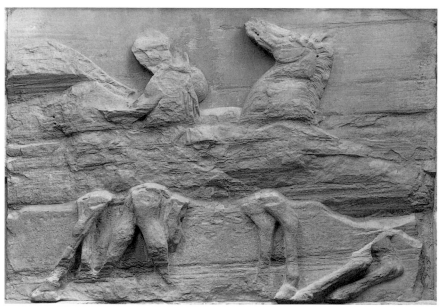

10a and b. The west frieze, slabs XIII and XIV. 'Horse-tamer' motif. The Acropolis Museum, Athens.

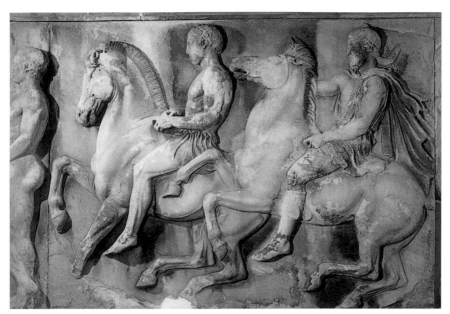

11. Figures W7 and 8, the west frieze, slab IV. The Acropolis Museum, Athens.

11). The men are differently dressed and have distinctive attributes; both are crooking their left arms and clutching the reins with their hands; but the front rider is holding his arm a little more tensely, as though he were about to get his animal to stop (its left foreleg pushes slightly against the ground, indicating that a movement has ceased); the second man's grip is looser and the crook of his arm a little wider – details that are reflected in the stronger, freer and more expansive movement expressed by the horse's body.

On slab IX the same differentiation recurs, in that the horse in front is coming to a halt with one leg tensing against the ground, but – with its head pulling alertly upwards – it is clearly still in motion; the horse behind, in contrast, is looking down, as is its rider (fig. 12). In this pair the men's arms echo each other, but their bodies are distinguished by a variety of details in their raiment and in the curve of their bodies; their left legs represent another duplication but, overall, the postures of the men and their horses vary so much that the configurations of rider-and-steed

35

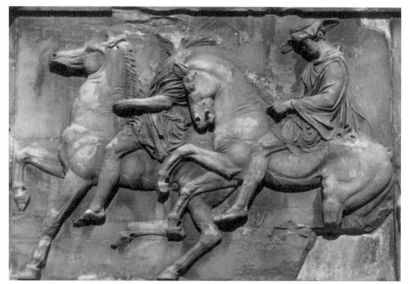

12. Figures W16 and 17, the west frieze, slab IX. The Acropolis Museum, Athens.

13. Figures W20 and 21, the west frieze, slab XI. The Acropolis Museum, Athens.

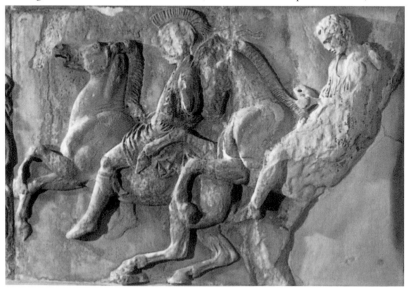

form quite different patterns. The men's knees and the bent legs of the horses both merge with the forward directional pull; the riders' lower legs are part of a series of limbs stretching diagonally backwards, suggesting the powerful holding force that balances a strong forward thrust.

On slab X the second horse appears agitated: three of its legs are clearly above ground level, its forelegs are raised dramatically, its head is thrown back and its muzzle is in the air (fig. 8). The rider's right hand is clutching its forelock, while his left seeks to curb it with a restraining hand. Both riders are leaning back, their bodies and their almost straight legs reinforcing the diagonal back-pulling counterweight.

The interaction between horse and rider is described in formal terms by similarities in posture, direction, angle and curve, as well as in the merging or clashing of violence in the horse and restraint in the man.

The group on slab XI seems to be flagging. The man behind is sinking back in an attitude that strikes me as almost melancholy. The profile of the front rider of these two is distinguished by a horsehair helmet, a detail that echoes the horses' manes (fig. 13).

These are the groups of riders which flank the single horse-tamer in the middle. Powerful movement thus proceeds unbroken from slab VII to slab XI, while towards the edges the dynamism alternates with standing figures, completed movements, or figures turning backwards.

The north frieze

At the western corner, obvious preparations together with a naked man facing the front, provide a link with the theme of the west frieze and thus indicate continuity.

The groups of horsemen are recognisable from the west frieze, but are packed more tightly here: there are more men and more horses, all much closer together, and some of the groups consist of three or even four riders.

In the north frieze speed is indicated by showing a horse apparently just at the moment when all four legs have left the ground (XLII, old number xxxvii); on the other hand there are no dramatically fluttering mantles here, of the kind that appear in the west frieze.

Slab XXXVIII (xxiii) provides a clear example of the interactions within a single group of horsemen: there are clearly three horsemen in the group, but they can be perceived as connected either with the horse

37

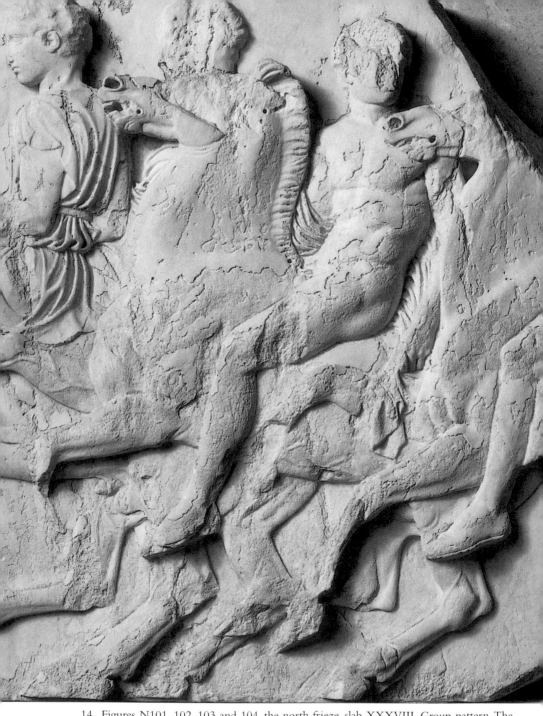

14. Figures N101, 102, 103 and 104, the north frieze, slab XXXVIII. Group pattern. The British Museum, London.

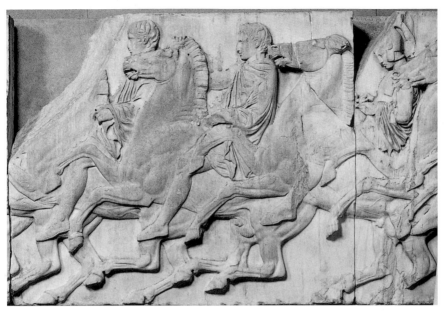

15. Figures N115, 116 and 117, the north frieze, slab XLII. Group pattern. Increasing movement is shown through the positions of the horses' heads. The British Museum, London.

close behind or the one in front (in each case the association is crossed by a seam) (fig. 14). The directional pattern in this group is shown by repetitions: by the positions of the legs and the similarity between the legs of the men and their steeds. Even the horses' heads provide slightly varied repetitions, whereby three of them build a gentle arch, with the middle one tossing its head slightly upwards. However, the main pattern of repetition is broken by the posture of the third horseman, who is turning to look back, his head and breast shown in slight *contrapposto*. The compulsion of the pattern is relieved by a certain easing-off, a breathing-space: variation is possible, there can be deviations from the forward flow.

In the dense groups of riders and horses the pattern of heads creates a special rhythm: each man's head is composed in relation to the head of the horse following him. In slab XLII (XXXVII) we can see how the head of one horseman is virtually 'twinned' by the head of the horse riding beside him, its muzzle just by his chin, while the rider behind is apparently being nuzzled in the neck by the next horse in line (fig. 15).

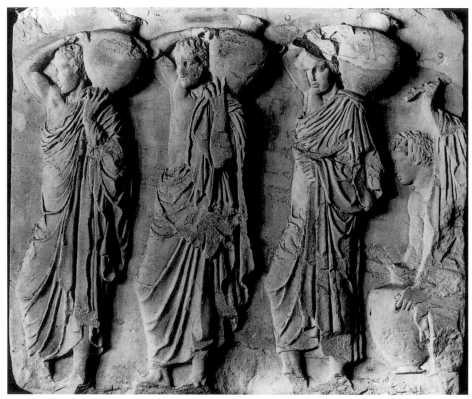

16. Figures N16, 17, 18 and 19, the north frieze, slab VI. The Acropolis Museum, Athens.

In this way the positions of the horses' heads in relation to those of the men indicate rapid and accelerating movement, as though the ones behind are gaining on those in front, or the whole cavalcade is picking up speed. The forward thrust appears to be checked by one horse whose head is still on a level with the rider in front of it; at the same time, though, it is looking down as its own rider suddenly reins it in. This pattern of movement, whereby a horse's head follows close on the neck of the rider in front, occurs repeatedly on the north frieze with the implication of increasing rapidity (while on the south it occurs only once in the long flow of paired heads, and is not used in the same way as on the north frieze).

A few male figures, depicted frontally and in emphatically expansive postures as though they had left the cavalcade, their torsos naked but their mantles visible behind them, act as deviating physical markers in the dominating pull to the left (slab XXIII [xvii], and XLVII [xlii]). Although they are far away from one another they still denote a kind of repetition, within which the difference in their postures – one leaning slightly left and the other slightly right – offers a small variation on the theme.

Repetitions with subtly individualised deviations can be seen even in the more static groups such as the four water-jar carriers on slab VI (fig. 16). The first three have adopted similar poses, with their right knees jutting forward, their jars on their left shoulders and their right arms raised above their heads to hold the handle of their jars. These three are clearly perceived as a unit, a smaller group within the group. The way they hold their heads varies slightly, however, suggesting a slow glance backwards, from full profile to visible faces; but the two three-quarters profiles are not quite the same, as the third man is looking down a little more than the others. The first two resemble one another in that they both support their jars with the fingertips of their left hands, albeit holding their hands slightly differently, so as to ensure variation within the repetition. The third water-carrier's left arm is covered by his mantle at waist level. The draping of the three mens' *himatia* both distinguishes and unites them in different ways: the middle man's breast is bare, while the *himatia* of the first and third cover them fully, but the men are distinguished instead by the different positions of their hands. The fourth *hydriaphoros* breaks out of the pattern completely, bending low with arms straight and loosely holding the handle of his jar. This attitude has been interpreted as that of an exhausted competitor in the torch-race putting down his jar, or as an eager carrier in the process of lifting up his jar at the beginning of the procession.[31]

The south frieze

The south frieze is organised in much the same way as the north frieze, except that the movement of the cavalcade suggests a slower rhythm. This may be due to our Western cultural convention, whereby a pattern moving in the direction in which we read a text, offers little resistance

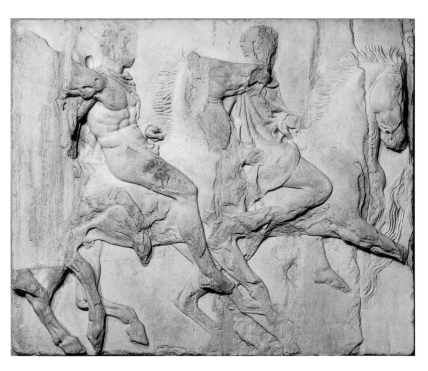

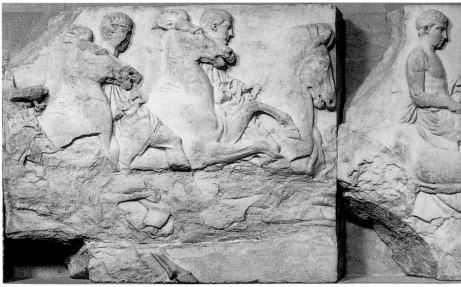

and induces an effect of some gentler, quieter motion, as though the very reading implied an easy interaction or meeting with what follows.[32] As accents of more violent movement, however, the horses' manes flutter more violently, falling into flame-like patterns.

Here too individual deviations do appear within the general movement of the groups. Figure 9 on slab III represents a surprising detail, for example, with a rider encouraging his horse forward with the knee of his right leg, which is sharply bent; the usual position for the riders' legs is otherwise at a slight angle, with the foot stretching forward a little (fig. 17).

Groups are distinguished by the raiment of their members, and hardly at all by their composition.[33] Counter-movements and backward glances are infrequent in this more disciplined cavalcade on the south frieze. The

17. Figures S8 and 9, the south frieze, slab III. The rider 9 encourages his horse with a bent leg, an exception. The British Museum, London.

18. The south frieze, slabs IX, X and XI. The British Museum, London.

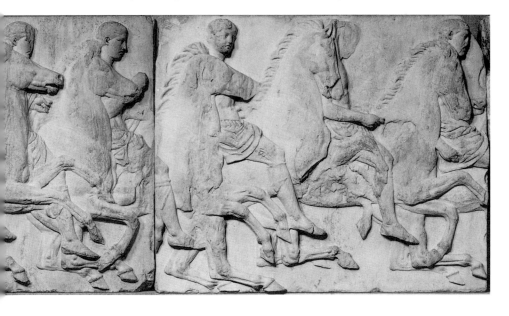

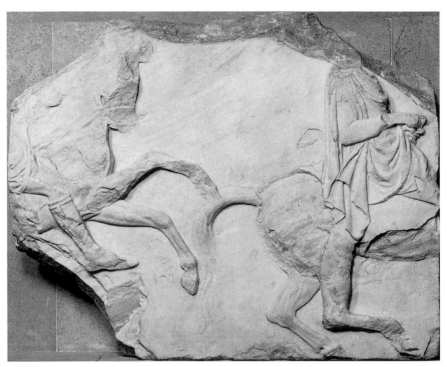

19. The south frieze, slab XIX. The British Museum, London.

dominating impression here is that of a row of pairs of heads, men's heads and horses' heads. Within the even flow of heads there are subtle variations. Not one single combination is exactly repeated: in one case a horse's head hides a man's chin, in another the man's head and throat are visible, and in yet another the 'twin' horse bends its head barring the man's shoulder from sight. The line is broken by more fully displayed riders (three such figures are preserved, but damage prevents judgment on frequency); these appear as independent of surrounding horses.

The feeling of wave-movements is transmitted through groups of three horses' heads: we sense the energy starting in one slightly lifted head, culminating in the middle, and falling off in the third.

The even and apparently rapid flow of the cavalcade changes just before the appearance of the next element in the procession, namely the chariots. The impression of rapid movement suddenly halted is created in

44

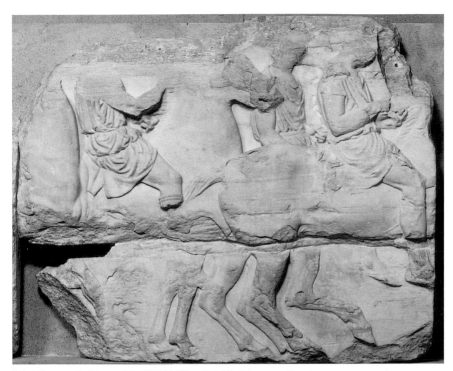

20. The south frieze, slab XXIII. The British Museum, London.

two quite different ways: on slab XIX by allowing a bigger space or greater distance between the figures, and on slab XXIII (xxii) by bunching the figures tightly together and letting their body language show clearly that they have stopped abruptly, their progress checked by the appearance of the chariots (figs 19 and 20).

In the chariot section of the frieze a series of sharp contrasts are played off against one another. In slab XXXI (xxx) great speed is depicted in the vivid fan-like juxtaposition of the horses' heads, with their bent necks and manes like flickering flames. The movement theme is reinforced as the tensed-bow forms are echoed in the hindquarters and tail of the nearest horse and in the footsoldier's shield, while the flame-like fluttering recurs in his mantle and the crest of his helmet. His slightly huddled pose and the turn of his head (looking back towards the charioteer rather than forward) represents a counterweight to the surging strength of the horses.

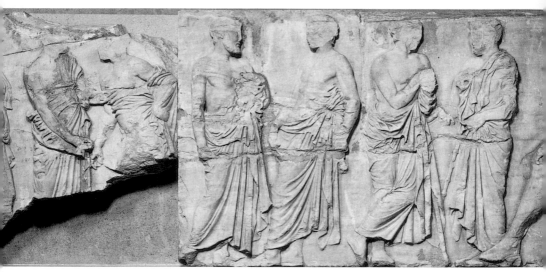

21. Figures E18, 19, 20, 21, 22 and 23, the east frieze, slabs III and IV. The British Museum, London.

The east frieze

Seen as a portrayal of a sequence of events, the east frieze divides readily into sections before our eyes, organised more or less symmetrically around its centre: furthest out at the edges are the parts of the procession where women appear in gentle, almost uniform poses; then come the somewhat mysterious groups of men with staves, seemingly preoccupied with one another.[34] Next to these assembled men, towards the centre, there are two groups of seated gods, larger figures flanking the middle section. And finally we have the central scene which in itself is not organised symmetrically; nor, in traditional formal terms, does it represent a self-evident climax. Separated from the continuous flow of the rest of the frieze and with its unique and more self-absorbed relational pattern, this highly charged focus of meaning is distinguished from the more prototypically strong movements of the focal scene on the central axis opposite, namely the horse-tamer of the west frieze.

The difference in size between the figures on the east frieze, i.e. between gods and mortals, creates distinctions within the sequence of

46

events on this side of the temple. It is not clear what the nature of these distinctions is. The only hint of a link between gods and mortals here is Aphrodite's pointing gesture and Eros's gaze directed onwards. What is perfectly clear, however, is that the human protagonists have no visible contact with the gods.

The distinctions between groups and events in the east frieze are reinforced by the markedly different body languages displayed. Among the gods, gesture is individualised and appears relaxed; it is not prototypical and easily 'readable', as it is not based on obvious codes of body language; the figures relate to one another in pairs. The men with staves seem to be having a conversation amongst themselves; most of them are evidently supporting themselves on their staves. A gesture suggesting dialogue or meeting apparently links figures E18 and E19 (fig. 21), for which reason they have sometimes been associated with the group of conversing men: if they are marshals, however, they may be intended as a counterpart of E47, E48, E49 and E52 on the other side, who are generally regarded as marshals. Within the procession these active officials differ from the

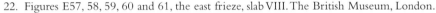

22. Figures E57, 58, 59, 60 and 61, the east frieze, slab VIII. The British Museum, London.

47

more passive women, who appear to be moving very slowly or almost to be standing still. A detail particular to the east side is that some of the figures have covered their hands. In the case of E57, E60 and E61 (women) and in E47 (a marshal), for instance, the mantles are drawn up in such a way as to conceal a whole arm − perhaps an indication that this is a prelude to the climax of the ritual (fig. 22).

The central scene of the east frieze strikes the viewer as singular; there is no repetition, not one codified gesture. In its singularity it pronounces a kind of climax: 'here it stops'. But in dramatic terms it does not reveal its content. If this is a scene of human sacrifice, then the aspect of such an event which is presented here is that of softness or gentleness. The situation appears in some way subdued.

THE PEDIMENT AS PERCEPTUAL IMAGE

Actualisation

'Image' to the Greek mind had aspects of meaning touching upon 'impression' − the mentally experienced visual 'imprint' of seen objects. And, even three-dimensional sculptures could be designated by the same words as flat pictures − *eikon* (image) and *mimesis* (likeness, showing characteristic shapes in living bodies).[35]

A three-dimensional sculpture could be considered in terms of the presence it evoked and represented, or in terms of the creative power of the artist, i.e. the power to 'make' the figure. But it also carried the aura of the 'impression', the merely seen.

The cult traditionally called for divine images in near-human form, in three-dimensional sculptures often slightly larger than life. Just as fifth-century art was starting to adopt a more naturalistic, body-imitating 'narrative' style (the classical style), the idea that the sacred images actually contained a divine presence no longer remained unquestioned.[36] Even so, it was felt that a life-sized free-standing sculpture did in some way 'substitute for' a living original, and that a two-dimensional image was unable to function in the same way because it could not be equipped with apparently serviceable limbs or other attributes.

We can spot traces of such distinctions in two Socratic conversations

which Xenophon reports in the *Memorabilia*. In the first, Socrates asks the painter Parrhasios whether a painting (*graphike*) is an imitation (*eikasia*) of 'things seen' (*horomena*) – a term which can be interpreted either as 'visible things' or 'things as seen'. To the sculptor Kleiton, on the other hand, he says that the full-length statues of athletes look to us 'like something living' (*to zotikon phainesthai*).[37]

In an ensemble which includes reliefs and three-dimensional sculptures in an interrelated scheme, the difference in the reality-endowing power ascribed to the various artistic modes is reinforced. The pediment figures could derive some of their radiance from the aura of the cult image, which is also echoed in the frontal composition of the pediment, with movements and gestures turning outwards and seen by onlookers from the front. The images on the frieze, in contrast, are organised in profile.

The pediments and the frieze naturally differ greatly from one another, and not only in depth, dimension or scale; the pediments 'depict' what has to be imagined, while the models used in the frieze could be recognised in the viewer's own reality.

The viewer of the pediments must be familiar with the stories of the myths and the shared memories of the *polis*. As a result of this familiarity (which we also possess to a high degree) the groups of figures transform before the viewers' eyes into enactments of events happening.

There is a parallel idiom in drama, emerging at approximately the same time as the great temple decorations of the fifth century. The ability to identify 'before' and 'after' in a sequence of events is invoked; emotions are strongly provoked. It is not only visual impressions but also feeling and knowledge that are aroused in the spectator of a drama and in the beholder of the pediments imagination, feeling and knowledge are aroused, not only visual impressions.

But the position of the beholder of the pediment is ambiguous and disturbed by the tense relation between the attraction of an overwhelming presence and the ungraspability of the vision. The sculptures – life-like, three-dimensional, and generally in frontal position – must have evoked associations with the old free-standing cult statues that honour a god or commemorate the dead. The sculptures must have appeared rather like cult statues 'activated', as though coming alive. The brightly coloured

scenes beguiled by reason of their apparent accessibility, far above the viewer. They offered a possibility of witnessing the life of the gods – a highly privileged and desirable vision, but one that was obstructed by the human condition, by the steep angle of view and the limited scope.

These very conditions are also visually enacted in the pediment, displayed on its outer boundary, where the divine world borders on the human: the sun rises in the figure of Helios, who seems, as we watch, to be bursting through the boundaries of visibility with his chariot (plate IV), while night retreats and the setting moon is drawn wearily to rest.[38]

This dramatic cropping of some of the figures is one of the many innovations to appear in the Parthenon sculptures, a device that suggests immediacy, a movement cut off 'in the act'.[39] Conceived in three-dimensional form, with heads breaking out beyond the frame, this pictorial concept undeniably makes a more powerful impact here than in the vase painting where Helios and his chariot are shown in the same cropped manner.[40]

A cropped figure emphasises the visual-image nature of the figure concerned, rather than its presence-invoking function. Thus we find in the representations of the pediment not only an invitation to the eye-witness role, but also qualities in the figures that suggest perceptual imagery rather than any realisation or substitution role. The description of the whole pictorial drama as one of 'actualisation' embraces the two functions of presence-evocation and visualisation.

Time: the momentary and the eternal

The east pediment sculptures describe the moment after Athena's birth.[41] The goddess emerges beside Zeus, complete and ready to assume her role. This, according to the reconstructions, is what the scene looked like. The impression of sudden brief happenings in the corners of the pediment seems to confirm that the scene in its entirety bridges a single short moment. The sense of time in the frieze comprises both overview and sequence. Here, on the contrary, the impression is rather of concrete simultaneity: the dawn of day and the end of night coincide. The short moments that meet as day begins and night ends also envisualise the measure of a day – exactly the time required by the procession alluded to in the frieze.

In the free-standing marble sculptures the captured moment is extended, literally, for ages. Not 'for ever', but for as long as can be achieved by using perishable materials. The character of time in the world of the gods is thus demonstrated with all possible clarity: here each single moment is indestructible; even if succeeded by other moments, it remains a moment of becoming.

Even in the world of the gods, change occurs and things happen. In the *Theogonia*, which was just as familiar as Homer's texts in fifth-century Greece, Hesiod describes how the gods are born at different times, how their struggles for power are resolved and how the divine world order is altered with the arrival of each new god. The Olympian world emerges as the final stage in a long process of genesis and transformation. Under the divine leadership of far-seeing Zeus a system of families and rulers is introduced and co-exists with harmony, or at least with the regulation of the conflicting wills in the world of the gods. In his *Works and Days* the poet tells how the different epochs have succeeded one another, since the time when mortals were created by the gods. Thenceforth, time becomes sequential, entailing destruction, and no more gods are born. The changes and happenings among the gods belong to a primordial age before history, and the conditions obtaining in the sphere of the divine are essentially different from those applying to men.

Thus when the goddess Athena is born, the world of the gods changes just as it has always changed with the birth of a new divinity, but without any ensuing loss or extinction. Night's retreat into invisibility is trans-formed into a new becoming, just as the presence and absence of Demeter and Kore alternate in the cyclical story of seasonal renewal.

If the reconstructions hold good – with a commanding, seated Zeus and a relatively static, heraldic Athena in the middle – then the temporal character of the pediment as a whole appears to include change: from sudden happenings and instantaneity at one side, to increasing stillness – or the almost unnoticeable passing of time – in the middle, and on to another momentary happening in the other corner of the pediment. The left-right movement which informs the pictorial field is underlined by the horses in each corner: the rising sun pulling towards the centre, and the horses of the moon moving away from it and out of the pictorial space on the opposite side.

In terms of content, it is the most dramatic event which is represented

23. Figure O, the east pediment, Selene's horse. The left-right movement is underlined by the horses in each corner. The British Museum, London.

in the centre, while the side sections allude to repetitious cyclical processes. In terms of form, the reverse applies: it is the tremendous, unique event that is shown as static and eternalised; the cyclical events are imbued with powerful movement, breaking abruptly into the visual space. I see these juxtapositions as an ontological statement: that the world of the gods borders on that of men. The movements of the sun and moon represent *kosmos*, the system of the functioning of the world; but they also represent *physis*, that creative nature within which the not-yet-visible human race will have its being. The closer we come to the border, the more powerful the mutability, the greater the effort and emotional force required. Here are intimations of the conditions of human existence.[42]

Bearing this ontological aspect in mind, it is interesting to compare the

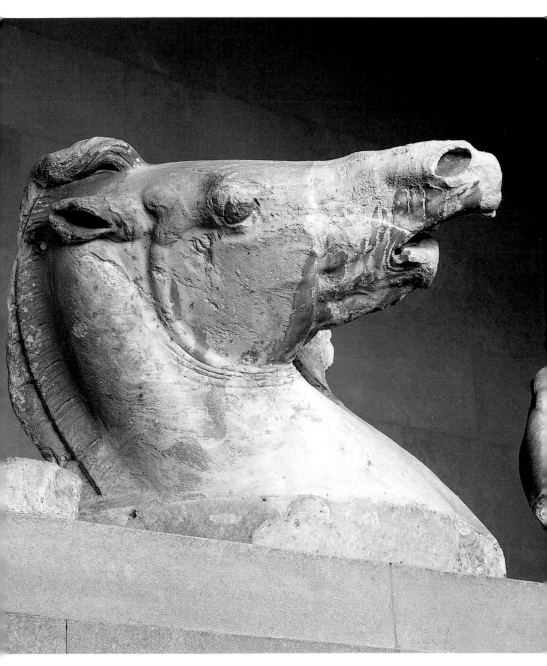

IV. Figure B, the east pediment, Helios' horse. The sun rises in the figure of Helios, who seems to be bursting through the boundaries of visibility. The British Museum, London.

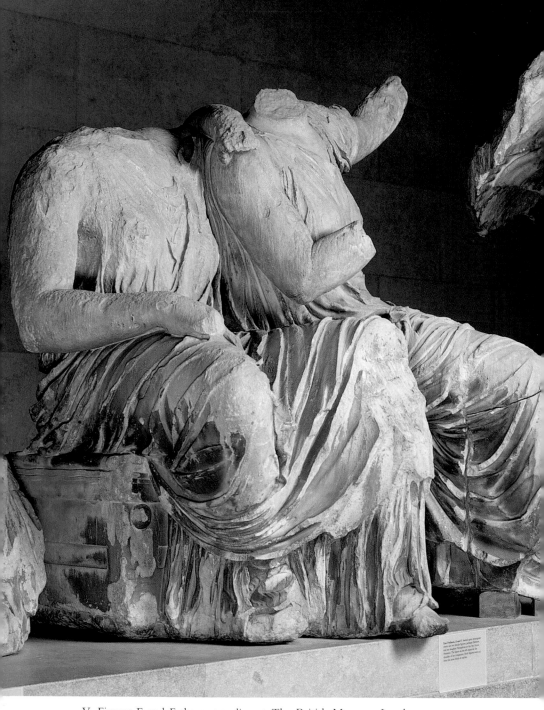

V. Figures E and F, the east pediment. The British Museum, London.

VI. Figure D, the east pediment. The British Museum, London.

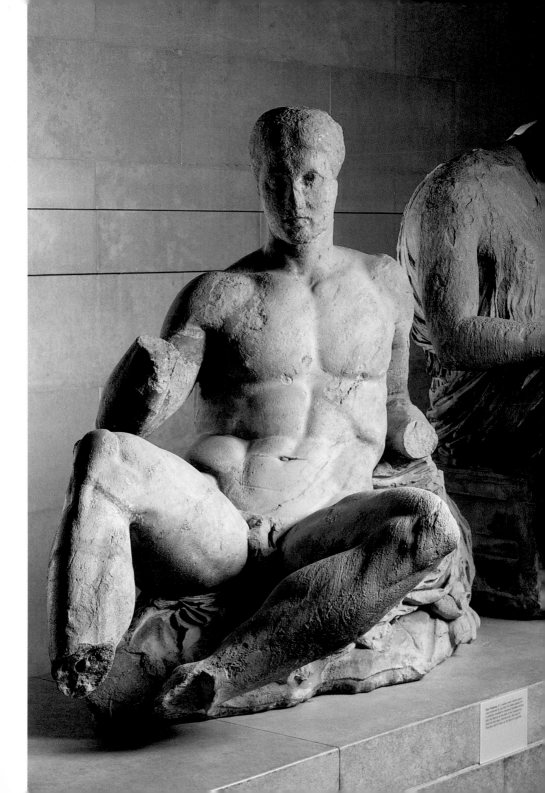

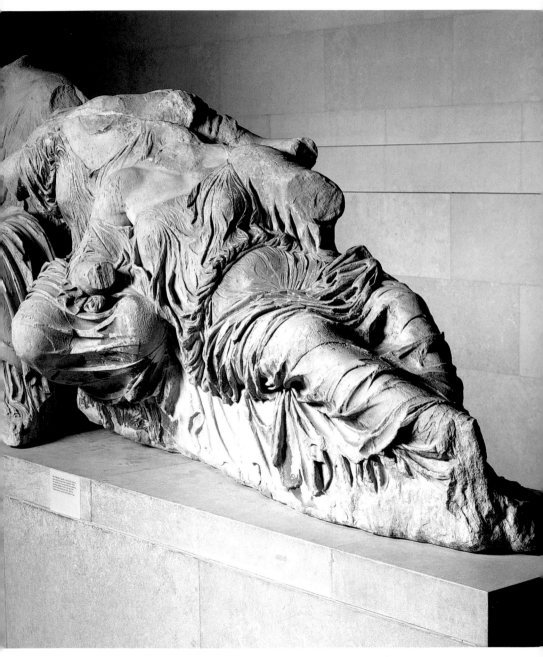

VII. Figure M, the east pediment. The British Museum, London.

drama of movement in the east pediment with that in the west. In the west the deeds and desires of the gods are depicted in a world in which men exist; some of the subsidiary figures on the west pediment may well represent the families of the legendary Attic kings. Here, where the gods appear within the same context as human life, they represent foci of violent and powerful movement, whereas in the east pediment, in their own world and their own time, this turbulence is no more than an intimation around the figures closest to the world of the human and corruptible.

The figures: essence and relationships

The rising of the sun and the setting of the moon can also be seen as visualisations of the essential attributes of these phenomena: sun and day can be spontaneously perceived as a rising mood; night, sinking down, could be suggesting weariness at the end of the day, or simply its own gentle retreat.

Thus even the lively movement of these transient situations can be interpreted as an expression of the presence or essential quality of 'actors' fulfilling Nature's order.

The only other surviving figure on the east pediment which seems to have been caught in rapid motion, is figure G. The problem of her identity has not been resolved, but she may be a messenger or an assistant. If this is so, swiftness is appropriate to her as an expression of her particular character and role, as it is to figure N on the west pediment, embodying the speed of the wind.

In two pairs of figures – E and F, and L and M – movement is expressive of belongingness. The figures are not involved in any obvious event or situation, nor do they represent any particular reactions. Rather, the focus here is on the interplay of similarities and differences and the physical contact between the bodies: the interest lies in the contrast between younger and older, heavier and lighter, vulnerable and protective (fig. 24 and plate V).

Perhaps the physical contact between the figures indicates ties of blood.[43] Several figures in the birth story are connected with one another through close bonds of kinship. No ties seem to be stronger, more

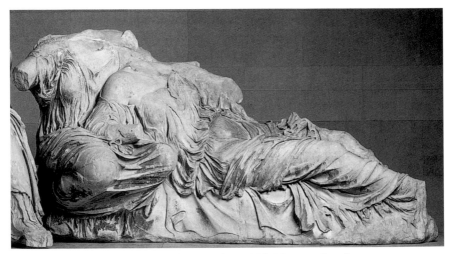

24. Figures L and M, the east pediment. The British Museum, London.

compelling or more clearly motivated than those of birth and family. The genealogical links between the citizens are emphasised in the frieze, as a kind of reflection of the pediment's kinship theme in the world of the gods.[44]

Figure M, generally identified as Aphrodite, is reclining in L's lap, as though she were a child. But the timelessness of the divine world allows her to be like a child as well as like a grown woman with a woman's attractions: for these beings, every individual moment is simultaneous with the eternal state in which, essentially, they exist. Thus the goddesses could represent protection for the human race which is exposed to the inevitable passing of time, while also demonstrating a synthesis of opposites from which mortals are forever excluded: the young Athenian girls spending a year in the service of the temple to prepare themselves for their female role in life, would never be able to combine childhood with sexuality, nor the role of warrior with the role of woman, as the patron divinity of their city could do. Nor could any man know the extreme experience of childbirth as Zeus the omnipotent was able to do. (The gods function as projections of boundary-breaking, as experiments in the art of difference. They represent the excluded Other and the uniting of opposites.)

Between the two sides of the pediment there is a certain correspondence, based on similarities and differences. The Sun and Moon are an obvious example. Next to them come figures D and M, one on each side and in roughly equivalent positions – both compelled by the slope of the pediment to recline or sit. Both are in fact half reclining, and their role as each other's formal counterpart serves also to underline their evident difference: D, the athletic male, and M with the soft rounded curves of the female. The demonstration of female alliance between L and M also echoes the affinity between E and F, thus reinforcing the contrast effect vis-à-vis D. Despite the marked differences between D and M, there is nonetheless a further correspondence between the two figures, in addition to their placing and their semi-reclining pose: they also share a kind of impassioned openness, a striking lack of reserve (plates VI and VII).

Figures in the outermost corners of Greek temple pediments are usually shown half-lying, crouching or crawling; but it is always a question of figures whose torsos are controlled and poised to move forward. The typical position is lying or reclining with the upper part of the body stretching forward and turning, so that the figure appears latently active, ready to leap into action or prepared for defence (even dying warriors maintain this pose, but then with its normal energy ebbing away). D and M break radically with this tradition as they turn to reveal the soft parts of their bodies – breasts, abdomen, genitals. To contemporary viewers this pose must have indicated approachability. In a warrior culture, a body reclining on its back and without the cover of arms, hands or weapons, is automatically vulnerable and defenceless. To begin with, to be on your back at all, leaving the front of your body exposed and indicating that you are without protection, is a shocking liberty to take with danger and fear – something which the gods could enjoy but mortals, never. D's defenceless pose is even more remarkable since he is so obviously the athletic warrior type.

D's reclining pose is codified traditionally only in connection with banquets.[45] It could perhaps support the identification of D with Dionysos. D is a member of a symposium, and M is the goddess of love and fertility. Both thus symbolise ecstatic and boundary-breaking states, and sexuality. M combines two natures, that of the child and the mature woman, which in the human context is an impossibility. D represents the dichotomy between intoxication and a latent capacity for battle. Both

possess attributes which typify their roles and which thus confirm their nature; but these attributes are combined with other atypical qualities. This makes the figures appear powerful: the gods are everything that mortals cannot be, they can combine opposing traits as mortals never could. The figures are also attractive in terms of artistic form; in all their ambiguity and the approachability suggested by their pose, they invite interpretive endeavour.

VISUAL NARRATIVE

THE FRIEZE AS VISUAL NARRATIVE

Stories within the story: group and individual

Like a series of happenings moving towards a single goal, the scenes in the frieze succeed one another in largely the same direction. Within this overall ordered arrangement, certain figures and groups emerge which diverge from the general system. Here, too, we find figures displaying curious details, apparently suggesting some specific situation or intention.

Most of the diverging figures are turning in the 'wrong' direction, looking backwards or perhaps outwards – thus adopting a frontal pose which deviates from the dominating pattern of profiles. Changes in tempo also indicate special events.

In the west frieze we can discern preparation stories. W30 is paired with W29, a young man tying his sandal who is also facing the 'wrong' way, and who has an obvious counterpart in W12 (figs 25 and 26). Progress in the preparations is illustrated by these two sandal-fastening figures: the youth furthest to the right seems to have plenty of time for his preparations; there is an air of calm and gradual start-up which is confirmed by his neighbour, the relaxed standing youth (W30). But the next

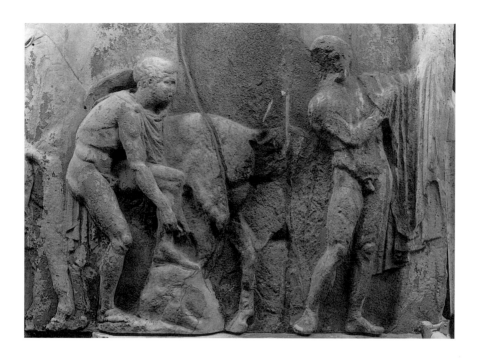

25. Figures W29 and 30, the west frieze. The Acropolis Museum, Athens.

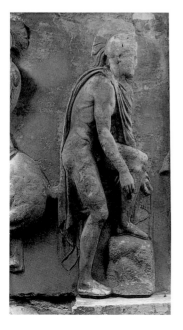

26. Figure W12, the west frieze. The Acropolis Museum, Athens.

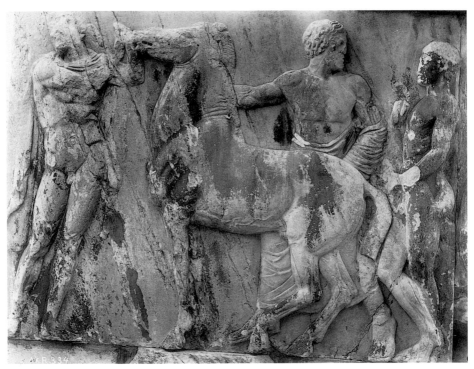

27. Figures W4, 5 and 6, the west frieze. The Acropolis Museum, Athens.

time the sandal motif appears, in W12, we find a young man who is late and in a hurry; and the horse confronting him is obviously panting to get off.

Diverging figures in the west frieze mostly belong to anecdotal scenes. W4 and W22, breaking the profile structure with their frontal positions, are each coordinated with pairs of figures (W5 and W6, and W23 and W24 respectively) (figs 27 and 28),[46] providing two variants of the 'older-man-assisted-by-a-youth' theme. W22 and W23 are obviously involved in conversation (they face one another and are gesticulating); W22 gently inclines his head and points to the horse immediately next to him, which seems to belong to W23; this horse has ducked its head low between its forelegs (a unique posture in the frieze).

Every group in the north frieze contains an element of divergence, sometimes of an anecdotal character. Among the cattle and their

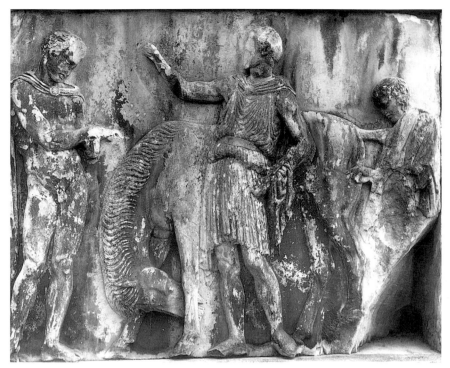

28. Figures W22, 23 and 24, the west frieze. The Acropolis Museum, Athens.

attendants there are signs of rising agitation. One herdsman faces half front, another – with bent head – seeks to control a recalcitrant animal. We find another anecdotal detail in the herdsman immediately in front of these two; he is standing in strict profile, his body expressing a slow forward motion, but he deviates from all the others in that he has drawn his mantle up over his mouth (fig. 29). Once again, this seems to be a sign calling for interpretation, but its meaning evades me.

On the north frieze the number of men on horseback who are looking back is striking (fig. 30). Why are they looking back, what is the meaning of their action? Interpreted as signs of will or intention, these glances over a shoulder testify to some kind of link with those behind, perhaps to check that the group is keeping together. As interruptions in the general forward flow, such details might also indicate friction or hesitations in the group, or opposing wills within the common effort.

63

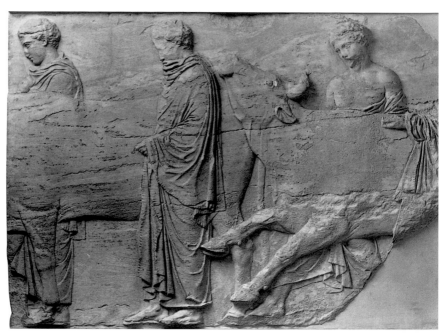

29. The north frieze, slab II. The Acropolis Museum, Athens.

30. Figures N112, 113 and 114 (only 2), the north frieze, slab XLI. – As signs of will or intention, these glances over a shoulder testify to some kind of link with those behind, perhaps to check that the group is holding together. The British Museum, London.

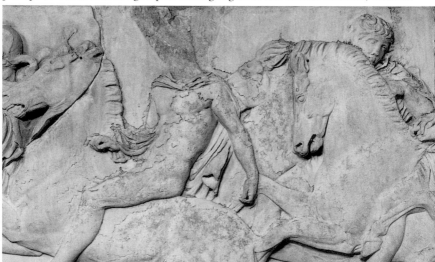

A group is held together by a uniform formation and by individual actions within this formation. The group pattern resembles the relations prevailing among the 'comrades' around Odysseus. Eurylochos is apt to answer back, and even to attack Odysseus quite fiercely (*Odyssey*, X, 230–73; 429–45).[47] Nevertheless he remains one of the companions, firmly part of the collective, once he has made his brief appearances as an oppositional force. Elpenor is another figure in the *Odyssey* who emerges from anonymity, although his solo performance possesses undertones of the trivial and the tragic: he gets drunk and kills himself by falling off the roof of Circe's house (X, 552–60; XI, 51–83).[48] Any basically united group can be disturbed by accidental occurrences, chance, foolishness, lack of coordination, egoism – but such deviations also provide some of the friction and resistance that is required to generate energy and impel progress.

On several fateful occasions the imprudence of Odysseus' companions brings disaster to the group as a whole: the winds are let out of Aeolus' bag; the sun god takes revenge when his oxen are unlawfully slaughtered. Dynamic counterforces or breakaway attempts in a group can be interpreted in two ways: as a threat of pending dissolution or as a condition of vitality. In the frieze the general progress of the cavalcade towards the east is not threatened, and the deviations serve to strengthen its forward thrust: despite countermoves, the formation still holds.

In the south frieze, on the contrary, only one man in the cavalcade, S13, is looking back; a few faces are shown in three-quarters profile, while the great majority are shown in full profile (fig. 31). Thus, relative to the cavalcade on the north frieze, what we see here is another way of holding a group together. On the north side the group is linked by backward glances, by men turning to look behind them. Here, instead, the group is given coherence by the fact that almost all its members are behaving in much the same way. The two figurations probably reflect two different aspects of the community spirit. In pictorial terms the north side clearly encourages far more individual opportunities for action than the south.

As a reflection of an aristocratic spirit the notion of individual movements within the group may represent the bravery and strength of the elite; as a democratic manifestation the idea would be about freedom from the contraints of personal leadership. Characteristically both aspects could be said to be interacting in the bodies of the riders.

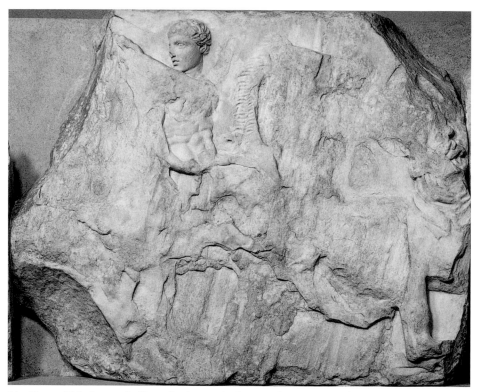

31. Figure S13, the south frieze. In the south frieze only one man is looking back. The British Museum, London.

The established continuity of the frieze as a whole is put to the test at the corners: here, some indication of the connection with the other sections is required. The westernmost group on the north frieze refers 'back' to the west side, and the riders on both the north and south sides suggest a kind of repetition of those on the west, albeit displaying a different pattern of movement.

Only the east frieze represents a new beginning, whose order and composition is unlike that of the other sections. However, there are marshals on the east frieze, as on the others. These figures act as coordinators, even in purely visual terms in the representation, where they are identified as active against-the-stream figures; there they stand, their garments falling

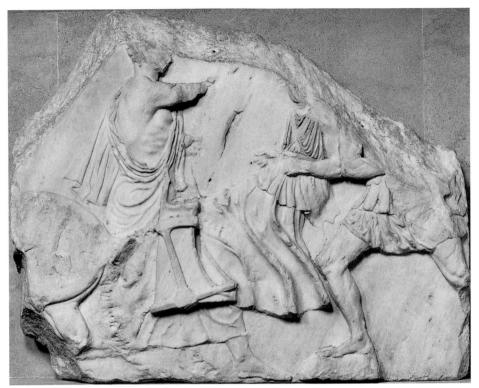

32. Figures N45, 46 and 47, the north frieze, slab XII. These figures act as coordinators. The British Museum, London.

in rich folds, gesticulating towards the other actors (fig. 32). Among the cast of characters on the east frieze their figures naturally suggest links with the other sections, but given their identity as participants recurring in several contexts, they become in some way more autonomous, more mobile and more prominent.

Two corners are occupied by such figures: the northernmost corner of the west frieze and the southernmost corner of the east. Located symmetrically and antithetically, they reflect and reinforce one another, and are thus lifted once again out of their immediate fictional context.

Although they are engaged in the fiction – indeed they are linking and organising it, and their movements allude to the events depicted – they

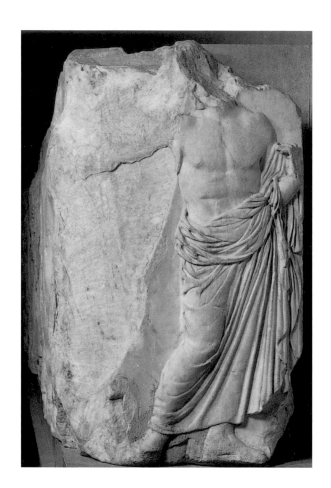

33. Figure E1,
the east frieze.
The British
Museum,
London.

also appear isolated from the rest of the depicted world. Their movements
thus have a double identity, directed on the one hand towards the par-
ticipants in the procession, and on the other – now with an aura of
ceremony and generality – towards the viewers 'out there'. It is as though
they were arranging not only the procession itself, but also its depiction
before the eyes of the beholders.

It is possible to conceive most of the events depicted as belonging primarily to the procession of a Great Panathenaia, the ritual climax of the festival. The procession started at dawn (the time also indicated in the pediment sculpture), and presumably continued for a whole day – the natural limits for a beginning and an end. Within this time span, which could be conceived as corresponding to the pictorial space of the whole frieze, every figure has a space of time relative to the movement in which it appears to be involved: static figures suggest a slow and lengthy event resembling a state with only the tiniest of changes; the musicians and tray-bearers of the north frieze are figures of this kind. It is typical that groups indicating a slow pace (the water-carriers, those escorting the sacrificial animals) include a figure that breaks abruptly out of the relatively static group pattern; the deviating pose suggests an incident, a sudden occurrence in an otherwise slow-moving sequence.

If the whole procession corresponds to the events of a day, then the groups of water-carriers, the attendants with the sacrificial animals, the musicians, the older men and the tray-bearers all represent more or less equal proportions of motion and situation in the procession. The horsemen, the chariots and the riders getting ready to set off, on the other hand, displace the focus of the visual narrative in relation to the conceivable events.

Active movements or gestures appear within the groups of horsemen, seemingly to suggest brief moments. But their repetition and their distribution in the pictorial space serve to emphasise and magnify these moments, rather like a film in ultrarapid motion. The quick transitions between the manoeuvrings of horses and horsemen seem to extend time, catching and halting for a moment a lingering, comprehending eye, like descriptive digressions in stories which seem to say, 'Stop, look, see how this symbolises a theme or an idea!' The men riding or controlling their horses are thus singled out from the other representatives of Athenian society; they are displayed as conceptual images and pointers to an understanding of the whole.

The frieze is constructed as a long ribbon, intended to be grasped in sections, with some group or groups catching the eye at every glance. This makes it easy to understand the frieze as a story, in which the scenes

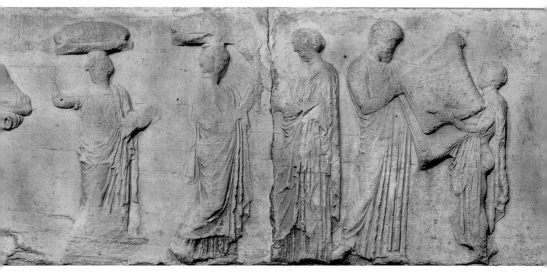

34. The east frieze, the central part with the *peplos*-scene and the assembly of gods. The British Museum, London.

are events succeeding one another. It is also easy to identify the beginning of the story in the south-western corner.[49] The direction of the story is determined quite simply by the direction in which the figures are moving, which in the west frieze is towards the north, while in the north and south sections it is towards the east. Thus all the figures on these three sides are clearly 'on their way', some more speedily than others and in more or less coordinated groupings. Their arrival, however, is problematic, to say the least. The whole east side constitutes a more sacred space, concentrated around the epiphany. The women belong to this sacred space – they are directed by the men, but as an essential element in the now heightened sense of holiness.

The proximity to the gods and the concentration of holiness on the east side are accompanied by a waning of the action. The active gestures of the marshals now function as little more than a characteristic link backwards to 'earlier' scenes on the other sections of the frieze. Within the assembly of the gods and among the men nearest to them – clan heroes or officials – the pattern of movement is introspective; the figures seem absorbed in one another.

There is no apparent 'arrival' for this procession. The marshals on the east frieze continue to act as organisers; they do not meet the group of magistrates or the clan heroes, nor are they received by them.[50]

The procession, then, can be apprehended as a phenomenon of the same structure and character as the frieze itself. It shows ongoing events – repeated, general or typical – but events that are actually happening.

The covered hands of some women and men in the procession close to the centre do express the idea of a change, of a much later phase in the narrative, where the solemn movements of the women and their ceremonial attributes also indicate the approach of a final stage. Shown in the proximity of the gods and the central scene, these figures can be interpreted as signs of the procession nearing its goal and thus in some sense as signs of an arrival. But no decisive action within the procession marks an end.

If the men engaged in conversation were to be seen as belonging to the same situation as the procession, to the same time-space, their actions would seem odd in view of their apparent lack of interest in the surrounding events. I find it possible to view them as in some sense personifications of civic order – the tribes and the magistrates representing the functions and institutions of the *polis*. Compared to the figures in the procession their behaviour is less bound to a group pattern; the men have an air of independence and of equal dignity.

The gathering of the gods in two symmetrical and paired groups, together with the central scene, stand in for an arrival or an end to the action. These scenes thus seem to me to be explanations of religious behaviour; they give meaning to the sacrificial procession as *aitia* ('this is why we perform our rituals').

There seems to be a value hierarchy of beings and events in the representations of the frieze, as follows.

The highest value attaches to the gods who are non-temporal, immortal, displaying absolute individuality; in the human realm they appear as the final and effective cause.

Next come the mortals in the central scene; to them belongs mortality, but also individuality of a higher order (as though echoing the mode of the gods); their behaviour is singular and exemplary; their time is an occasion, long ago.[51]

Next in order are those in civic roles, who act both individually and

71

as a group; they belong to the ongoing civic reality, but as personifications of the functions of the *polis*. Their time is not dependent on actions, since they are allegories of ideals.

The procession, finally, also belongs to the ongoing civic reality, with mortals bound to a group character and to the accidents of mortal life.

What is peculiar to this scale of value and reality is the correspondence between high value and individuality. The hierarchy is clearly religious, imbued with paradox, and differing from the philosophical and rational solutions to the problems of mortality in Plato's system, with which I will be dealing later in this book in relation to the sculptures.

The rite

If the frieze is a visual narrative, then one of the literal stories which it tells concerns the religious festival, and especially the part leading up to and encompassing the sacrificial rites.

The frieze is devoted predominantly to a procession, which identifies the various situations as elements in a solemn social festivity. The procession of the Panathenaia was the important prelude to the rite of sacrifice. Its social relevance – its role in manifesting and confirming community and participation in society – is revealed by its route: starting from the swarming throng in the craftsmen's quarters, through the agora with its political institutions and public meeting-places, passing the Areopagus (symbol of an earlier centre of power), and finally up to the cult places on the Acropolis.

In the context of a cult celebration the procession is a preparation, barely even a beginning, representing a passage to the sacred 'area' or the culminating part of the event, when the actions needed to communicate with the gods are actually performed.[52] The institutional attributes of the rite that appear in the frieze are the mantle, the sacrificial animals, the incense and libation bowls, the water, the musical instruments, the trays and baskets (probably envisaged as full of cakes and flowers). The religious climax was the handing over of the mantle (a collective votive gift) and the sacrifice of the animals.

If the central scene is about the sacrifice of Erechtheus' daughter, then there is also a human sacrifice. Let us assume this radical, but far from

obvious interpretation of the central scene, and look at its consequences in the expression of the representation.[53] This scene will then appear as separated from the contemporary procession and the animals. The subdued action could be a reminder that humans are no longer killed to please the gods; the gods no longer receive or partake of human flesh and blood; communication is effected through symbolisation instead. A layer of commemoration implies a distancing from the ultimate sufferings of a past era.

Ritually, the important items were the *peplos* and the slaughtered animals. But it is the *peplos* that is the symbol of the original human sacrifice, while the celebration embodied in the animal sacrifice constitutes another type of communication.

The votive gift is present as a commemoration, a thanksgiving, a token of reconciliation after great human suffering, as homage and the fulfilment of a promise – a largely private cult custom, enacted in the Panathenaia on a grand official scale, embracing a whole empire-building city state. The animal sacrifice, a much older cult form which probably reached out to all members of society through representative roles for different groups, demonstrates instead man's subjection to mortality, his dependence on food and his fear of the natural powers personified by the gods.[54]

As regards the animals, the sacrificial aspect is toned down in the frieze and, in spite of some vigorous movements, the general impression is that they are simply part of the procession. The official who is to perform the actual slaughter is not singled out, nor is the person (usually a young girl) who generally carries the sacrificial knife hidden in a basket.[55]

From the religious point of view animal sacrifice was not unproblematic. This part of the cult can perhaps be regarded as secularised, as a tradition based on group solidarity and an opportunity for feasting, rather than implying any communication with the gods. We know, however, that the rite of sacrifice was charged with feelings of guilt, while also being deeply rooted in the Greek imagination; it was both compelling and an expression of piety. Homer's characters show gratitude to the gods, and appeal to them, through sacrifice and gifts. There is no guarantee that the sacrifice will be received, but the gods show their anger clearly if it is not

forthcoming. The sense of guilt surrounding animal sacrifice does not only concern the domestic animals that were killed, but it also springs from the knowledge that men could make use of all parts of the resulting carcase, while it is difficult to imagine what joy there was in it for the gods – especially as the fat and bones were their allotted portion. Hesiod develops a whole complex structure of betrayal and guilt around the person of Prometheus and the disrespectful way in which the parts of the sacrificed animals were distributed.[56]

The uncertainty about the results of cult acts is demonstrated in the Parthenon sculptures, where no god is seen receiving either a sacrificed animal or the mantle, and where no act on the part of the gods seems to imply any unequivocal promise or guarantee, or even any goodwill towards mankind.[57] Nor, in fact, is there any display here of divine power over mankind.

The mantle, the gift, duplicated by its mythical replica in the frieze – is thus an uncertain investment in benefits or blessings. The most famous literary example of this kind of situation is the story in the *Iliad*, where the Trojans give their most beautiful and costly mantle to Athena, but fail thereby to gain any help from her. The Athenians, descendants of the winning side, could always hope for a better response, but it was never more than a hope.[58] The gods punish men for failing to offer adequate gifts or to pay their divinities sufficient attention, but nothing is promised in exchange for either worship or gifts.

The mantle was a splendid thing, a votive gift or *anathema*, as well as a luxurious object, an *agalma*, whose beauty would testify to the artistic skills which the Athenians had received from their goddess, and which they gave back to her in gratitude and reverence. It was intended as a manifestation of communication with the godhead, as close as one could come to such a thing in view of the obscure or capricious nature of the answers men received from their gods. In any case it was a personal (and in itself a useful) gift, addressed to the goddess as personified and embedded in the holiest of holies, the wooden statue.

In his book on Greek religion Walter Burkert defines ritual as follows:

Ritual, in its outward aspect, is a programme of demonstrative acts to be performed in set sequence and often at a set place and time – sacred insofar as every omission or deviation arouses deep anxiety and calls

forth sanctions. As communication and social imprinting, ritual estab-
lishes and secures the solidarity of the closed group;[59]

In discussing the sequence of events connected with animal sacrifice,
Burkert points out the heightened nature of the ritual that surrounds the
actual moment of slaughter. Several definite and prescribed acts and attrib-
utes precede and succeed the climax of the rite, with its blood-letting
and screaming women.[60] It is as though we were to learn about a sequence
from descriptions which delineate and particularise the beginning in far
greater detail than the rest of the action. Essentially it is of course the
actual slaughter and the shrieks of the women attendants which are the
climax to the rite of sacrifice, but for these acts to take place at all, and
to have an effect, the preparations and initial acts are crucial. (There is
something reminiscent of compulsive behaviour here: to get it 'right' one
has to cross the threshold with the 'right' foot first, and so on.)

Perhaps the rites associated with oath-taking and the handing over of
votive gifts, followed a different pattern. The procession on the Parthenon
frieze acquires part of its identity from the animal sacrifice theme, and it
seems likely that in this context it depicts an extended prelude, the climax
of which is not shown.

How then should we explain why the goal of the rite, the essential
cult act, is not included in the pictorial representation?[59] Perhaps we can
do so by invoking the importance which the prelude enjoyed, thus regard-
ing the frieze procession as a way of prolonging and eternalising the *over-
ture* required for a successful ceremony. The culminating act is not shown,
since its accomplishment depends on its being carried out in reality: the
animals must be slaughtered, the mantle must somehow be made and
installed.

The acts of the opening stages were more fundamental and more sym-
bolically crucial, but also more conceptual, more in the nature of a scheme
or a system of 'ideal' actions, than the actual slaughter of the animal and
the manufacture of the gift. The opening proceedings could be preserved
through the power of symbols, whereas the killing itself had to be repeated
again and again.

The *pompeia* shown in the frieze is certainly part of an introduction,
but it also precedes the beginning of the act itself. Definitive rules for
gestures and the order of events could hardly be applied to this festival

procession, with its crowds of participants and all the incidents that must inevitably occur along its route. Nonetheless there were probably quite specific regulations about the elements that had to be included in it.[62]

As one ingredient in a series of ritual acts, the frieze procession has a double identity: certain qualities fulfil the requirements of the prelude to the rite, others are certainly the fruit of chance occurrences, of the eddy and surge of all the little secondary happenings connected with the realisation. This is of course what it is like in reality, but the frieze artists have chosen to raise such chance occurrences to the dignity of the visual image. Why? They could equally well have concentrated exclusively on the essentials of the prelude to the cult acts.

Their choice here may have had the same motivation as their way of depicting movement, namely that although the identity and worth of the characters were bound up with that of their group, the realisation of any action nonetheless requires the 'irritant' of the chance occurrences that arise from the immediate moment or the personal particularity.

Secondary incidents, anecdotal digressions and deviations from the main directional flow are all required to show that things are happening on the human plane. These elements in the pictorial world of the frieze demonstrate clearly that what is happening, and where it is happening, together constitute the human sphere – where a general group identity combines with the accidental circumstances of individual incidents.

Such a depiction gives a deeper sense of the full meaning of 'ritual'. A 'rite' involves a kind of schema designed by men to allow in some way for contact with, or control over, the powers which lie beyond the physical limits of human life. Just as important as the basic structure provided by the rules, however, is that the acts are genuinely performed. Only in the realisation in time and space of the prescribed gestures or utterances, can the link with the gods be established (cf. the words of the Roman Catholic liturgy, 'ex opero operato infusa'). The 'chance occurrences' in the procession are consequently essential to the rite; they indicate that the acts are actually being performed, that it is not simply a question of depicting the plan, the idea or the general concept of the cult ceremonies. We are witnessing, or can read, their accomplishment.

The realisation of a schema or design involves an appeal to many facets of the human soul. Typically a rite implicates the participants both emotionally and intellectually in several ways, and by appealing to a variety

of sensory impressions. The man or woman participating in the cult should as far as possible be actively aroused by its manifestations. In the pictorial world of the frieze we find characteristic allusions to several of the senses: hearing, activated by impressions of people moving, by musical instruments playing, by men's voices; smell and hearing, by incense and the bodies of animals; taste and thirst by references to food and water.

The message

Assuming a narrative code, then the sculptures tell us a story. They might even be given voice as if addressing the onlookers: 'Behold yourselves!' But the events and identity-reflecting nature of the frieze are also contingent on, or motivated by, the suspended struggle caught in a frozen moment in the metopes, and the apparently 'real' moving gods of the pediments.

Observers of the completed temple could let their gaze wander between the different parts of the ensemble, absorbing the message or 'voice' which was explaining and exhorting more or less as follows:

Thus are you compelled, this is what you must face: struggle is your existential condition; if the struggle is temporarily over and has fallen out to your advantage, then gratitude is due to the gods who have achieved this outcome by granting to mortals – and particularly to you and your kind – certain abilities and strengths: skill, endurance and courage. Not only by the number of your weapons, but by your abilities is the outcome determined. The gods no longer join in the battle themselves, but they have given you the skill – under the conditions of struggle – to sustain life and to win.[63]

The artistic form of the frieze, somewhere between the two- and three-dimensional, contributes to the expression of this message. The impression of reflection is reinforced: a picture of the models themselves is being 'thrown back' at them.

In contrast, the metopes are largely devoted to scenes of battle, of apparently perpetual and undecided struggle, sometimes even with signs of heroic effort on the part of the enemy – Centaurs, Trojans or Amazons. The myths told that the Lapiths defeated the Centaurs, but in the metope

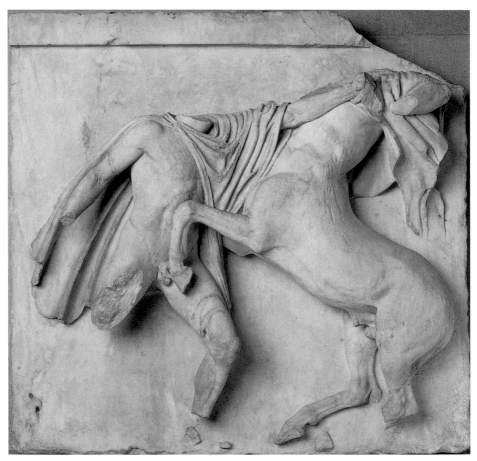

35. South metope VII. The battle is neither won nor lost. The British Museum, London.

scenes the battle is neither won nor lost (fig. 35). War encompasses both outcomes: the threat of defeat is an element in the will to win, and is almost as near to victory as the reflection of our faces in a mirror is near to us. A warrior is close to his enemy, and – in the Greek view – the quality of the struggle is enhanced by an opponent who is his equal. In play after play the tragedians depicted the plight and emotions of battling and defeated enemies, with recognition and distancing in a kind of double reflection or self-reflection through empathy and contrast.

The ideal of citizenship displayed on the frieze is not a strictly military one. A few figures – the *apobatai* – are wearing shields and helmets, two men on the west frieze have horsehair helmets, and only one figure, W12, is shown with a weapon (a small part of the handle of a sword can be seen, but it is almost 'hidden' in the folds of the cloak).[64] The talents in which the Athenians show pride here are youthful strength, flexibilty and quick reactions, endurance, and individualism combined with coordination – all qualities which served them better in war than mere skill in arms. The celebration of these qualities is of course also a celebration of the gods, and in particular of Athena who granted these very gifts to the citizenry depicted here.

THE PEDIMENT AS VISUAL NARRATIVE

Mythos

The classical Greek mentality typically turned to personification as a way of comprehending all kinds of phenomena. The forces of nature and a variety of existential conditions, for instance, were reformulated as actors who behave in certain characteristic ways and are confronted by certain situations. Similarly, the concept of depiction or representation, *mimeisthai*, was applied to all kinds of variously stylised imitations of behaviours.[65] Every figure portrayed is thus connected with a story which can be told, a stream of episodes among which key scenes can be selected and to which allusions can be made. According to Aristotle, imitative artists represent 'men in action'; no representation is possible without a story.[66]

The distinction that was made between *mythos* and *logos* in classical Greek thought confirms the revelatory power of narration, or myth. When knowledge on some question cannot be achieved by means of 'dialectic' (logical argumentation), ideas can instead expand and intensify themselves in the form of myth. This is the way Plato sometimes proceeds, 'painting' in words the scenes that explain by way of visualisation. He describes for instance how men are trapped by their senses as though held by chains in a cave.[67] Or he 'explains' the human soul in a figure, likening it to a charioteer trying to control two winged horses pulling in opposite directions; he shows how the wings of the soul, lost during physical life, start

to grow again, felt paradoxically as a physical swelling in the 'roots' of the wings, as an itch and a heat at the recollection of things the soul once beheld in the realm of pure Forms.[68]

Theoretical philosophical problems are sometimes presented in Plato's texts in pictured situations, as if performed before our mind's eye: Socrates in prison surrounded by his followers and guards, before receiving the poison for the execution of the death sentence; guests at a banquet in the house of the tragedian Agathon, and the mounting sleepiness that succeeds their long discussions; two friends taking a walk outside the city in the midday heat, and listening to the cicadas. Thus Plato's texts make their effects much as drama does: knowledge and reflection on existential conditions are realised in voices and countervoices, movements and gestures within an action setting.

Familiarity with Homer's texts had accustomed the Greeks to complicated narrative techniques, which included framings and insettings. The stories of Polyphemos, Circe and the visit to the underworld, for instance, have a layered structure of this kind: when Odysseus 'speaks', he knows what is going to happen right up to the time when he entertains the Phaeacians with the story of his adventures, while the superordinate narrator (the one describing Odysseus's description), knows everything that will happen from beginning to end.

Greek literature provides examples of extremely subtle distinctions within the general code for depiction or description. In the Homeric texts situations are often 'painted' in such vivid detail that we seem to see moving figures caught beautifully and precisely 'in the act': a flung spear touches the ground, dust swirls round a head, a shadow falls over the earth. In Homer such segments of time, made visible, can sometimes depict not only an action or an event but even a state which is already a 'picture': a frozen second, captured for all eternity and stylised as a recollected image. Take for example the dead Orion in the underworld, an 'image' in which the giant hunter, club in hand, forever drives before him the wild beasts that he used to hunt in life. In this underworld shade I see how a memory, a depiction, a frozen moment and the cessation of life can all come conceptually together.

In Plato's texts the accumulating messages are often stacked up, layer upon layer. In the *Symposium*, for example, the core of the argument appears as the reflection of a memory, concealed in solid strata of nar-

rating, and constantly threatened with obscurity or displacement because of the physical obstacles – weariness, forgetfulness, ageing – that come between us and the message.

The effects of allegorical narrative – its interventions in the mechanisms of thought – are contingent on what is being allegorised. What is decisive here is the degree of vagueness, of abstraction or of 'ungraspableness' in whatever is to be made comprehensible by the narrative. Sometimes it may not even be clear whether this 'whatever' is in fact 'anything', before the myth has grasped it.

We know that the Greeks envisaged natural phenomena symbolically, for instance imagining the dawn as a divine charioteer skilfully manoeuvring his chariot and his lively horses up over the horizon, as if he were pulling the orb of the sun behind him, or as if he and his horses themselves were the very power of sunlight. The speed and strength of a victorious racing charioteer lent their own colourful force to the image of the rising sun. The meeting of picture and symbolised phenomenon presumably has a reinforcing, representing effect, but we can also imagine that at some breakpoint the picture continues under its own steam, supplying the natural phenomenon with increasingly far-fetched projections, until the two of them seem to go their separate ways. Stories about Helios lending his horses and chariot to his son, or Apollo destroying the huge snake Pytho tend to distance the processes of nature, in favour of ethics and adventure. Thus the natural phenomenon of the dawn has been elucidated by a metaphor, such as that of the charioteer, and then eventually hidden by the narrative potentials of the story within the verbal image itself – as though the events and complications in which the chariot may be involved rise up and block our view of the dawn which it has symbolised for us.

Pictorial art belongs to the same sign family as narrative and drama, but has its own special character due to the medium employed.[69] Monumental figurative sculpture had value due to its enduring nature and its ability to capture and immortalise visual impressions of life in lifeless materials.[70]

Admittedly the Greeks distinguished between narratives about actual events and narratives about fictional people and happenings.[71] But the

81

descriptions of society's memories nevertheless contain much of the 'once upon a time . . .' character, with a story that moves towards some kind of ultimate goal. The idea of reality as more or less satisfactory realisations of a goal, a *telos*, explains the syncronisation of distant and contemporary events, the superimposition of myth, heroic time and present time.

Birth of the goddess: myth and event

It is probable that the sculptures of the east pediment represented Athena's birth. The subject had been popular in Athenian vase painting during the sixth century, but had fallen into disuse during the fifth. The vases generally included a few central figures only: Zeus on his throne, a tiny figure of Athena by his head or on his lap, and Hephaistos who brought on the birth with the blow of an axe to Zeus's head; sometimes we can see the *Eileithyiai* assisting at the birth, and sometimes also a divine witness such as Dionysos, Ares or Apollo.[72]

The great panorama of the pediment required quite a different approach, with more interweaving of themes and associations – a staging at least as complicated and artistic as Pindar's Olympian ode (which is one of the written sources for the myth of the birth of the goddess).

A few figures flanking what was once the central scene are all that remain of the original mighty composition. They are the only figures that can now be activated by our possible interpretations. The instrument for interpretation here is the myth itself; its constituents will have to give substance to the still visible figures, as well as to the gap once occupied by the main characters.

The various possibilities of the myth can be charted with the help of the texts in which they are described. In the *Iliad* Athena is referred to as the daughter of Zeus, who is said to be her only progenitor, but without any reference to the actual story of her birth.[73] The following texts provide other pieces of this mythical puzzle: Hesiod's *Theogonia*, 886–900, 921–8, 929g–t; *Homeric Hymn to Athena* no. XI and, more importantly, no. XXVIII (henceforth I will refer to no. XXVIII as the '*Homeric Hymn to Athena*'); Pindar's *Olympian Ode*, VII, to the boxer Diagoras of Rhodes.[74]

From the descriptions in these texts I have constructed a set of events and circumstances:

Zeus' first lover is Metis, a female being who is wiser than all gods and mortals. On the advice of the Sky and Mother Earth, Zeus swallows Metis in order to circumvent a prophesy according to which she would first give birth to Athena, Zeus' equal in wisdom, and then to a son who would be wiser than all others before him, and who would assume power.

Metis remains inside Zeus and transmutes into the capacity which endows him with wisdom. Metis carries Athena within the body of Zeus, which means that Athena acquires wisdom from her mother, and her most dangerous weapon – her mythical shield, *aegis* – from her father.

Zeus gives birth to Athena from his head, either alone or with the help of Hephaistos.[75] Athena emerges as a young woman, a girl or a maiden (*kore*) in full armour; she is described by the following attributes and epithets: she has bright eyes, she is *glaukopis*; she is 'dreadful', *deiné*; she is strong in heart (relentless, gives no ground), brave, tireless; she stirs up struggle (battles and the tumult of war are 'sweet' to her); she is a leader of hosts and a protector of the people, bringing victory; she is named '*Tritogenia*' (a difficult name to translate, it could refer to water, the forest stream Triton in Boiotia or the lake Tritonis in Libya, both thought of as the birthplace of Athena, to the fact that Athena was born from her father's head, or to her being the third of his children);[76] as she appears her armour is bright with gold.[77]

Her emergence from the head of her father is sudden; she runs or jumps out. She runs or rushes down the slope which is her father's body. She shakes a long sharp spear and gives a terrible battle cry which echoes throughout the world.

Her appearance arouses a variety of reactions: Olympus trembles in dread before her warlike strength and ruthlessness. The gods and goddesses are filled with reverence at the sight of her, as before something holy. The Sky and Mother Earth quake before her. The sea is stirred up; great waves of purple appear and sudden sprays of foam. Helios stops his horses (i.e. time stands still) until: she takes off her armour and abandons her weapons, whereupon Zeus rejoices. These last three items constitute a chain of events according to the *Homeric Hymn to Athena*.[78]

The rapid sequence of these events and their consequences as revealed in fear and powerful physical reactions ceased abruptly at the moment when Athena removes her armour and shows her gentler

qualities, which in turn are greeted by the father of the gods with joy, with a feeling of relief and pleasure which would presumably have spread throughout nature and among the gods.

Of the figures which survive in this pediment ensemble, Helios and his horses are the most prominent in the texts and in the mythical events described there. Helios apears in an active role in two of the accounts. Pindar probably introduced him in order to link the poetic images in his ode to the island of Rhodes, which according to the myth is Helios' domain in a double sense: as a woman and as a land – the people of Rhodes are his sons. Since we cannot assume that any Rhodes-associated symbolism is relevant to the Parthenon decoration, it is Helios in the scenery of the *Homeric Hymn* which endows the sculptures with a narrative identity.

The hymn describes how Helios stops his fleet-footed horses when Athena, armed for battle, rushes up out of Zeus's head, clamorous and shrieking. The course of events, the flow of time, starts up again when the mood transmutes from the warlike to the fair (the beautiful shoulders freed from their weapons). The paradoxical contrast at the moment of the goddess's birth between sudden events and time standing still, dissolves into a milder tension between a sequence of happenings and lessening activity after the change in mood.

Helios's horses are shown just as they seem to be breaking through the boundary marking off the domain of the gods and the visibility of the pediment's pictorial world. The whole conception of this figure suggests movement happening now. If it is the hymn that has inspired the artistic concept here, then Helios's visible movement could have been caused by the switch from the first terrifying, warlike appearance of the goddess to the sweetness and calm of her subsequent peaceful mood.

The other surviving figures, interpreted as gods in a divine assembly (Olympian and Eleusinian) are shown in repose, in gently reclining postures (all except G). This could also accord with the transformation, which in the hymn embraces Helios's action. It is said of the other gods that they first *see* Athena, and are then gripped by reverence blended with fear. Neither D, E, F, K, L or M are expressing any sudden fear; D is not looking towards the centre of the scene, nor probably are L or M. If the hymn can nonetheless provide some indication of what is happening to

these figures, then it must be a question of their condition just after the transformation. The gods' reclining poses are explained by the same event that triggered Helios's movement, namely the change in Athena.

Dionysos and Aphrodite do not appear in the story as autonomous actors, in the same way as Helios.[79] Their personalities are less pronounced than his, a point which agrees with a reading dictated by the myth; even Selene, the Night or Moon goddess at the opposite corner of the pediment, becomes secondary to Helios. Her presence is motivated by her role as his counterpart, and as a sign of the symmetrical or cyclical order which is demonstrated in the pictorial world of this pediment.

The reclining figures express the relief and euphoria that ensue, once the surprise, the solemnity and the fear ebb away, and the threat is transformed into its opposite.

The myth of Athena's birth alludes to war and peace, among the gods as well as in the world of men. Her strange birth is after all a result of her father's fear of a divine 'palace revolution'. The struggle for power between the gods is a constant concern in the Olympian world. When Athena emerges, clearly inclined for war, the other gods are moved by an impulse to greet her with reverence (i.e. in a manner subservient and, in a way, subdued). But she does nothing to change the order of things; she lays down her arms, and thenceforth the relative peace and joy that obtains among equals persists under the supremacy of Zeus.[80] But as a result of her father's fear, and the ruse he uses against Metis, Athena arrives fully equipped with the joint resources of her father and mother. And, since owing to the nature of her birth she is completely 'male' and completely 'female', she is spared any subjection to the passions of love.

In the role as protector of her mortal followers, however, her disposition for war is an asset. Peaceable towards the other gods and warlike towards the enemies of Athens, she maintains peace and survival on Olympus and in Attica. With war (or the capacity for war) as the ultimate frame within which a virtuous creative capacity can flourish, she is the incarnation of the dialectic of Athenian society. For her mortal followers (the actors on the frieze) the peace which she maintains with the other gods is a condition for her participation as an ally or lodestar within their dimension of reality. Within the compass of the frieze Athena takes her place unarmed and in complete harmony with the rest of the divine family: her relationship with the figures in the frieze and with the living

onlookers on the ground below the temple, is determined by the fact that she is at peace with the other gods. The colossal statue, on the other hand, revealed her nature as she first burst forth, terrifying even to the gods, born in shining armour and prepared for war (her technical skill or artistic talent is not something she acquires or exploits; it is a quality she possesses like the brightness of her eyes).

The 'birth of Athena' is a myth, or one bit of a myth. However, the goddess's history can also be seen as consisting of events in the world that emerges from the web of belief and fantasy that constitutes the Greek imagination. In Hesiod's *Theogonia* the myths are depicted not as ingenious fictional stories as they are in Homer, but as history or accounts of a causal sequence.[81] The *Theogonia* consists entirely of the divine succession from generation to generation, like a long chain of causes and effects. The divine births are also important ingredients in the Homeric hymns, since they represent the decisive occasions when gods and mortals converge. Procreation and birth give the impetus to new forces in the world; the birth of every new god entails new conditions there. With Athena's arrival in the arena, a warlike being has appeared – but one who, unlike Ares, also incorporates its own opposite: war combined with peace, the male with the female.

The consequences for mankind of her coming-into-being include: a relationship between god and man involving intervention, help and guidance, but lacking any sexual intermingling and totally subject to the whim of the goddess. Further, her existence heralds remarkable artistic skills: the art of weaving, the grooming of horses and picture-making, all activities in which her elect can share. And finally her being envisualises the complexities of social roles which the male and female identities represent. With her arrival even the problems of boundary-breaking become visible: not that her deeds or her character could ever provide patterns of identification for mortals; rather it is that individual men and women could reflect upon and come to understand their own roles in relation – and in contrast – to her identity. In the Greek mind a cause was not only condition but also goal (*telos*) and accomplishment – an active implementation. Athena's existence was thus not only the cause of various consequences in society and culture, but also a goal for realisations and a means to self-insight – a comprehensive intentional activity which included the temple and its entire decorative programme.

SYMBOL

THE PARTHENON SCULPTURES AS SYMBOLS

'Symbol' is rather a vague term, and yet it has a ring of abundant promise. A reading of the work of art as 'symbol' betokens depth and existential texture (or such is the expectation), and perhaps even explanations of elusive connections. If the promise of the symbol appears multi-faceted and many-layered, it must be because of the multiplicity of roles and functions – often very exacting ones – which representations labelled 'symbolic' have been made to support in a variety of traditions.[82]

If an art work or an image of any kind 'symbolises' something, then this 'something' is an intellectual configuration whose elements are brought into contact through the image, and this image both affects it and is affected by it.

THE GODDESS

The temple was built in honour of the goddess Athena: the 'Athena' theme endows the sculptures with a particular kind of significance, and what emerges is a range of female identities in relation to the male – in the divine and human dimensions and between the two.

Although Athena is a war goddess who is associated with men (gods, heroes and mortals), her figure embodies the female theme and crosses the boundaries between the gender characters. The facets of Athena's being which most evidently reflect the feminine, serve to under-line the qualities expected of a modest Athenian wife: to breed male chil-dren capable of making war (the women were tied to the rules of Athena as *kourotrophos*, as the being or divine power who nurtures and guides strong and brave men), and to work at the loom as the maker of textiles.[83]

The male identity – its appearance and functions – is revealed in the cast of characters in the frieze: expansively, affirmatively, and touching every corner of Athenian culture. The facets of the female identity are much more inaccessible and ambiguous – visible in the female bodies of the temple decoration, certainly, but in an equivocal manner. The gentle

female procession in the frieze is a clear reflection of women's social role, defined in counterpoint to men's. There is an echo here of Pericles' funeral oration and the way he addresses the various groups. Turning in the end to the mourning women, he declares:

> If I am to speak also of womanly virtues, referring to those of you who will henceforth be in widowhood, I will sum up all in a brief admonition: Great is your glory if you fall not below the standard which nature has set for your sex, and great also is hers of whom there is least talk among men whether in praise or in blame.[84]

The complex picture of femininity, or rather of femininities, in the temple decoration embraces several themes, which have not been fully charted in Parthenon scholarship, and which are anyway subject to many lacunae where parts have been lost. Athena herself determines the core meaning of the temple as a whole. In relation to mighty Zeus and Poseidon on the pediments, and in relation to Zeus and Hephaistos on the frieze, it is she who dominates. Other female divinities also appear in some way as dependants of the male beings: Hera in relation to Zeus on the east pediment and on the frieze, Amphitrite (presumably) in relation to Poseidon on the west pediment, and Night or the Moon in relation to Helios on the east pediment. In counterpoint to such relationships we see clear indications of female alliances: the women in the procession stand close to one another and obviously belong together, but – because of their freer body language – the feeling of belongingness is even more marked among the goddesses in the pediment and in the divine assembly of the east frieze. I am referring to those usually identified as Aphrodite and Artemis (E40 and E41), and to figures E and F, and L and M, on the east pediment.

What these representations of strong female ties are really trying to convey remains obscure. Explanations have been sought in the Eleusinian myth of Demeter as she mourns, seeks and regains her daughter Kore (E and F). But why does Aphrodite, the goddess of erotic love, lean against Artemis who represents the powers of virginity, and why – like M – does Aphrodite recline voluptuously in the lap of her mother or of some other emblematic female principle? Why does the chaste Artemis in the frieze wear the attribute belonging to Aphrodite, a sign that is also explicit in figure M – the slipping chithon, revealing a bare shoulder? Mark builds

88

much of his interpretation on the unity between Aphrodite and Artemis: together they can strengthen the foundations of society – the prosperity of a society as a result of motherhood and child-rearing. But the meaning of this exchange of attributes has not yet been clarified with any certainty.[85]

Female figures also appeared in the decoration of the Parthenon in particular thematic contexts, where woman is marked down as the origin of all evil, or as the 'enemy'. Examples are the 'Pandora' motif which occurred on the base of the colossal statue, the 'battle against the Amazons' in the metopes on the west side of the temple, and the same theme on the shield of the colossal statue. Both Jenkins and Osborne have noted how these elements problematised femininity as a theme, and masculinity in relation to it.[86] Duality and ambivalence are the message of these feminine counter-images: the charming Pandora, who brings punishment and constant suffering to mortals who have tried to trick the gods;[87] and the Amazons, in appearance like the ordinary women whom men expect to defend, but shown here in the guise of a threatening enemy.[88] Do we know if women had access to the holy shrines of the Acropolis? The representation of the procession in the frieze is one piece of evidence, although it cannot be seen as purely documentary. We know that women performed important functions of the cult – the Athena priestess and the *arrephoroi*, for example. But there is no clear evidence regarding restrictions of access. We can assume there were female beholders; but how far, and in what way, did they respond to the different images of femininity: the strong ties of belongingness between many female figures, and, on the other hand the misogynistic aspects?

It is impossible to get any clear answer to these questions, which has naturally been a problem for those scholars who, over the last couple of decades, have been making an intensive study of the lives and mentality of women in Antiquity. This branch of scholarship can be regarded as one strand in a broader feminist theory-building project, but it can also be seen as the deep interpretation of text and image in socio-historical contexts.

For me as a woman researcher this knowledge is provocative. The theme raises in me an echo of pain, and I find myself wondering why.

My reaction is not primarily aroused by the manifestations of misogyny, although this is one of the recurring themes in Greek

literature; nor by the women's indisputable political subordination. Rather, it is a question of their silence. We may consider art and literature in some sense as reflections of real life – but we have no idea as to the person reflected by the images of women in classical culture.[89] As the origin or model of the many reflected images, women are absent. A scattering of votive inscriptions, from liberated slaves for example, is the only pale reflection to reach me from approximately half the population.[90]

The signals, the meanings, which I can discern as I seek to make my interpretations, thus spring originally from the formulations of free, controlling males. But they testify to a society in which these males must have been relating not only to one another but also to the silent groups – to women and to slaves. Thoughts and images emanating from the will and imagination of the silent characters may be embedded in the visible traces which I have set myself to interpret, but my chances of finding out whether this is so or which pieces are relevant, are almost non-existent.

One component in my overall conception of Greek women in Antiquity is represented by 'Antigone', she who defends the ancient customs of family ties against the political decisions of mighty Kreon, and who dies a heroic death in the attempt. But 'she' speaks in the words that Sophocles puts into her mouth, in the voice of a male actor, and in front of an audience of men.[91]

We can only guess at what these male dramatists were trying to achieve through their many subtle and powerfully expressive portrayals of female positions: whether they became uneasy at the thought of these silent beings who could speak; whether they felt, within themselves, the presence of these Others as negations, correctives, phantom figures, the reverse of the medal of self. Or were the female roles rather a means of achieving distance to deal with more relevant problems concerning relations between citizens, and thus to expose patterns of conflict?

The women figuring in the plays appear as expressions of society's obvious fear of women. The multifaceted repression of women and its shadows of uncertainty and uneasiness have risen to the surface, especially in the plays of Euripides; the potentially threatening reactions of the mute women of society are here paraded – and eloquently. The female protagonists convey the ideals and horrors of the male rule.

The most crucial conflict between male and female in the plays is the one pertaining to the sacrifice of women – parallel to the main theme

of the Parthenon east frieze, if Connelly's interpretation is admitted. In Euripides' *Iphigeneia in Aulis* Agamemnon's daughter is finally celebrated as the true victor of Troy; without her bravery the war would have come to nothing.

The Dionysos cult was probably annexed as a society-moulding feast, just because Dionysos represents something as far away as possible from civil order and obedience, an invitation to the intoxication of the senses and orgiastic behaviour. Dionysos' arrival at Delphi and Apollo's welcome to intoxication – that other aspect of creativity and the poetic art – also implied the taming or assimilation of what was menacingly alien.[92] Dionysos is not often mentioned by Homer.[93] He is not very easy to place in the Olympian family, with its patriarchal system and family conversations. In mythology he remains faithful to one chosen woman (unlike the other leading gods, particularly Zeus and Apollo),[94] while in the original cult he was surrounded by maenads – the frenzied and joyous female bacchantes who break the boundaries of taboo under his inspiration.

Athena and Dionysos were the two divinities whose festivals in Athens were imbued most strongly with societal meaning. For the individual, the role and identity attaching to membership of society were at the heart of these feasts, alongside the religious association with the divine. The Panathenaic festivity included no drama, but there were recitations; in the Dionysian feast there were no athletic competitions.[95] Athena is both Olympian and Homeric; Dionysos is the unknown alien, the Thracian, uncontrolled, belonging to the night and associated with women breaking away from their seclusion.

What were the dominant views on women's roles in society?

Attitudes to reproduction and breeding as formulated by Aeschylus in the *Eumenides*, or Aristotle in *Peri zoon geneseos* gave the woman no active part in the vital impulse to the inception and begetting of children.[96] The woman's body was fit to serve as container or nourishment, like the soil in which seed is sown and germinates. In Plato's account of how the gods shaped men and women in *Timaeus* 91 A–D, the sexes are both described as contributing through desire and need (the man to have the condensed marrow, coming from his head, let out through the genital organs; the

91

woman to have her womb made fruitful). But the woman is still described as ploughed soil, while the animate and human part of reproduction comes from the male seed.

The sharp distinction between the functions of the sexes seems to be a polemical point in Aeschylus's text, legitimised in the mouth of the 'speaker' Apollo. In the detailed descriptions of human anatomy – the Hippocratic and the Aristotelian corpus – there are two different ways of interpreting human reproduction:

a: The Hippocratic: both sexes provide seed for the offspring, albeit different in kind and value. The woman's menstrual blood is acted upon by the seeds and transformed into a foetus.

b: The Aristotelian: only men provide seed, but women's menstrual blood provides the material for the child; men's seed is the 'formal' cause and women's blood is the 'material' cause of the reproduction. Moreover, semen and blood are the same kind of fluid, but refined in men to its most active and purest state.[97]

Common to both theories seems to be a conviction that the material (the physical matter) for the child is derived from the mother (from her menstrual blood), just as plants are derived from the soil of the earth. The literature contains innumerable agricultural metaphors on the subject of women: they can be 'ploughed'; they are also compared with the domestic animals who have to be broken in and put under the yoke.[98]

The law on marriage and citizenship did include a requirement regarding the genealogical acceptability of the mother. Nonetheless, the woman's physical presence in her offspring was regarded as indirect only: what she contributed to the new being was its basic material and its nourishment, not its form or the personal aspect (that which bears the name); what mattered in connection with the genealogical origins was her father's presence within her. We could almost say that marriage was a way for a man to associate himself with his wife's father, and for the latter to disseminate his offspring in another man's family.

The paradoxical juxtaposition of virginity and motherhood in Greek myths and rites, is paralleled by the demand for 'purity' before marriage: a girl could be sold into slavery if she lost her virginity under uncontrolled circumstances.[99] It was apparently not the 'defloration' of the girl's body that mattered (there are no indications in Greek medical writing

that the notion of a virginal hymen even existed for them); what mattered was the identity of the offspring and the social control exercised by the father of the *oikos*.[100]

How a man 'tames' or 'breaks in' his wife within marriage is vividly demonstrated in Xenophon's *Oikonomikos*: the blushing girl-wife, ashamed at not finding the right things at her husband's command, is given a lesson in the importance of order in the military life; she is also taught how the two parties in a marriage complement one another exactly, because of the differences given 'by nature' (courage on one side, fear and the caring instincts on the other; physical endurance and strength on one side, and skill in acquiring, storing and maintaining household stocks on the other).[101]

If the Parthenon sculptures are seen as a mirror of the Athenian identity and a salutation to 'the beholder', we have to ask ourselves precisely who is receiving the salutation.[102] First and foremost, the citizens – those who appear in ideal form among the horsemen and the men conversing with one another in the frieze – the civic persona that is also addressed in the dramas.

Any women who might perhaps consider themselves to be singled out in the frieze, would all certainly be members of the leading tribes. If the figure in the middle of the east frieze is not only a queen of a heroic age but also the priestess of Athena, then she corresponds to the woman of the Eteoboutadai tribe, whose life-long task it was to occupy this role, which even gave her a certain amount of political influence.[103] The other women in the frieze appear to have been introduced collectively, just as they are kept collectively in the 'women's quarters' in their homes. The groups do not appear to be formed into any socially structured pattern; the figures have been assembled together, but are not organised internally on any kind of action-generating lines.

On the supposition that the central scene of the east frieze is about the sacrifice of Erechtheus' daughter, then a heroic female theme is being heralded as the climax of the events in the human realm, and one which is also underlined by the confluence of female presence and the concentration of holiness on the east side of the temple. The small figures engaged in this decisive act – could they be images of identity for

Athenian girls and women, the female beholders? Could the carved girls give visual expression to a message for the living? And if so, what does the message say?

The most obvious attribute of these figures is that they are 'under age', they relate to the adult pair through obedience: they do not really act, but are led to act, as children are obliged to let themselves be led. Female roles, set apart from the closed group, can then only be envisaged as 'tender', attenuated; female actions are rendered as ritually cast, as unrelated to the energies of intention and mind. (True, the man and the woman forming the adult pair do appear as equals, but their action – looking unique, particular, and gentle – is a means whereby women's ultimate role as attached to ritual can be emphasised.)

How could women relate their bodies or their minds to the goddesses depicted in the pediments and in the assembly of the frieze as exemplars or as sources of power? It is very obvious in the sculptures that the difference between the behaviour of the goddesses and the women is greater than the difference between the behaviour of the gods and the men. In physiognomical terms the women resemble the goddesses, but the space around them is so restricted and confined that the bold unhampered postures of the female divinities appear even more expansive and autonomous in contrast. And yet the goddesses do provide a kind of mirror for female identity.

Athena is a female being, a goddess, who teaches the art of war, inspiring men to warlike deeds and promoting military victories. Athena protects her warriors. She leads them and cares for them as their comrade and guide, not as a sister or mother; ruthless and partial, she tips the balance in favour of Diomedes, Achilles, Odysseus or Herakles. As a goddess Athena also has the power to destroy or punish men; even the lives of her favourites may be in peril, if they appear to be threatening the boundary separating the divine from the mortal realm.[104]

No citizen could possibly compare his wife or sister with this; nor could any woman compare herself directly with the goddess of war.

The address to Athenian men was radically different from the one we may derive as relevant for women. Athena's salutation to men conveyed the following message: men are autochthones, sprung from the Earth; like Erichthonius, who was reared by Athena herself, they are nurtured and helped by an asexual goddess. It was this very freedom from sexuality

which gave strength and success to men's relationship with their goddess. Their communion seems effectively to exclude the need for living women. The myth told them that their seed in the warm Earth, and a guiding warrior goddess were the only powers needed to secure them. Seed spilled on the ground grew into greater heroes than those which grew in women's bodies.[105] As in Aeschylus' play, the motherhood of living women can be explained away, rationalised as non-existent.

The salutation to women confirms them as victims sacrificed to the self-preservation of the *polis*, as those bound to embody and perform strictly regulated tasks as a pattern of what is most holy; and as relegated on the individual level to an assortment of painful, reproductive, threatening and silencing tasks. Take the *arrephoroi*, for example, the young maidens serving Athena under the supervision of her priestess, who had to bear 'secret' objects on their heads through an underground passage and into Aphrodite's garden. They gave visible form to the story of the daughters of the mythical half-snake, half-human king Kekrops. Their task was to care for the newborn baby Erichthonius, hidden in a basket and guarded by a worm or a snake (or who was himself a worm); when Kekrops' daughters revealed the secret, they were harshly punished.[106] The small *arrephoroi* are not yet sexually mature, albeit on the threshold of their initiation; they are supposed to be unaware of what they are bringing with them into Aphrodite's garden; they embody the idea of virginity as a 'pure' and unsullied preparation for the inception of fertility.[107]

The female divinities appearing in the Parthenon decoration and associated with the local cults, could give individual women insights into their own condition from several different angles. In Aphrodite they could see desire or instinct in the process of reproduction, and in her opposite pole or complementary divinity, Artemis, they could see virginity and the guarantee of pure motherhood. In Athena they saw virginity indicating an independence which to them was unattainable, and 'motherhood' in relation to sons as an asexual ideal at the very foundations of the state. In Demeter they could see motherhood once again, but now in relation to daughters and in a deeper and more emotionally charged female communion.

The living women confronted by Athena's image give concrete form to the female relation to war, as existential condition and principle: the Greek social structure and the Greek conceptual world are aspects of war.

Did the women want the warlike deeds, or did they long to be free from their dependence on men – and thus from war? When Aristophanes makes the women rebel against the warmongering all around them, or Aeschylus shows us the women's grief and lamentations in *Seven against Thebes*,[108] they are not necessarily testifying to any characteristic hatred of war felt by women in the real world. Rather, the female role in the plays is to provide a reverse perspective. I can only assume that women in Greece knew fear at the threat of torments from which only the trained warriors of the state could protect them, while suffering the anguish of knowing that their own men perpetrated deeds of equal cruelty. War meant 'ethnic cleansing', and the most vulnerable – then as now – were children, women and the old.[109] An Athenian woman would certainly have understood the grief of her Persian, Theban, Melian or Corinthian sisters. In Homer, Andromache describes in minute detail the fate of the weak in war.[110] That military action is more than single episodes of combat between equal warriors, that it also means systematic violence against the weak – all this becomes obscured by the sight of the beautiful, well-coordinated horsemen, controlling their steeds with a sensitive touch to the reins. The war goddess with her female form blocks and conceals a genuine female perspective: the gaze which can penetrate to the evil deeds concealed by but contained within the heroic ideal.

The different patterns of reception applying to women and men also highlight a difference in the level of the meanings which the goddess theme projects on to signifiers of 'femininity'. The actions which have to be performed in the women's world are to some extent secret, very holy and – literally – vital, and surrounded by the taboos of religion.[111] The women symbolised 'femininity', mainly through repeated actions. In the men's world 'femininity' is embedded in ideas and texts, in conceptions and representations generally.

Some of the pictures of women that men had in their minds reflect just those positions which give women – despite their silence – real power over men, namely virginity and motherhood (essentially, bodily manipulations for the continuing survival of the species). These positions are characteristically and paradoxically combined and constructed in the figure of Athena as a force favourable to men, not threatening but powerful.

I shall now look, in isolation, at some of the most typical and recurrent characterisations of the female identity in the minds of men which seem pertinent. In doing so I have noted how signs of 'femininity' function both as defining counterpoints to those of 'masculinity' and as integral parts of them.

a: 'Virgin' – this can have two rather different meanings. Either it conjures up a picture of female power, of the sacrosanct, the woman who eludes the reproductive role and is preserved for a god; or, as in the case of the *arrephoroi*, it is a picture of the potential childbearer who is pure and unknowing, but in some sense prepared.[112]

b: 'Nature' – here, too, there is a dual meaning. Nature refers either to the fruitful earth which can be sown and which will bear fruit, or to the wild and uncontrollable, to darkness and to magic – clearly in this second case a hostile or threatening image.[113]

c: 'Work of art', or 'imitation'. Here the Pandora myth is the prototype (Hesiod, *Theogonia*).[114] This myth must have been regarded as a carrier of a crucial meaning by the creators of the Parthenon decoration – since it was positioned in the focus of attention for anyone entering the cella, namely on the base of the colossal statue, at eye level. Here woman is 'soulless': a reality at second hand; she is also deceitful, since she pretends to be something 'natural'.

In the narrative about Pandora the male imagination acknowledges its dependence on female beings; the threat and deceitfulness of the image reveals an awareness of dependence as fear and degradation. At the same time the threat is rendered harmless, in that woman in the myth is transformed into a work of art, a manufactured object. The being who helps the men, and makes mortal women appear to be of secondary rank (as descendants of an image), is Athena, the asexual patron and preceptor of Athens, she who is 'mother' only in the sense of protectress. The concrete, physical life processes (desire, the begetting of children), whose attractions and risks are symbolised in Pandora, exist in her only indirectly, as in a picture. One of the tasks of art, as Athena's domain, is to transform the fearful aspects of nature into an observed, distanced and pleasurable phenomenon; at the same time the artificial being the enchanting Pandora figure giving form and being to women, reminds

people (men) of the punishment that can befall them for failing in their loyalty to the gods.

There seems to have been a conceptual 'civil war' between the rational male thought about the democratic *polis* on the one hand and the archaic and female (the 'old' powers) on the other. In the classical culture the female principles, associated with nature, appear as: *controlled, attenuated*, and *replaced or rationalised*.

Gender roles and gender conflicts are often displayed in drama and art. By simple changes of clothing or of place a person's 'right' role can easily be revealed: Achilles shows himself to be the warrior he is, albeit concealed in women's dress among the daughters of Lycomedes;[115] Paris reveals his lack of manliness by staying with Helen in the women's quarters;[116] Herakles is turned into a subject of the Lydian queen Omphale and, being in servitude, is forced to handle her distaff clumsily, while she dresses herself in his lionskin;[117] Praxagora takes her husband's mantle and stave and goes to the people's assembly, while her husband makes a fool of himself in her thin saffron-yellow gown (Aristophanes, *Assembly Women*). Here the two principles play off against one another, defining each other's boundaries. Integration of the two gender characters is more challenging, more rare, but has great potency: the dream of a natural merging is manifest in the figures of Athena and Dionysos (who is sometimes ascribed female attributes), and occasionally in the picture of the young warrior – e.g. in the description of one of the attackers in *Seven against Thebes*,[118] in which male and female characteristics are both opposed and combined: the young fighter is the son of a 'wild' mother (living in the Arcadian mountains); he is called by a feminine name that does not 'suit' him; he is 'savage of heart', but is not yet fully a man. This image of the boy/man/warrior with a maiden's name is also an example of a topos in Greek literature – the interest in the faces of very young men, where a touch of 'childish' softness still retains something of the feminine, but where the downy beard of early youth has started to mark the gender differences.[119] In connection with this topos, it is interesting to remember that, sexually, the very young man and the girl played the same passive role in relation to the active adult *erastes*; the soft beard would visualise the qualitative difference between loving a boy and loving a girl, and thus probably the more exquisite nature of the love relation between men (more turned to the refinement of intellectual discourse).

In the *Eumenides* of Aeschylus (performed at Athens a decade before the initiation of the Parthenon sculptures) the 'feminine' is archaic, collective and arouses dread, and it is played off against the male principles of reason, supreme power, lawfulness and light. This play, together with Euripides' *Ion* and the Parthenon sculptures, is probably the clearest expression of Athenian identity – of what it is like to be an Athenian of the classical period.

The terrifying and primitive Erinyes of the play (who smell their way to their victims) portray the 'feminine' in a distorted, monstruous way: they combine bloodthirstiness with dull wits, they are utterly body-bound, claiming the ties of blood as bonds of unity and threats of vengeance.[120] They represent the rights of the mothers, rights denied by Apollo in the famous passage where he describes the mother as a mere container of matter for the son of the father and as such unworthy of respect.

The goddess Athena thus appears as the 'proof' of a motherless birth. She is completely on the side of the male, but characteristically she has to come to terms with the 'feminine' as representing genuine natural power: the strength of growth, the abundance of the earth. Athena's desire for reconciliation, like her decision to agree to Orestes' release from blood-guilt, represents a plea for Greek unity; killing among kinsmen must be brought to an end through purification at the altars of the Olympian gods (now centred upon the Acropolis).[121] The old powers of the feminine kind must continue to be honoured in a cave under the great cliff of Ares, where the Amazons had their camp in their fight with Theseus and where the law is 'now' installed by Athena.

Thus the meanings in this play and the symbolic places it refers to are layered, just as gods, heroes and contemporary mortals are layered in the temple – albeit in a different value perspective. In the play the subterranean and remotest layer comprises the collective 'mothers', daughters of the Night; the heroic layer is the fight with the Amazons, while the contemporary level is the institution of the law through Athena. The play stages all the levels with the help of different female principles, all apparently embodying the conceptions of women that prevail in Greek culture.

Athena is the female principle siding with the men; she is the junction between the symbolic female levels of the *Eumenides* (leading from the cave upwards), and the hierarchic Olympian levels of the Parthenon

(leading from heaven and light). In the perspective of alien, hostile feminine powers, Athena is the last link – the transformation into protection and victory.

In the glorification of the male order in the Parthenon Athena is the primary cause, the new beginning; at her birth Night drives wearily back into the darkness.

By celebrating woman as protector, principle, power or passion, and condemning her as threat or betrayal, a web of ideas is created, denser than the woven mantle presented to the goddess. It is a web that envelops and excludes the women.

DEMOCRACY

The period when the Parthenon sculptures were being made coincided with the time when Athenian democracy – the form of government, the social structure and the life view which this concept embraces – had reached its peak. Few ancient societies are so well documented or so abundantly written about as fifth-century Athens.

In the incalculable web of causes from which the temple and its decoration once emerged, actions and intentions and the structures of democratic Athens were all included. The temple is a consequence of a society and of that society's particular way of functioning; thus it testifies, as a vestigial sign, to its own origins. But how exactly is this origin or condition visible in the artefact? And how is the frieze relevant to the democratic political system?

J.J. Pollitt is perhaps most consistent in claiming that the experiences and society which give rise to a work of art are also reflected in its appearance and its expressive content.[122] Thus the idea that the Parthenon sculptures express or symbolise democracy seems to him self-evident. This is suggestive but also circular: the work of art expresses its own conditions, and the conditions express the work of art.

The idea is seductive. Surely the spirit of Athenian society would intrude itself into a work of art like the Parthenon frieze, in which its own members were taking part? Nonetheless, such a signifying relation is neither obvious nor unequivocal.

The suggestiveness is of course strong. Not only do we project a social

structure and a mentality on to the figures of the reliefs, but we also tend to read their norms in light of our own ideas about 'democracy'. The 'equality' and 'freedom' which Greek democracy apostrophises can appear akin to my own contemporary and similar-sounding ideas. I am familiar, like any scholar, with the analyses of archaeologists and philologists indicating the fundamental differences between the concepts of ancient and modern times. And yet the suggestiveness does work. Something of the moral values, the possibilities for justice which can be found in our contemporary democracies, attaches to my expectations in confronting the modes of expression in the antique prototype. I have to force myself to think of the Athenian democrats as first and foremost eager warriors in their disputes with the other Greek city states; I must remind myself of the selective and ethnic nature of their definition of 'freedom'.

And so, in confronting the problem of the presence in the Parthenon frieze of 'democracy' as a concept or a cause, I am in fact confronting two problematic themes: how do we understand a work of pictorial art as a vestigial sign or symptom of the ideological components in the web of causes from which it arose, and how do we understand what was meant by calling this ancient Greek society 'democratic'? Some scholars claim that 'democracy' in Athens was no more than a façade concealing a practical oligarchy, that democracy was an expedient in the hands of the elite. This idea is refuted by Ober.[123] It would certainly be misleading to abandon the distinction between oligarchy and the practical distribution of power in a democracy. Despite the presence of powerful actors such as Pericles, Nicias and Alcibiades, the distribution of power and popular control over the wielding of power did work as a potent impediment to personal supremacy.

In what way can we envisage 'democracy' as being made visible in the Parthenon frieze? The label 'democracy' is above all a political category, referring to citizenship and forms of decision-making. I can imagine identifying certain figures in the frieze as 'citizens', and thus in the narrow sense as expressive of a democratic role. I can also read some aspects of the whole in terms of the attitudes and values promoted by leading actors in democratic Athens.

Identification of an Athenian male as a citizen depended on group affiliation. The great democratic reforms of Kleisthenes in 508-7, of Ephialtes in 461-60 and of Pericles in 451-50 resulted in the following

conditions: the Athenian citizen was above all a member of a *demos* – a locally defined administrative area.[124] There were 139 such areas in Attica, differing greatly both geographically and demographically. They were represented in the council in Athens, the *boule*, according to their size.[125] The largest units of structure were the ten tribes.

The population had previously been divided according to tribal affiliation, but into four tribes only.[126] This construction was left intact, but more as a traditional custom than as a system having any formal political implications.[127] The older tribal division depended on ideas of family and kin. It was a network consisting of several families (*gene*) and in which the household or *oikos* was the smallest unit. The new one was based on geographical area: registration in a *demos* granted membership in one of the ten tribes; it also granted citizenship with all its rights: the right to speak and vote in the people's decision-making assembly, the *ecclesia*; and the right to act as 'judge' in a court of justice, a *dikasterion*.

Aristocratic or oligarchic power was counteracted by the *deme* system and the constant changes in positions of authority. Nonetheless wealth and birth remained a base for power and influence. In practice the rights of citizenship were best exercised by those who owned a lot of land and many slaves (particularly in mining), and who thus had the time and resources to spend on a political education and political activity. The system of bribery was highly developed, so that wealth gave a certain automatic access to political influence. On the other hand wealth gave no dispensation from bearing the greatest societal costs: only very prosperous people could take upon themselves the kind of heavy expenditure required by major undertakings affecting society as a whole – the equipment of warships, for example, or the training and sponsoring of festival singers and musicians.

The democratic way of life means talking – with one another (in discussions) and to one another (in orations). The aristocratic style entails richly attired and opulently equipped men flocking round powerful leaders, excelling in the display of their own beauty and skill. Both these ideals are on show in the Parthenon frieze: the first in the group of men engaged in conversation on the east frieze; the second is transformed into an image of distributed value, or equality of importance, in the groups of riding men.

Citizen status inevitably implies its opposite: exclusion (assuming that

'citizen' is understood mainly as the right to speak and to decide upon matters of state). The excluded were slaves, women, immigrants (metics), children and youths up to the age of eighteen.

Most of the adult men among the cast of characters in the frieze must be citizens, probably representing a variety of social roles: some are administrators, others have specific tasks connected with the cult. The identity and function of the horsemen is not altogether obvious; they may be an escort, or participants in the competitions, or members of the cavalry; or they may simply be ideal figures combining democratic and aristocratic qualitics with some kind of political relevance. At any rate they are citzens, and can be regarded as the main characters in the frieze. Most of the riders appear to be young; perhaps they are *epheboi*, men between eighteen and twenty who have thus recently achieved citizen status (normally involved in military exercises and local patrol duties on the borders).[128]

Some of the adult male figures may be metics, and thus not citizens; according to the written sources on the Panathenaic festival some of the tasks connected with the procession were performed by well-to-do immigrants.[129] However, it is not possible to identify any of the figures definitely as aliens resident in Athens, either from their features or from their tasks in the procession. Metics actually constituted a considerable proportion of the population; many were wealthy, they paid taxes and did their military service, but they had no right to take part in decision-making or to share the executive power.[130] If they are included in the frieze, and are indistinguishable from the Athenian citizens, this could be a mark of appreciation of their role ('they are just like us'), or − equally well − a mark of condescension ('everything they do, they do on our conditions').

Socially, the female groups appear more homogeneous. The priestess of Athena was elected for life, and was always a member of the aristocratic Eteoboutadai clan. Girls from the best families could act as *kanephoroi*, bearers of baskets; the task of weaving the cloth for the goddess was reserved for women of good lineage.[131] Aristocratic girls also acted as the *arrephoroi*. Metic girls took part in the Panathenaic procession, but cannot be definitely identified in the frieze. As a group the women represent the traditional aristocratic families of Athens; their importance lies in their family affiliation, and the fact that they can guarantee the continued existence of their distinguished lines.

103

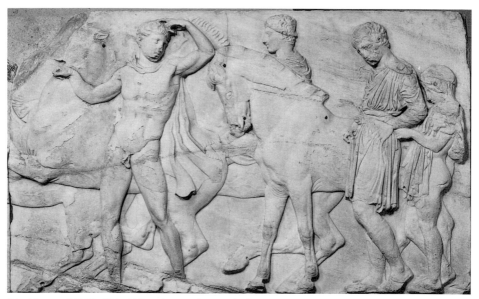

36. Figures N133, 134, 135 and 136, the north frieze. The British Museum, London.

In reading the frieze as a social manifestation, a crucial question concerns the possible inclusion of slaves. If they are present here, together with the citizens, the metics and the aristocracy, then it is more than the community of the citizens which is being apostrophised; it is the whole *polis* which came under the protection of the goddess – although the different categories are probably shown in proportionate numbers, reflecting the level of their power and status. If slaves are included, then they are probably represented by the rather short young people assisting the men with the horses.

Let us look, for example, at the pair of figures on the north frieze nearest the west corner, N135 and N136: the man accompanied by a boy (who is either helping him to tie his girdle, or holding the horse's long rein). The relationship expressed here would be very different, depending on whether this is a citizen together with a younger brother, or a citizen with a slave: the boy is either a candidate for citizenship, or a possession. The tendency in the frieze for all figures to exhibit a kind of individual mobility within their group's composition, suggests that slaves are not included: slaves, after all, had no opportunities for behaving

in an individual way within their social roles; a slave did not own himself, and was not in command of his own actions. On the other hand these rather short, serving figures are shown clearly to be attached to the men next to them.

The fact that N136 breaks with the principle that all heads in the frieze should be on roughly the same level, cannot be taken as an indication of unfree status, since the similarly small assisting figures in the middle of the east frieze certainly cannot be slaves; it can therefore be presumed that short stature need mean no more than that the particular figure represents a young person not yet fully grown.

Physiognomy gives us no clue on this point. The figures are distinguished throughout by age, their tasks in the procession and their sex. But the serving figures are not distinguished from the predominant horsemen collective by any essentially different physical features. If the small figures are slaves, then the very fact of their representation here could testify to an ideal of man in which the difference between controlling and assisting is of minor importance. On the other hand this apparent equality could be a way of cementing a connection: the organic union between two principles – soul and body, or planning/controlling and working/doing. In a very similar abstract argument Aristotle legitimates slavery as 'natural'.[132]

According to classical Greek thought the ideal code of conduct was that of the free man, who was both 'beautiful' and 'good': social, private and moral character merge in a beautiful and appropriate appearance. (Socrates was the first public figure to deviate from this principle, having the looks of a satyr and a moral character of incorporeal 'beauty'.) Freedom was a condition of moral strength, indeed of moral capacity as a whole. A contemporary idea was that as a race the Greeks differed in mentality and character from other peoples: the Greeks were free, the barbarians more apt for slavery.[133]

The concept of 'freedom' is predominant in Herodotus' accounts of the Greek way of life and of events and actions in Greek history. 'Freedom' to Herodotus meant being independent of the personal caprice of a single despotic ruler.[134] Herodotus did not yet connect 'freedom' with democratic government (and not at all with the concept of 'slavery'!); it was the act of keeping the *polis* free from foreign domination that the word *eleutheria* ('freedom') referred to. Being a member of the *polis* as a citizen

thus involved being free through sharing the freedom of the *polis*. The structure of conflict – the threat of tyranny – was subsequently projected on to the *polis* itself: the ambition of anyone claiming arbitrary personal power bore the shadow of 'foreign' tyranny.

'Freedom' was thus linked with 'democracy' – first as a sign of conflict within the *polis*, and with a pejorative or polemical slant to the word 'democracy'. The tensions between oligarchic aspirations and a democratic system were thus manifest in language.[135]

The idea of slavery as a 'natural' consequence of a person's character first appears in the classical period and is not to be found in Homer.[136] According to Aristotle's social philosophy, written during the 330s, the relation between master and slave had become a condition of the good life for both parties, providing they had the characters appropriate to their roles. However, Aristotle does acknowledge distinctions within the slave population: the man who will suffer from being a slave is the man who lives as a slave only because of the outcomes of war or of legal circumstances, as opposed to those having the character or birth appropriate to slavery.

This legitimation of slavery can of course be seen as the attempt of a flourishing imperialist economy, in which slavery is the other face of the 'equal' democratic system, to square its own conscience. Nonetheless there may still be an awareness of slavery as part of the condition of every man's life, as a kind of humility theme – an existential theme, perhaps, with Homeric resonances: what awaits the conquered, be they kings or subjects, is either death or slavery. Only the name separates the slave from the freeman, complains an old servant in the *Ion* of Euripides.[137] In Homer we witness the despair of Hector and Andromache at the thought of the approaching slavery for her and their child,[138] while in the *Odyssey* Achilles in the underworld laments his death and longs to return to life, even if only as the drudge of some impoverished peasant – obviously an example of the ultimate wretchedness that life on earth could offer.[139] The worst possible fate was to have to subordinate oneself to an 'inferior': even Herakles complains in the underworld of the bitter experience of having to obey an inferior man.[140] Aristophanes' comic Athenian in the *Wasps* echoes these sentiments when he finally becomes suspicious of his own 'sickness' (the urge to serve as a judge in the *heliaia*), just when his son accuses him of being the people's 'slave'.[141]

37. Figure W8, the west frieze, slab IV. The Acropolis Museum, Athens.

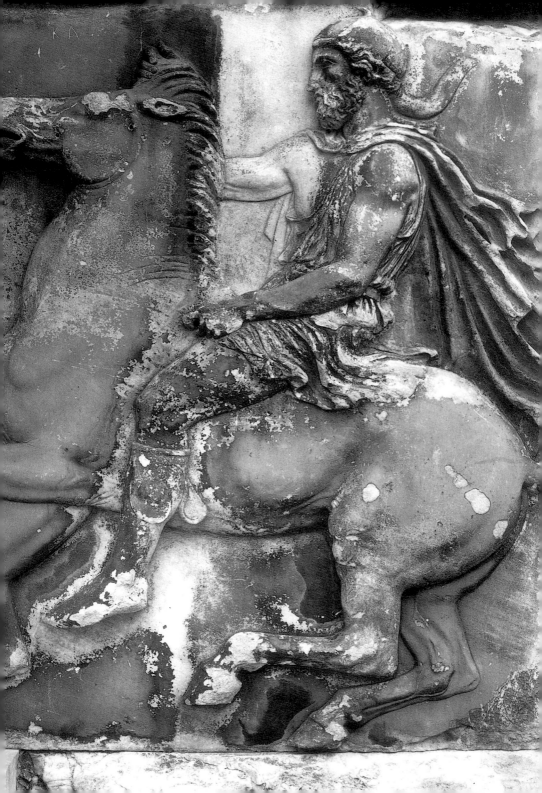

If the cast of characters on the frieze has any connection with slavery at all (limited, if so, to the pair on the north frieze, N135 and N136, and one or possibly two pairs on the west frieze, W5 with W6, and W23 with W24), then the differences have been ironed out and rendered almost invisible – which again can be interpreted in two ways: 'They are our loyal aides, let us honour them and allow them to be visible here, as we are'; or 'They exist, but not in any other sense than as living tools; they could as well be part of our bodies, except that they happen to be physically separate; as part of our bodies they can be permitted, in pictures, to resemble us'.[142]

It is possible to see a wide range of roles in the frieze, covering the whole of society. At the same time there is a clearly indicated hierarchy, centring on the vigorous citizen. The whole display, and the equilibrium that informs it, is subordinate to the order of precedence, or is perhaps even a way of emphasising this order: the excluded, those on the fringes of the 'citizen' category, define by negation the particular manifest qualities of citizen status.

If the free and vigorous male citizen stands out in contrast to the women, the boys and (maybe) the metics, can we also distinguish them from one another in terms of power or dignity? The answer is no. Here we come up against the balance at the heart of Greek democracy: no person among these male citizens, depicted in the frieze, emerges as a leader, any more than landowners or other wealthy men could seize more than their due share of the formal power in political life. The horsemen of the frieze are being organised and controlled by the marshals halting them, and the marshals in turn represent the joint decisions, the impersonal system of regulations contained in the 'laws', the supreme power in the community.

The great majority of the citizens in the frieze reliefs are on horseback. What might this circumstance suggest, if it is now considered in relation to the theme of 'democracy'? The answer depends primarily on the way these people's actions are identified: what exactly are the men doing as they ride along here?

In the type of research that is bent on a documentary reading, various suggestions have been made about how to identify the riders. Perhaps the horsemen are one element in a depiction of the procession, maybe an escort of *epheboi* or a cavalry troop, maybe a group about to take part in the equestrian events which were part of the festival games. After all, elsewhere in the procession we can see the *apobatai* and their chariots. Their activity is more clearly identified and is connected with the Panathenaic festival: they perform in a particular competitive event, which had a military origin but had now been transformed into an element of the festival games. Nonetheless the *apobatai* group alludes to skill in war, a gift for which the Athenians had their goddess to thank.

A reading of the cavalcade as an escort of *epheboi* is contradicted by the fact that at least one of the riders is bearded (slab IV, W8), which was traditionally a sign reserved for the strength of maturity or even for middle-aged and old men, but not for those in their twenties (fig. 37). The horse-tamer in the central position on the west frieze – slab VIII, W15 – also has a beard. In the other sections we see only young faces among the horsemen. (Damage may of course be concealing further deviations, but nothing definite can be said about this.) The bearded men could perhaps represent special roles, such as tribal leaders, but in that case there should have been more of them, one for each of the ten tribes. If the cavalcade is simply read as a cavalry troop, then a typical group could well include one or two older members.[143] The two older men have also been interpreted as cavalry generals (originally three, later two) – roles connected with the organisation of a permanent cavalry force of 300 men (increased from around 440 to 1,000).[144] If these older men do represent organisers or leaders, it is interesting to find them in the thick of the activities rather than alongside the troops or at their head.

But why should Athens be parading its cavalry here? It was the navy which had been chiefly responsible for defeating the Persians at sea and founding the Athenian empire, while heavily armed hoplites were predominant in battles on land. However, Glenn Richard Bugh points out that the decades before the Peloponnesian wars had witnessed a new strategic approach: a stronger cavalry was needed for the ever more frequent disputes among the different Greek city states.[145]

I.G. Spence was convinced that the Parthenon riders belong to the cavalry, and in a book devoted to social and political aspects of the use

of cavalry, he summarised the situation of the classical Greek cavalry as follows: 'the general military standing of cavalry at Athens, the state for which we have the most evidence, seems to have followed a pattern of sporadic triumph and prominence separated by longer periods of obscurity, neglect, and even unpopularity'.[146] It hardly seems likely that the groups of horsemen referred exclusively to the cavalry; rather, we should ascribe to them a more general function in the overall meaning of the frieze.

The horsemen may be a straightforward descriptive element, but they could also be seen as a symbolic expression of the ideal of citizenship for which Athens was famed: in other words as an aspect of Athena. In the light of this assumption, an almost imperceptible shift in the representation occurs, from an image standing for a concept to more documentary allusions in the procession on foot: all these characters – the bearers of trays, jars and instruments, the animals and their attendants – could be readily recognised as the sacrificial procession of the Panathenaic festival. A symbolical function can of course be attached to an image that is also a documentary depiction.

Presumably then these horsemen evoke an aspect of Athena and can be seen as symbolising heroic warfare: in *Seven against Thebes* Aeschylus suggests the threat of invasion by evoking the 'noisy snorting of rampant steeds'.[147] Athena herself was closely associated with the breaking-in of horses and with the equestrian art in general – a characteristic that brings her close in yet another respect to her 'antagonist', Poseidon.

The demonstration of cavalry could also be seen as a demonstration of power in terms of wealth: more cavalry implies a wealthier *polis* and a whole people who can share in the protection thus provided, just as a whole people share in the building of the Parthenon (cf. Plutarch, *Pericles*, 12: the people 'owned' the buildings of the *polis*, and they could literally gain from this sector of production, by taking part in the building activity).

However, if they are regarded as emblematic of citizenship, then the horsemen convey the complexities or fields of tension in their society: aristocratic principles and the mentality of the élite groups, in contrast to the equal distribution of power in a democracy.

The distinguishing mark of the horsemen is their tribal identity.[148] The

distinguishing mark for the tribal affiliation is the dress. The types of dress vary considerably; on the north and the south frieze the men are dressed the same within the groups, but on the west frieze there are individual variations: some wear only short open cloaks and sandals; some wear thin chithons; one has a cloak with animal paws; two have brimmed hats (*petasoi*); two have horse-hair helmets, and one of these has a cuirass.[149]

Since the horsemen (at least on the north and the south frieze) are displayed as members of the clans, the concretisation of citizenship which they represent is both the genealogical ground for, and the consequence of, citizenship (family affiliation determined citizenship, which in turn indicated tribal affiliation). The empowerment which they symbolise is connected not with decision-making rights but with the legitimacy of the blood tie.

The image of the young horseman carried a strong aristocratic charge at this period: only the very rich could devote themselves to the breeding of horses. Members of the cavalry traditionally kept their own animals – a situation which was reflected in the property-based class divisions introduced by Solon at the beginning of the sixth century, in which the *hippeis* was the second wealthiest class. Anyone belonging to that group would be sufficiently prosperous to keep a horse and to provide food for around fifty adult males.[150] Furthermore, the image of the horseman had associations with life under the 'tyrants' of the sixth century, when names beginning with 'Hipp' – were very frequent.

Is it possible that the function of the horsemen here is to demonstrate in visual form the emblematic figures of the aristocracy in the context of a democratic behaviour pattern? I have tested the validity of this idea by reading the figures in terms of the qualities said to inform democracy, according to Pericles' famous funeral oration in honour of the fallen Athenian warriors in the first winter of the Peloponnesian war.[151] How well do the ideas proclaimed in the oration match the depiction of the figures in the frieze? And what happens to these figures, when the world projected upon them is the world of the oration?[152]

Pericles (still according to Thucydides) makes a clear distinction between 'us' and 'them', between the Athenians and their enemies. Among the Greek enemies he mentions the Spartans, but above all the word 'enemy' must refer to the Persians. Pericles describes the values which are cherished in Athens: there, the citizen enjoys 'freedom', i.e. he is not

subject to the whim of any individual, but his moral duty is to put the common interests before his own; his personal life is incidental to the interests of his society. The citizen is driven by a strong personal desire to defend the land and the organisation which his predecessors – the 'forefathers' – once achieved by their struggles and passed on as a legacy to their heirs. This desire, whose goal is honour and posthumous fame, takes precedence over concern for one's own life or property. Power in the community is distributed equally among all citizens regardless of wealth. The citizen and the forefathers share a common genesis in this very place (they belong together with the land itself). Only the continuing survival of the shared values makes personal life worth living.

One condition for the maintenance of this political system, according to Pericles, is openness: no secrets should be kept from the citizens about how decisions are made, about the grounds on which they are reached and the options that were available; military secrets should not even be kept from the enemies of the state. Such openness implies a willingness to enter into full debate before any action is decided; debate does not prevent decisions being taken, but it reinforces the decision-making process and the generally auspicious nature of the decisions. Since the citizen is given the opportunity to affect decisions, it also becomes his duty, and is concomitant with his character, to do so. He wants to do what it is his duty to do. He becomes effective. Such public spirit leads to a sense of 'beauty', 'wisdom', 'moderation' and 'active participation'.

The life of a citizen in democratic Athens, in this rhetorical version, thus embraces *freedom, unselfishness* and *active participation* (in the service of beauty, wisdom, honour and fame). These three facets of existence entail one another, endowing each other with meaning.

The cavalcade exhibits two grouping patterns: on the north side, more varied individual mobility within a single overall configuration; on the south, uniform behaviour among the individuals in several fairly compact homogeneous groups.

The individual faces that have survived in both sections could almost belong to the same person appearing over and over again. What Pericles says about personal life in the oration seems to accord in this respect with the message of the frieze, i.e. that the individual actor identifies with the collective. But the two patterns whereby individuals are associated with the groupings in the frieze do not correspond to any indication of alter-

112

native attitudes in the way the spirit of citizenship is described in the oration.

Finally I ask myself whether the evident 'us' and 'them' dichotomy of the oration is also present in the frieze. This brings us back to our earlier argument about the different social roles of the frieze characters. 'Citizens' were obviously defined by the boundaries fixed between themselves and various categories of the excluded. A position on one side or the other of the boundary could literally be a question of life or death: anyone who appealed against a decision not to grant him citizenship, and who lost his case, could be sold into slavery.[153]

A hundred years later Aristotle justifies the division of power on grounds of 'natural' differences: children and women are not capable of handling independence. The war ethic (women and children cannot protect themselves against violence) lurks behind Aristotle's ideas about the indisputable control exerted over the body by reason and spiritual strength – an analogy with the control exercised by the free adult male over those deemed incapable by 'nature'.

It is possible, as we have noted, to identify several social roles or distinctions in the frieze as well as that of the 'citizen'. In particular men are distinguished from women both by body language and type of group. Nonetheless the overall impression is that all the people arrayed along the frieze are of the same kind – youthful, athletically trim, well-developed. There is no indication at all in the pictorial language of any kind of subordination, for example no hierarchical ranking or size differentiation other than that which can be naturally explained.

Thus the representatives of the citizenship ideal are not differentiated in relation to some alien 'them'. The frieze is not a demonstration of power, in the sense that it displays any kind of repression. Rather, it is a demonstration of power in that the figure of the male prototype is all-encompassing: everyone takes part in the game on the citizen's conditions, showing the 'face' which is determined by his.

Definition by contrast with an alien 'them' first appears openly in the metopes with their depictions of Greeks in battle with monsters, with the Centaurs. In these stylised mythological images in which struggle is raised to the level of an existential condition, the 'enemy' appears in very different guises: sometimes grotesque and grimacing, at other times deceptively like the noble battling Greek.

113

The clearest and at the same time most ingenious and refined distinction in the frieze is that between the groups of horsemen on the north and south sides. This difference could be a mirror of a political tension, between the aristocratic elite mentality and formal democratic equality – in many ways Pericles' own political territory. It could also be a manifestation of the two-sidedness of citizenship: individual freedom and obedience to the social rule. Embracing both these aspects, the tension demonstrates the energy and coherence of the Athenian system.

This brings me back to the question of the political relevance of the frieze. I now see a fundamental meaning in the frieze reliefs that has to do with the way opposing forces can generate motive power. I noted earlier how movement acquired a forward impetus from bodies leaning backwards and straining against it; in a narratological analysis I perceived the way in which deviations signalled an ongoing realisation, not only a plan but also an event. Now, looking at the frieze through the lens of democratic principles has revealed another kind of tensional theme, directly visible through knowledge of the many-layered meanings expressed by the figures of the horsemen. This tension too I perceive as fruitful, as productive of activity. Something of the dynamic, processual character revealed by the analysis of movement above, also informs the spirit of citizenship which can be read in these figures.

This idea of 'democracy' embedded in the representation can be seen as cause transformed into signifier. It can also appear as the normative ideal, as a persuasive vision with which the citizens can identify. The representation visualises the main messages for citizens of the Periclean system: 'We organise ourselves together; our leaders are officials who have no personal power, but who execute the functions of the *polis*; the legitimacy of our power structure is its invocation of our ancestors, the heroic tribes; the legacy of aristocratic values must yield to the democratic system, but it still works as a force for effectiveness within the framework of the constructive tensions of democratic politics.'

Reflecting upon the Parthenon sculptures means thinking about frag-
ments. And, looking at the battered remains of this pictorial world, I am
reminded of some features of a particular aesthetic of the fragment, which
emerged in the late eighteenth century and have since persisted in various
guises within romanticism, modernism and postmodernism. I note that
the aesthetic interest in shreds, broken pieces and the loss of perfection,
and the idealisation of the unattainable, all more or less coincided with
an entirely new awareness of classical sculpture – and the beginning, if
we like, of the artistic and scholarly interest in the Parthenon sculptures,
forming the origin of modern scholarship concerning them. From the
presentation of genuine ancient Greek art works in the impressive engrav-
ings of Stuart and Revett (*The Antiquities of Athens*, first volume published
1752) and the appearance in London of originals transported from Athens
by Lord Elgin at the beginning of the nineteenth century, stemmed the
whole encyclopaedic intellectual enterprise of reflection upon and around
the Parthenon.

Towards the end of the eighteenth century the 'fragment' as an aes-
thetic concept was becoming intimately associated with a profound and
escalating antiquarian interest, inspired by objects that had survived from
Antiquity. The damaged and imperfect but still observable represented one
extreme in an aesthetic spectrum, at whose other end lay the 'whole' in
all its unattainable and radiant perfection.

Antonio Canova's neoclassical sculptures give visible form to two
qualities – formal perfection and the unexpressed or inexpressible –
which, as the polar opposites of the fragment, also represent the idea or
'telos' to which the fragment points, as an opposite, in its imperfection
and frailty. In some of Canova's works, such as the *Pauline Borghese as
Venus* or the funerary monument for the Archduchess Maria Christina,
formal precision and an allusion to the emptiness of space emerge as the
two ultimate value-bearing principles of representation, induced by
empathy with Greek artistic skill. To the cultivated observer around 1800
the damaged remnants of original ancient artefacts may have been per-
ceived like signposts on a journey which culminated in the style of
Canova.

During the late eighteenth century the rediscovery of *Greek* Antiquity,

of the genuinely 'classical' art behind the many imitations, gave to the face of Antiquity an aura of concretion and primordiality. Greek Antiquity was much more remote than all other 'antiquities', and at the same time much younger: it represented a beginning, a youthful stage in what was later to be transformed so many times and in so many different ways. Confrontation with this art must have seemed to the passionate antiquarians of the eighteenth century like a meeting with something new and yet archaic, as though remembering a friend who had died young a very long time ago. They themselves, on the other hand, belonged to a later stage; they were old in an old world, and thus excluded from the true freshness which was apprehended as essential of Greek Antiquity.

These decaying remnants of an ancient world could also become the light of a new dawn, a fresh beginning in the aesthetics of romanticism and the ideology of revolution, guided by the Utopian lodestars of Greek thought and classical form.

In introducing the fragment into the aesthetic canon, however, the artists and writers of the 1790s were also suggesting the idea of exclusion and tension in relation to a lost 'whole' – unfathomable and unattainable – from which the fragment had been torn. In reaction to what he regarded as the absence of a coherent world view with its attendant explanatory value, Friedrich Schlegel launched the critical and reflective aphorism, a form of textual fragment in which the creative self is rendered visible in a continually ongoing 'now'.

The fragment represents a physical concretisation; it is visible and evident, it is present in time and space; it is mutable, transitory, but clearly apprehensible. It is infused with an awareness of absence; as part of a whole that is now lost it constantly alludes to something outside itself, to the context to which it once belonged.

In its physical character the fragment recalls the human being: the human body – corruptible, its wholeness gradually crumbling away; and human knowledge – eternally groping for fixed points in some holistic view and eternally failing to find them. Interpreting the fragment means exposing the human condition, reminding ourselves of exclusion, of bordering on the separation from the metaphysical, and of physical decay. Reflection upon the fragment thus reveals a predicament of a higher

order: of never being within the 'whole' upon which we are reflecting, of remaining forever outside, observing and deciphering enigmatic and elusive hints instead of participating genuinely in a manifest taken-for-granted world. The visions and emotional drama of this predicament inform the poetry of the romantics – Novalis, Schlegel and Hölderlin.

Greek art appeared as a 'wholeness'. In Schiller's *Über naive und sentimentalische Dichtung* (1795–6) Greek Antiquity typifies 'naiveté': clarity, presence, the complete identification of signifier and signified, in a sunny and brilliant but at the same time essentially cool concretisation.[154] This naiveté represents a lost dimension, an authentic but unattainable enchantment from which the present – caught up in reflection, observation and a passionate yearning for wholeness – is irrevocably severed.

To Hegel classical Greek art was 'Art' at its highest level of potency. For him this meant that the age of art was over; the 'truth' could no longer reveal itself in art, but must come through religion, philosophy and the social order.

The fragment has no art or style. It lacks that form which can bear within itself a clearly conceived meaning. It is *here* in all its physical disintegration; it exists and can offer itself as an object of reflection – a frail vehicle, but one that is charged with value. But whence comes this value, if the broken shred is now so fragile, impermanent and essentially formless? The value of the fragment is simply that of the signpost. According to the romantic – and even the symbolist – conception of art, the visible is valuable as an intimation or mirroring of spiritual existence, of dimensions which would remain forever beyond the reach of human thought without the presence of the fragment. We might (if we took the romantics seriously) find ourselves believing that these traces had been scattered before us like crumbs before Hansel and Gretel, a gesture from some metaphysical 'will' which has taken pity on us poor defective mortals.

The fragment does not in any way replace its spiritual whole or polar opposite (to which it belongs, according to the principle of the fragment), but it points in that direction. It refers to a possible experience of which we would otherwise know nothing, not even enough to be able to imagine it or yearn towards it. The fragment inspires dissatisfaction, curiosity and longing.

This whole conception agrees fairly closely with Plato's world view,

and those with a classical education in the early nineteenth century would have been able to locate their antiquarian reflections within a Platonic explanatory frame. Romantic philosophy latched on to Platonic thought, despite obvious differences in the intellectual approach: Plato's aim was to turn our minds outwards, towards the immutable Forms, while the romantics remained among the fragments on this side of the divide, but yearning for eternity and spirituality. In Plato's view the visible does not primarily represent a remnant, an intimation or a shred broken off from a whole; rather it offers a kind of indirect reflection of the spiritual; it is a kind of 'likeness' of the spiritual. But Platonism and romanticism both regard the visible and immediately apprehensible as an imperfect and indirect language which can be 'read' – the only indication available to man of an inconceivably grand and non-physical reality, perhaps a dimension of 'pure' knowledge. This intimation is without any value of its own, being inferior to the spiritual domain towards which it turns the mind of the beholder, but it is valuable indirectly as the only possible path to this highest spiritual value.

Plato's philosophy, in common with romanticism, symbolism, modernism and postmodernism, focuses on the limits within which the visible (the manifest) is operative. These boundaries can be viewed in transcendental terms: the physical (for the romantics, essentially the whole of the objective world) is a mere remnant of an unattainable sphere of spirituality; in this metaphor the physical world is a fallen angel. The boundaries can also be defined in linguistic terms, as in semiotics and the postmodernist tradition: the physical – the manifest – is one half of a sign, whose other half is an idea or mental image. The ideational element in the sign is the meaning produced in some kind of inscription; as soon as this meaning has been formulated or stated it constitutes a new inscription, with a new meaning to be sought. Thus meaning also becomes transcendental, as the postmodernists insist in their sceptical critique of knowledge. In practical terms, however, there is sufficient difference between a formulation and its meaning for the distinction to be manageable; at least it seems to correspond to a genuine difference.

All physical things can thus be regarded as fragments – utility objects, natural objects, works of art. In a religious world view – in the branch of mediaeval Christianity inspired by neo-Platonism for example – the whole of nature, the whole of creation, can be seen as traces of a text

38. Figure N122, the north frieze. The British Museum, London.

written by God. But an aesthetic of the fragment does not necessarily have to rest on a religious metaphysic. Objects clearly intended for messages or communication between people are perceived as a matter of course as the visible manifestation of something more insubstantial – thought, intention, emotion or meaning. The actual surface of an artefact can then appear as part of a whole, embracing both the signified and the signifier. Artefacts, pictures and texts can be perceived as clues to something that is not immediately visible, something whose potency determines the identity and function of the sign. Not until the concrete form is paired with this partially inexpressible dimension does it become animated: luminous and evident, part of the language and a channel for communication between human minds. The analogy between religious interpretation and the 'readings' of art is significative of the interests which art touches upon. The intensity of the experience that certain works of art can provoke affects the limits of consciousness in just the same way as religious or existential reflection.

A damaged and extremely old work of art – such as the ensemble of the Parthenon sculptures – reinforces the sense of distance between manifest form and what is implicit in the form – its message, its voice or soul.

The sculptures are certainly authentic, but different from what they were. They are objects whose anatomy can be studied and whose details can be discovered – but whose essential meaning has gone for ever. But the former meaning or expressive quality has been replaced by something new and possibly just as powerful: an aura which acquires its glow from a paradoxical attraction, a presence that clearly demonstrates both what is there, and what is not.

Looking at the frieze, my eye is often drawn to particular details, which seem to acquire a sort of autonomy in response to my close examination, to expand in meaning as though the very act of examining can enhance the expressive power of the thing examined.

Concentrated attention to details is motivated by the damaged state of the frieze. From the almost obliterated working of the surface, a hand

39. Figure E35, the east frieze. The young child touching the *peplos* has a particularly expressive hand. The British Museum, London.

emerges – plastically defined, knuckles showing, a tensed thumb pressing against an index finger which was once curved round a horse's reins.

In the pictorial world of the Parthenon frieze it is just such hands – their positions, the way they look – that stand out for me as fixed points in the whole. The position of the hands seems to be of great importance in defining actions and roles. The significance of the gestures belonging to figures E18 and E19 is perhaps not quite so accessible, although it seems likely that the touching of their hands is connected with whatever they are talking about, but the subtleties of this gentle contact between the men evade me.

The effect of the young women's hands on the east frieze is generally a little static, but even here my eye is caught by particular hands, some hanging loosely down, relaxed, suggesting both strength and softness; capable hands. The young child touching the *peplos*, on the east frieze (E35), has a particularly expressive hand – carefully holding up the fabric while also apparently stroking it, even creating a slight bulge in the material (fig. 39).

The carefully modelled hands, arms and breasts of the women are emphasised by the abundant drapery over their shoulders and waists. This

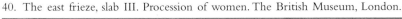

40. The east frieze, slab III. Procession of women. The British Museum, London.

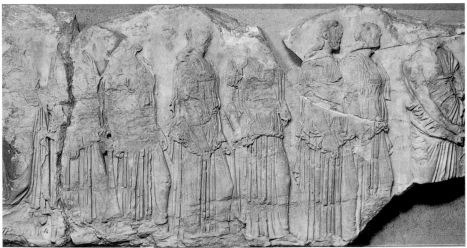

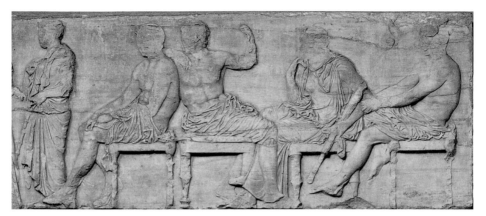

41. The east frieze, slab IV. Assembly of gods. The British Museum, London.

rather luxuriant style contrasts sharply with the lower part of the women's bodies, where gowns fall in almost statuesque, unbroken folds over their legs, as though the women had become the kind of columnar figures which were later created at the Erechtheion (the folds call to mind decorative fluting) (fig. 40).

On the east frieze it is not only the body language that varies between groups of figures; even the fall of the drapery and the pattern of folds act as distinguishing features. Looking at the assembly of the gods I am struck by this way of marking them out from the others: their garments appear thinner, the folds much richer, some almost crumpled, evoking the idea of heat and light (fig. 41). The impression of ethereal lightness and perhaps of intense heat seems to me to come together in the slightly frizzy little curls escaping round Hephaistos' face and standing out delicately against the slab behind, which represents the background or space round the figures (fig. 42).

In the case of the horsemen, hands are sometimes more clearly expressive and more humanly interesting than the men's facial expressions. In the variety of their movements, the hands closer to the background – on the horses's necks, palms or fingers gripping the reins – demonstrate control combined with lightness of touch, strength without strain. Other hands, in the foreground and with their backs towards us, are also subtly varied: sometimes clenched on the reins; sometimes with an index finger

123

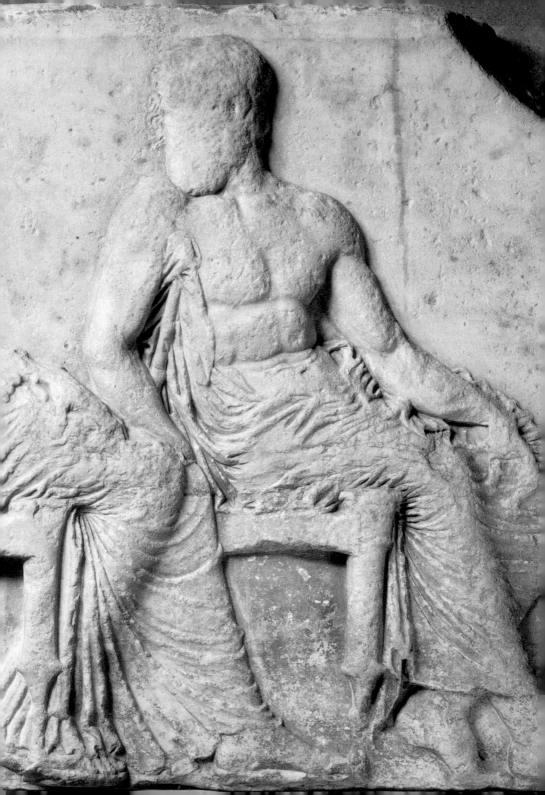

and a little finger raised to reveal the easy smoothness of a grip, while the middle fingers keep a restraining hold. It is easy to see that the rider is giving the horse its head and yet retaining control, at once encouraging and curbing.

Since so much of the artefact has survived and so much of it is damaged, the observer's response is challenged from two directions. First, my curiosity is aroused: I long to know more about what seems to be so near, even close enough to touch. At the same time I am face to face with decay, with an indistinctness that blurs any clear impression.

The depredations of decay vary, and thus also the way I perceive the sculptures. Some of the scenes on the frieze in the British Museum appear almost intact in their detailed precision, sometimes in sharp contrast to patches of severe erosion, or cracks and bits of rough surface where pieces have broken off. Other bits almost look as though they have been 'mounted' in the rougher and damaged parts of the stone, so that I seem to see the fine details and the smooth surfaces framed in what has once more become the original raw material.

Confronted with some of the west pediment figures, for instance figures B and C (generally identified as 'Kekrops and his daughter') in the Acropolis Museum in Athens, I am startled as I become aware of their imminent final destruction, as though I were witnessing an irreversible end. The expressive quality of the bodies can still be dimly guessed at, like a meaning half hidden behind a veil of rough stone (fig. 43). Faint veining is just discernible on the supporting hand of the male figure. But my main impression is of two great boulders, as though nature were even now reclaiming the figures for herself. If they were transformed into simple stone again they would lose their 'age', they would belong to the present in the same way as any other stone that has been worn down by the feet of men or covered with layers of deposit. In such anonymity the sculptures would regain their youth, as mere matter. They have almost reached that stage: one more step, and they will fall completely silent.

Naturally interpreters and observers have wanted to 'fill out' the now imperfect sculptures. Descriptions seldom start from the present status of the figures; instead it is the lost whole that is sought, or at least an identification. And yet the brilliant surface with its colours, metal attachments

42. Figure E37, slab V. Hephaistos. The British Museum, London.

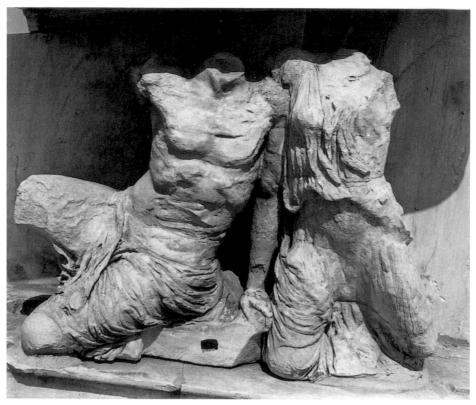

43. Figures B and C, the west pediment. The Acropolis Museum, Athens.

and fittings is rarely invoked. The language of analysis tends to stop somewhere half way – at the form of the bare stone, but without the damage, cavities or hollows in the surface. In this way the figures which are the subject of the discourse are rendered sublime, rehabilitated and compensated for their broken state, but without their original appearance being restored.

With their combination of damage, signs of ageing and traces of perfection, the sculptures invite our projections. For many people this is certainly one of their most important aesthetic functions. The figures and their pictorial space challenge our imagination as though pleading to be made whole again. They provoke us to try to recreate their appearance, as well as their context.

126

The most common type of evaluation of the sculptures shows just how widely the aesthetic of the fragment has been adopted in approaching these artefacts, how a tradition stemming from romanticism has become a staple of Parthenon scholarship. The contrast-and-synthesis principle which informs many authoritative evaluations of the sculptures, reflects the structure of the fragment, evoking the idea of tension – of contrary pulls across a great divide or between the poles of a magnetic field – combined with the suggestion of an ideal whole somewhere in the interactive field between the two forces.[155]

The discussion of self-evident meanings and analogies with natural phenomena – two more common features of Parthenon scholarship – suggests a kinship with the transcendental aesthetic of romanticism as well. A figure's movements are ascribed a spontaneous self-evident meaning: a marshal suddenly moves to avoid the horsemen, a man lays down his jar with a tired gesture, someone else waves eagerly, the gods chat to one another absent-mindedly or perhaps in curious expectation. Such emotive meanings apparently need no further argument nor any great array of comparisons; rather, this kind of interpretation of body language appears immediately accessible, wonderfully simple – the foundation for a meeting with the remote and strange.

The highest ranking figures in aesthetic terms – the reclining bodies and horses' heads of the east pediment and the female torso of the west – are all ascribed a special aura in current mainstream interpretations, by invoking analogies with nature (fig. 44). The figures emanate the power of nature and the memory of physical experiences: of sun-drenched mountain slopes, currents of water and wind, rising and falling rhythms, contrasts between muscular tension and deep repose.[156]

As in the romantic aesthetic there is an underlying idea here of closeness to the heart of nature. The more powerful the expressive force of the figure, the closer we are to the site of primordial contact with nature. Any form or hint which can lead our reflections towards this elemental memory, patently possesses a special visual authority.

I am not insinuating that such meanings are transient or unfounded. I am not trying to promote alternative readings in order to overthrow established interpretations. I simply want to alert myself as far as possible to the needs and forces that produce the elicited meanings. And in the Parthenon sculptures and the interpretations that have grown up around

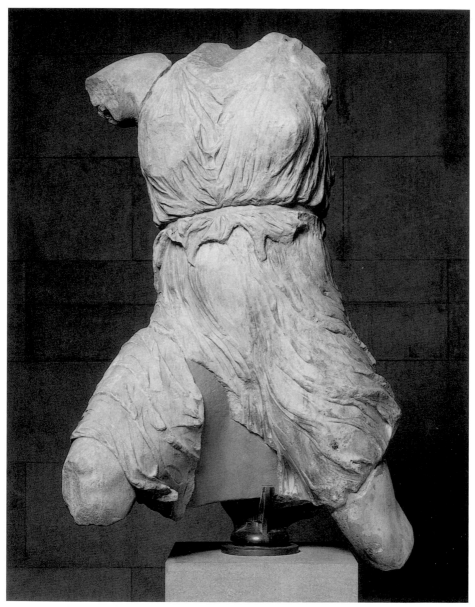

44. Figure N, the west pediment. The British Museum, London.

them, I perceive images and modes of thought which have been incorporated into the existential themes of the romantic aesthetic of the fragment.

Space for the viewer's own projections plays an important part in the attraction of works of art. Despite the striving of the mind to recreate a genuine whole, the void persists and – lacking any certain or confirmable content – is apparently 'negotiable'. The physical shape and meaning of the figures are both unknowable, but are filled out by the observer's own personality and needs. As they make their analyses, scholars are indirectly and evasively portraying themselves behind a veil of science. Part of what they observe depends on their own desire to see something that the fragment apparently warrants. The space for projections is thus a mirroring of the observer, but it is still the void that remains unfilled – the sublime space at the heart of the inexpressible.

This image brings to mind Pliny's story of the artist Timanthes and his painting of the sacrifice of Iphigenia, daughter of king Agamemnon and queen Clytemnestra – a sacrifice made with the consent of the victim's father, to propitiate the gods and ensure wind in the sails of the Greek ships.[157] Pliny points out that Agamemnon's face remains concealed in Timanthes's painting: the father's feelings are such as to defy expression. We are left with the imagined qualities of what is concealed, the unformed and indeterminate that never need face the test of observation. This aesthetic principle was popular with artists in the late eighteenth century, and the Timanthes example illustrated an important aspect of the thought and aesthetic theory of the period, coinciding with the introduction of the aesthetics of the fragment.[158] It has also remained relevant to the reception of Antiquity in scholarship up to our own time.

The 'Timanthes' quality endows the ancient work of art with an aesthetic dimension which it did not originally possess, and which is unconnected with any kind of reconstruction. The aura of sublimity is concomitant with distance and an unbridgeable gulf.[159] The ancient artefact naturally possesses a certain sublimity from the sheer passing of time, but also because it represents an unfilled and unfillable void.

In brief the aesthetic of the fragment is composed of the following elements. The manifest, i.e. the fragment, strains towards its own antithesis, the inexpressible or transcendental; fragment and whole are linked through time, in that the fragment is a remnant of something that existed

long ago; interpretation re-encompasses the fragment in the whole; the passionate interest of the observer springs from the capacity of the fragment to lead towards this whole, which acts in turn as a criterion of arrival or 'successful' interpretation.[160]

My own approach diverges in some respects from this type of aesthetic. Standing before the damaged sculptures I too am aware of distance, of the void that is not filled, and the various possible amplifications which could 'animate' the forms, but I do not find myself yearning for a whole to smooth away the tensions or dislocations; I long for no explanations. Consequently I do not regard the visible qualities as soundings or pointers to some kind of 'transcendental' reality which could motivate or legitimate the presence of the traces, or could satisfy my longing or fill in the gaps in my knowledge. I expect no accommodation from the other side of the divide – no plan, intention or world view; nothing unconscious or metaphysical redeems the degeneration of the fragment or my own imperfection.

But when I observe the sculptures as fragments, I do perceive them as taking part in the marking of boundaries. Beyond the boundary are aspects of meaning established by the boundary itself and by the fragment: the time of its genesis, the creative work itself, and the society which provided the conditions for it. There, too, are various model theories revolving round ancient thought and style, including formal qualities in related artefacts within the classical style as well as in the essentially different expressive modes of archaic, Hellenistic or non-Greek art.

Poststructuralist interpretation theory has introduced a concept recalling the idea of the fragment, namely the 'supplement'.[161] A supplement can be described as the meaning ascribed to a form or an expression on a basis of what is being suppressed by the manifest meaning. Thus the supplement is not identical with the fragment of romanticism: it is not directly perceptible by the senses, nor has it the same kind of formulated meaning. But like the fragment it suggests boundaries, by interacting in a relation of complementarity with another part, which it is both separate from and connected with.

The notion of the supplement as one piece in a strategy of suppression opens the way for an almost unlimited number of possible combi-

nations between an expression and what it suppresses. What limits are there to the suppressed layers in an established meaning, heavy with the guilt of supremacy? Which currently subdued but unreformed enemy will be the one to topple the apparent meanings of the ruling power? The supplement is to the taken-for granted, what the dissenter is to the orthodox or the distorting shadow to the well-proportioned body. Sharply focused and well stated it can leave indelible marks on the appearance of its other half – the half which faces the light.

Despite the obvious risk of arbitrariness in the interpretive structure offered by the supplement, the idea of the fellow-player (or opponent) facing the opposite way in the taken-for-grantedness game, does seem to reveal something important about the production of meaning. It reminds us of the victims that are created every time a boundary is drawn, and about the subversive potential of language.

Works of art as famous and influential as the Parthenon sculptures obviously do not lack 'opponents'. We need only think of the Persian style and world view, or the mind-set and life-styles of the Spartans or of Athens' allies ('friends' as well as 'oppressed'). Such against-the-light effects suggest simple contrasts within a set of not altogether unrelated cultures from which Athens nonetheless deviated. Obvious symbolic differences would emerge from a comparison with the style and expressive forms of artefacts that are patently alien to classical Greek art. Such a statement would be a truism if we were merely analysing contrasts, but with the introduction of the 'supplement' the comparison of differences becomes involved in the considerations of power relations.

Another type of relation occurs between the Parthenon style itself and its stylistic kin, i.e. imitations of the classical style in Hellenistic art, neo-classical sculpture around 1800, the formalistic aesthetic, and responses in the mainstream scholarship of ancient Greek art. Here the gaps and con-trasts are more difficult to pin down, although they can be both seen and felt. The interaction with space, for example, is essentially different in neo-classical architecture and sculpture on the one hand, and in the Parthenon style itself on the other, despite the many similarities – the highly devel-oped formal precision and the treatment of surfaces – that appear in both.

However, the essential supplement relationship implies that what is expressed on the surface is being challenged or undermined by suppressed layers of meaning. Take for instance the picture of the young men riding

along in easy concourse, simultaneously enjoying community and independence. Does not this display conceal just those exclusions which are a condition of their perfect and voluntary togetherness? My discussion of the female theme above, is in fact an analysis of a supplement: how 'man' is detached from 'woman' and 'woman' conceals the women.

III

MEANING

It is (probably) the same divine assembly that is twice depicted in the Parthenon decoration, and in two essentially different ways: in the pediment the gods are shown as living, moving beings; in the frieze they appear as an eye-witness might see them – seated figures only slightly larger than the neighbouring mortals. Among Pericles' contemporaries were presumably some who would have doubted the view implied by the first approach, i.e. that the gods look like mortals on a grander scale, that they are active beings with some kind of intentions and desires of their own. The figurative world of the pediment clearly asserts such a conception of the gods: here they look much as the myths and epics have described them, implying that beings such as these had really existed. The frieze gives us a picture of the relationship between mortals and gods: here men reveal their need to approach or to confirm their gods; and the gods, receiving the homage of men, appear as men envisage them to be.

The leading interpreters of the Parthenon sculptures (Pollitt, Simon, Mark, Harrison, Gauer, Jenkins, and Castriota) emphasise the relevance of the temple sculptures to Athenian society, and discuss ways in which they were supposed to confirm or mirror both Athens and its citizens. This confirmatory function naturally includes expressing religion as a social factor: how were the cult rituals performed at the festival for Athena; what was the significance of the celebratory feast; how did people understand the role of the gods in the organisation of life, in the exercise of power and in men's view of themselves? But what the scholars clearly do not do is to suggest that the sculptures were intended *for the gods*, for the gods themselves to perceive and interpret.

The adoption of such an interpretive frame means abstaining from the 'evident' meanings, i.e. those with which we can readily identify, and from any affinity that we might feel with this remote period. Of course we can all recognise the attributes of the various gods, we know the areas they control and the way they can be identified, we know which stories they appear in and how they were thought to influence human life. But none of this helps us to experience what it was like to live with a world-picture that included these gods as – in some sense or other – a reality. And so we emphasise those parts of the symbolised world view which we *can* share or identify with: political action or mental self-reflection.

The desire, or the need, to reduce the gods and to fit them into our reality is a strategy for rationalising the ancient Greek people, transforming them in our minds into variously skilled actors in this or that sphere of power. A 'secularised' attitude towards the world of the gods certainly seems to greet us in the works of leading thinkers in fifth-century Athens – the sceptical Sophists, for instance, and the nature philosophers who were active in Athens in circles close to Pericles at this time, and who probably influenced his thinking.[1] But the notion that there was a deep and widespread religious crisis in fifth and fourth-century Athens cannot be confirmed. Despite the intellectual challenges and the great defeat inflicted by the Spartans in 404, the state religion did work.[2]

The Sophists and the analytical thinkers shared common ground in their resistance to the idea in the Homeric tradition of Olympian gods in near-human form.[3] But they do not abandon the idea of a divine will or of divinity in some other more abstract sense. Pure atheism was the exception.[4] The gods could be reinterpreted as forces of nature or life principles or as mirrors of human (immoral) behaviour.[5] The designation 'god' could also, as in Euripides' plays and with a trace of philosophical speculation, be applied to a higher level of greater moral perfection than that represented by the Olympian gods known as Zeus, Hera etc.

In the Periclean age and even later there seem to have been different ways of dealing intellectually with the concept of the Olympian gods, reinterpreting them or distancing oneself from them:[6]

a: The myths about the gods are untrue stories, told by ignorant people.
b: The *polis* religion is assumed to be esteemed and respected by politicians to promote unity and morality in society.[7] Thus the content of

religion is a means to establish order in society, not knowledge itself.

c: The gods are names for phenomena in nature, in particular the air and the 'ether'. This view draws on an older tradition of nature philosophy, and sees the gods as primordial or ultimate nature, *physis* (Anaxagoras).

d: The gods are names for human values, institutions or feelings.

e: 'God' refers to a supreme mind which has planned the universe or is identical with the regularity of the world's functions, a self-sustained 'reason' or 'soul' (Plato, possibly Xenophanes, Anaxagoras and Euripides).

f: The supreme mind of the universe has created the many gods of the myths and the cults; these created gods act in time, they represent a reality that is 'imperishable' but not 'eternal' (Plato, *Laws.*).[8] It is in this dimension that the births of the gods described by Hesiod are to be understood.

None of these alternatives, however, appear to have disrupted the *polis* religion. On the contrary, its strength and its weakness are revealed in the sheer conceptual flexibility that lies behind the carefully observed rites and rituals of the cult.

Jon D. Mikalson emphasises the conceptual gulf between the gods of the Athenian cult and those of epics, drama and mythology. The core of Athenian piety was a pattern of behaviour embracing respect for the gods of the state religion, respect for the rules of *xenia* (hospitality) and the rights of asylum, and the 'observance of tradition and law in cult sacrifices and in tendance of the dead, loyalty to one's country, and proper care for one's living parents'.[9]

Were the gods of the cults mere homonyms of the gods of the narratives? The average Athenian could call upon perhaps forty or fifty different divinities with no precise equivalents in the tragedies or epics. When this ordinary citizen worshipped Athena Polias or Athena Hygieia, did he also believe in the existence of the Homeric Athena as a goddess worthy of religious acts? There can be no obvious answer to this question. The stories of mythology and the dramatic narratives seem to have been a necessary means for visualising the divine principles and explaining religious customs in *aitia*, i.e. stories about the cause of the particular celebrations.

Mythology and dramatic narrative are always staged in the remote past: all this happened a very long time ago; the gods appeared and possessed certain specific features; the fate of the heroes conditioned life in the present. I find it hard to dismiss the mythological gods from the cult altogether, as Mikalson does. Their relevance is obscure, but if stories about Athena or Erechtheus or Apollo or Dionysos or the others explained to the Athenian why he paid his religious tributes in certain ways and at certain places, then the 'surface' of the stories (how the figures act, what they look like and so on) must have influenced his religious mind set in some way.

I shall leave this complicated question here. When I speak below of the world of the gods and its existential conditions, I refer to the gods in the 'Olympian' version maintained by the dramas and other narratives of the state religion in the classical period.

Pericles may well have believed that the gods existed as principle or energy but not as near-human actors, and yet could still have initiated a grandiose enterprise of divine representations in the Homeric spirit. He may have decided to embark on this venture to hold his people together, to make a symbolic demonstration of his power, to impress his enemies, or to provide the Athenians with visible images for the traditional pursuit of an ancient faith which he himself no longer shared. The traditions of the people naturally took priority over the doubts of the individual. He may simply have been a cynical and expert propagandist, whose real motives were the glorification of the state and the legitimation of power (legitimacy based on the old entrenched customs).

The gods in the decoration of the Parthenon certainly exhibit traditional features, but also suggest new interpretations. It does not seem to be a question of using the gods as a pretext for other realities and other motives. The ensemble as a whole seems to convey a very carefully designed and coherent world view, in which every expression acquires its importance in relation to every other. There is no trace here of the 'new dogma' of the Euripidean type; rather, it is a question of a revival and a new visible focus on the traditional *polis* religion.

It is possible to proceed from a mythical figure to a concept, and back to a mythical figure. One can agree that Zeus is explained by thunder,

136

but that thunder is not explained by Zeus; that the anger of Poseidon is the storm; that Zeus the family patriarch and all-powerful ruler symbolises the order and system of the world – and then again to envisage these nature phenomena or abstractions as moving, human-like figures. What distinguishes the two stages or levels of the divine form is an ontological difference: in the first phase the gods are colossal beings who rule and fulfil their desires at whim, in the second they are symbols whose attributes signify the fundamental conditions of nature, life and history.

The real content of the relation between the divine and human dimensions is not so different in the two alternatives as one might at first assume. Even 'rationalised' nature has a further substratum of mystery and fear; here too traces of a 'will' can be sensed, and an animistic presence which can be ritualistically approached and appeased. The transition from belief in immortal beings to belief in the fundamental forces of nature or a supreme 'reason' is not necessarily clear or sharp.

Herodotus, Thucydides and Plutarch all sometimes tell of leading politicians who made purely 'irrational' decisions, because they had listened to the gods. Nicias, Pericles' successor, delayed a military action in Sicily, for instance, because an eclipse of the moon was interpreted as an unfavourable sign from above. In strategic terms this meant that the last opportunity for a retreat was lost, and the venture ended in a disastrous defeat.[10] Herodotus tells us in detail (VII, 140–4) how the Athenians tried to unravel the intention of the oracle at Delphi before the battle of Salamis – how the god's words about a 'wooden wall' caused the Athenians to become seamen (when Themistocles had explained that the 'wall' meant the 'fleet').[11]

Religious rites surrounded every military decision. If a very large proportion of the citizenry and soldiery believed – in an uncomplicated sense – in a galaxy of active, giant-sized gods in near-human form, then of course the strategists were wise to consult the oracles and make sacrifice to the gods, all in the cause of reinforcing the compelling mandate of their own decisions. They may have been manipulating parts of the religious machinery for their own ends, but it is impossible to be sure. There is no evidence that many of the leading politicians had ceased to regard the gods as possessing wills and actions in some way personal to themselves. Acts at the public level in the city state were part and parcel of its religion.

To the sophisticated sceptics of the fifth century the actual existence

of the gods was taken as a postulate. What was being questioned was not so much the basic reality to which people's knowledge referred; rather, it was the validity of any statements which could be made about it. The designations 'god' or 'gods' were not problematic in themselves, but claims about who or what could be so designated probably were.

Protagoras writes in a well-known passage that he cannot determine whether or not the gods exist, or what they are like in form, for there are many obstacles to knowledge; the subject is too obscure and human life too short.[12]

Plutarch reports Pericles as saying in his Funeral Oration for the Athenians who died in the Samian expedition in 440, that we mortals do not see the gods, but we believe in their immortality because of the marks of respect we pay to them and because of the good things we receive from them.[13] Pericles' purpose on this occasion was to identify the recently fallen warriors as heroes; when the dead receive the marks of their compatriots' official respect, they rise to the level of the gods, since the gods themselves receive self-confirmation in ceremonies of a similar kind. Pollitt and Boardman thus appear to be right in claiming that the age of Pericles (and of the Parthenon) experienced a rapprochement between the divine and the human. However, it is important to note the nature of this rapprochement: it is not that the gods are perceived as more human than before, nor that they are described in unequivocally naturalistic terms. Rather, it is human demands which become the medium for the undefined links between human life and the 'first things' or causes. The rapprochement implies that, more clearly than before, the common domain of mortals and gods is now that of human thought and human expression.

Herodotus points out that the Greeks knew very little about the gods, until Homer and Hesiod described them in their works.[14] Although this comment is rather extreme, it does remind us that the ancient epics reinforced a historical awareness of which Herodotus' own work is a symptom. With the works of Homer and Hesiod the Greeks acquired a narrative which included themselves as well as the gods. It confirmed that their own beginnings belonged to a relatively late period, that only a few of their contemporaries would be able to achieve heroic status, and then only after death. Thus the Greeks of the Parthenon age could see themselves as part of a narrative to which even the gods belonged, but they also saw themselves as separated from the gods by a vast temporal and

communicative gulf. Severed from direct links with the gods and unable to see them (in any real epiphany), mankind was relegated to seeking signs of the divine. Such signs or traces could then testify in turn to a certain character in the 'first things', about which nothing could be known with any certainty.

In the typically Greek distinction between *physis* (nature or material reality) and *nomos* (customs, beliefs and behaviour), the gods thus tended to be classified in the *nomos* dimension.[15] Consequently an attack on the gods was above all a threat to the social order, to all the human ties and ideas that motivate the distribution of roles and the structure of power. The Greek term expressing belief in the gods was *theous nomizein*, where the *nomos* root reappears in the verb: belief in the gods thus means primarily acknowledging them or respecting them, and confirming their existence in rites and visible symbols. Men do not sacrifice to a void, men do not make images for no reason at all, men do not search where there is nothing to seek.

Plato's late work, the *Laws*, is one of the most lucid literary documents ever to address the integration of social order and religion. The state he describes here resembles a normative abstraction of actual Greek city states, rather than an ideal state of the kind introduced in the *Republic*. In the *Laws* Plato attacks any deviations from the state religion. Plato, or his mouthpiece 'the Athenian', attacks the natural philosophers who identify the gods as phenomena of nature; removing the gods from the realm of *physis* (letting Helios become a lump of stone) and making them subject to conventions in the realm of *nomos* instead, means relativising them and making them dependent on man. And yet the social dimension in Plato's own text is so strong that the gods are actually described in terms associated with the state bureaucracy (the supreme god, the mind that planned the universe, is called *basileus*, and the created gods are *archontes*, 904A, 905E).[16] Even the gods who had been reinterpreted in more philosophical and sophist terms were seen as objects for the traditional cult rituals.[17] So long as the religious acts could be practised in harmony with traditional religious beliefs, actual beliefs themselves (whatever they contained) did not constitute an attack on the state religion.

If the only, or the most important, way for the gods to exist was in the customs of mortals, then we are perhaps justified in interpreting the Parthenon sculptures as mirrors of society and social ideals, in accordance

with much current mainstream scholarship in the field. Sculptures which represent gods can surely imply the social order, if the gods are in some sense internal to that order? The most systematic interpretation of the Parthenon sculptures along these lines is presented by Ira S. Mark. According to Mark the theological background or motivation for the assembly of the gods in the frieze lies in the religious conceptions of the sceptics and Sophists: every god there is the embodiment of a specific social principle. The sculptural representations appealed to the contemporary Athenians as a self-confirming reflection, in which every divine figure has an emblematic meaning.[18]

But even if the Olympian pantheon is linked with civic society, the emphasis may be on one side or the other of the relation. Society interfuses with the gods as much as the gods interfuse with society. As far as we know, the Greeks may have conceived of eyes that could see on the far side of the boundaries of human existence.[19] The decoration of the Parthenon can be regarded as symbolising a particular world view, but it can equally well be seen as a language directed at the gods. And if men chose to address the gods in symbolising and 'narrating' mode, they may have been counting on a place for themselves in the dimension where gods also speak to mortals.

A sculpture which represents a god and depicts that god convincingly as 'living', is not necessarily expressing the belief that such beings exist; nor, however, is it suggesting that the figure means anything other than what it actually shows. The range of belief appears to be pretty elastic. The gods are often present even in the ideas of the intellectuals and the discussions of the learned, at any rate if we are to believe Plato's accounts in the *Symposium*. Whether these 'pictures' are metaphors or real names seems uncertain. When the tragedian Agathon praises the beauty of Eros's form in his eulogy on love, it is not clear whether the god is a metaphorical projection or a being in his own right. What certainly matters most to the speakers at Agathon's feast is the influence of the god on human behaviour. But it is the 'nature' of the god which causes the behaviour, and this nature becomes intuited in the representation.

According to John Gould an important aspect of the Greek religion is that it recognises the inscrutability and ambiguity of divine communications with mortals; the unravelling of this special language could make the difference between life and death to men, who were always in danger

of misinterpreting the messages.[20] According to Heraclitus, Apollo did not 'speak' or 'conceal' through his oracle at Delphi; he used 'signs'.

From the human point of view a corresponding mode of expression through pictures might thus seem just the right way of answering the gods, of placing oneself in a realm of meaning common to both gods and men. If the gods are primarily a problem of interpretation, then signs and images are particularly important to men as channels of communication to the unexpressed or inexpressible. Imagery allows us to believe and not to believe at the same time, in other words to be just as inscrutable as the gods. If the actual pictorial representation is a condition for communication, one could perhaps go so far as to say that the more images there are, and the better they are, the more real are the gods.

The seeking and testing and experimenting that informs the Parthenon sculptures and the intellectual world that produced them, were ultimately perceived – in light of the war and, even more, of the aftermath to the defeat of 404 – as too great a threat to society. Crimes combined in the concept of *asebeia*, impiety and disrespect for religion, came to be punished with ever greater zeal.[21] Purges among the Sophists and nature philosophers began after the death of Pericles, with the onset of plague and the disasters of the Peloponnesian war. Society reacted fiercely to attacks on its traditional religion; Socrates' trial was part of the pattern. And yet scepticism and relativism had been the target of Socrates' harshest criticism, at least as reported to us by Plato. Only with the affirmative metaphysics of Plato himself was a new faith established, strong enough to resist doubt and analysis reasonably well, since it exploited just these qualities in its own argumentation.

But, paradoxically, the defence of society meant the defeat of the gods. He who admits that the gods and the social order are jointly threatened by the teachings of the Sophists, is acknowledging that the gods share our human limitations. In the Parthenon sculptures, by contrast, everything is still possible. Never have the Olympian gods appeared so finely realised, never have they seemed so accessible to salutation, never have communications in both directions seemed so open despite the recognition of difference. If a definitive separation is being established here, then at least the intensity of this last meeting almost succeeds in breaking through the divisive barrier.

It is possible to envisage the Parthenon sculptures as literally turning

towards the gods, as invocation or language at the human level and as 'sensory' impressions at the level of the gods. It is also quite possible to see the two groups of gods as the difference between *physis* and *nomos*: on the one hand the portrayal of the gods in their own domain and on their own existential conditions, and on the other the gods participating in *nomos*, the social functions. This kind of interpretation gains credence from the passionate speculations of the Periclean age, in philosophy and drama, on the sources of knowledge and the conditions of existence.

What, then, is the content and quality of this indirect meeting over an ontological divide? Let us assume that the images of the gods symbolise a reality which has much the same attributes as the works of art seem to imply – stories, sculptures and paintings. What qualities would these beings – in contrast to men – then possess?

The Homeric gods and those depicted in the Parthenon decoration all resemble mortals in appearance; they invite identification, but immediately demonstrate their different nature by distancing themselves from human conditions. The biggest difference, of course, is that in man-to-god situations it is the gods who are 'immortal': they cannot be killed (although they can be wounded) by men, but are capable of threatening one another. Sons have killed divine fathers from time immemorial. The relative uncertainty in the omnipotence of the gods is a specific feature of the Greek religion, distinguishing it from religions such as Christianity and Judaism based on a dogma 'written' by God.

A kind of unequal equality, combined with the divine advantage of 'immortality', can sometimes lead to purely comical effects, as when Achilles fights in vain against Apollo outside the walls of Troy.[22] Why does the warrior waste his strength fighting an immortal, Apollo wonders, and Achilles answers, somewhat disrespectfully, that he would gladly revenge himself upon his divine enemy if only it were possible.

And now Apollo turned to taunt Achilles: 'why are you chasing **me**? Why waste your speed? – son of Peleus, you a mortal and I a deathless god. You still don't know that I am immortal, do you? – straining to catch me in your fury! Have you forgotten? There's a war to fight with the Trojans you stampeded, look, they're packed inside their city walls, but you, you've slipped away out here. You can't kill **me** – I can never die – it's not my fate! Enraged at that, Achilles shouted in mid-

strife, 'You've blocked my way, you distant, deadly Archer, deadliest god of all – you made me swerve away from the rampart there. Else what a mighty Trojan army had gnawed the dust before they could ever straggle through their gates! Now you've robbed me of great glory, saved their lives with all your deathless ease. Nothing for you to fear, no punishment to come. Oh I'd pay you back if I only had the power at my command!'[23]

In Homer's poetry gods can be mistaken for mortals, but only because they can change shape at will (or can so affect the eyes of those around them, that mortals believe they are seeing one of themselves rather than a dissembling divinity).

If the world of the gods, as mortals understand it, thus offers the Greeks a way of mastering their fear of the unknown, of dealing with the threatening, the destructive or the unpredictable by reinterpreting it in familiar guise[24] – if this is indeed so, then the gods will soon rise above their apparent limitations: they look familiar but can do and be the impossible. The gods are what people can never be – not a magnified reflection of human existence but a polar opposite. It is in the nature of the gods to visualise qualities which exist (or which could exist) on the other side of the boundaries that confine our human identities.

What united gods and men – a quality that grew in importance with time as an explanation of the rites, sacrifices, prayers and other manifestations of Greek religious behaviour – was the narrative or historical dimension introduced by the descriptions of Homer and Hesiod. Hesiod's account of divine births and succeeding events in the lives of the gods indicates a temporal dimension to their existence: the divinities reigning now have not always existed; they came into being with the passing of time and seized power by rebelling against earlier gods. Their hold on power cannot thus be taken altogether for granted; their very 'immortality' contains an element of the finite.

The focus on the actual moment of the divine birth in the pediment decoration implies an exact starting-point for the succession of eras and events which relate to the Athenian present. This long perspective of time included a history of increasing distance between gods and men, a loss of closeness, and more and more refined inventions to invoke the gods, to establish new powerful communications.

143

If the gods are to be successfully invoked, they have to be able to *see* the fabricated figures, perhaps to enter into them and – depending on the quality of the representation – even to show their benevolence towards mankind.

The conditions for this communication are revealed in the different modes of divine existence represented in the temple decoration. The world of the pediment reveals a primeval phase: the figures appear to be breaking out from the depths; everything seems new and unpredictable; a sense of suddenness is everywhere.

In the metopes the mode is one of stylised mental images. The episodes depicted here appear frozen, emblematic: struggle as a theme, a condition or a warning. The actors are all mythical, inhabiting the world of the heroic epics.

The human world of the frieze shows an ongoing and purposeful activity, involving the group as a whole as well as every individual in it. Of course we find typical or general attributes here, but the abstract patterns or generalised forms have become concrete: the plan becomes visible in the movements of chance occurrences in a realisation of the ceremony.

A whole range of pictorial modes corresponds to these distinct types of reality. In the pediments the material itself – great heavy blocks of marble incorporated into a building – is dramatically transformed in the pediment statues. It is a long step from the reality of the solid flat stone to the impression of large-scale 'moving' bodies, bearing their own weight with strength and ease. Here art has achieved a greater miracle of transformation than at either of the other two levels, where surface and stone are more readily perceptible in the mode of expression.

The metopes, the intermediate level, represent a definite shift away from the world of the pediment; some traces of 'moving' free-standing sculpture certainly persist, but an element of heraldic surface-bound stylisation imposes a stronger sense of distance and abstraction.

The frieze is carved in low relief, but has a few touches of the full sculptural idiom. These details never project beyond the fairly shallow space allowed by the flat stone. The onlooker sees everything that happens; the sense of playing an eye-witness role enhances the effect of

144

authenticity; but the eye-witness experience also introduces perception as a layer between the events and the onlooker.

These differences in pictorial mode provide a continuum along which the activities of the gods can be staged. J.P. Vernant and J.S. Clay have both pointed out that the gods are included in two functional systems: one is horizontal, concerning the distribution of their roles and spheres of influence, *timai*; the other is vertical or diachronic, and it embraces the chains of events in which they are involved or which they trigger by their actions, and whose subsequent course is determined by these actions.[25]

Since the birth of the goddess depicted on the pediment marks an exact moment in time, a beginning, each separate pictorial level – including the pediment – can be envisaged as representing an era or a phase in divine and human history. The highest level represents the time when mortals were still a mere impulse of the divine will, the target of the gods' deeds; the time when gods were born and their world was still changing. Although resembling mortals, these gods are – and can command – what men can never aspire to: they are born but do not die, or not at least as mortals do. In his genealogy of the gods Hesiod tells how the first divine rulers were destroyed – Uranus by Kronos and Kronos by Zeus. But the aura surrounding these gods suggests some primary element or principle rather than active beings, and in analogy with the cyclical workings of nature they are associated with the idea of return and rebirth.

In light of this theory of the history and functions of the gods, the pediment could be said to demonstrate the era of greatest generative and creative power among the Olympian divinities. Athena emerging triumphantly into life on this pediment is a goddess pre-eminently involved in the fate of mortals, supporting her favourites and crushing their enemies.

The next phase, which appears in the metopes, displays the first great struggles against alien and destructive forces – struggles which were to become emblematic. This is the heroic age when contact was still direct between gods and men, and the joint procreation of heroes was still possible, the time commemorated in the Homeric epics. Significantly, the Trojan war is one of the subjects depicted at this level.

But according to contemporary religious ideas the termination of this period was due, ultimately, to the original actions of the gods. The world of the frieze, and thus the world of Athenian society under Pericles,

belongs to the time which followed the 'heroic age' in this religious sense. Gods now no longer join with mortals in acts of procreation, nor do they reveal themselves to men. But men can regain heroic status through self-sacrifice in death; or they can seek contact through ritual with their divinities who are no longer directly accessible. In this last phase art appears in the mortal world as an instrument for establishing forms whereby the gods can be addressed, an instrument that stems for good or ill from the gods' own last great gift to man. It is also a medium that resembles the language – the signs – which mortals interpret as intimations of the gods themselves. Regarded in this light the almost incredible achievement of the Parthenon ensemble and the subtle figurative ornamentation of the temple frieze as a symbol of that achievement, seem to suggest that the creators of the Parthenon are inspired by a sense of beckoning heroic status, they are on their way to a renewed and direct apprehension of the gods.

Such a mythological view of history seems apt in relation to the Greeks. Clay describes a similar world view to underpin her interpretation of the Homeric Hymns, and it is her explanation of the intellectual world of these poems which has inspired my own general interpretation of the hierarchical structure of the Parthenon sculpture ensemble.[26]

Clay sees the inspiration for the hymns lying somewhere between the ideas behind the *Theogonia* and those that permeate the *Iliad* and the *Odyssey*. In the *Theogonia* Hesiod recounts the original causative events and internal struggles that ended in the assumption of power by the Olympian gods under the leadership of Zeus. In the *Iliad* and the *Odyssey* this power constellation holds more or less unrestricted sway, while the Hymns describe territorial conflicts and threats to the divine order. In the course of this struggle for supremacy in the immortal world, gods and men gradually draw farther apart in a process that began with certain events described in the Hymn to Aphrodite: Zeus decided to punish Aphrodite for exploiting her power over the other gods, condemning her to suffer a tragic passion for a mortal – Anchises, the father of Aeneas. The bitterness of this experience was the beginning of the end of the heroic age, when gods and mortals had been able to mingle freely with one another.

Hesiod offers us two versions of the Prometheus myth, another story that explains the separation of mortals from the gods.[27] In one version

Zeus punishes Prometheus for seeking to rival the all-powerful father of the gods in cunning, by stealing fire and giving it to man; in the other, Prometheus tricks Zeus by giving him bones covered with fat to eat at a feast attended by gods and mortals. In revenge Zeus withholds fire from mankind, but Prometheus steals it, hides it in the stalk of a fennel plant and gives it to man. In both versions Zeus sends Pandora to punish humankind – Pandora, false and fatal, a creation of the gods and the first mortal woman. Through her, toil and grief come to afflict the human race (i.e. men), as she opens the lid of her box and sets loose all the evils and diseases of the world.

The Homeric Hymns are thought to have appeared some time between the eighth and sixth centuries, and to have been collected together during the sixth century, possibly after some revisions and reinterpretations.[28] Like the texts of Homer and Hesiod they seem to encompass all Greek culture within their comprehensive embrace.[29] They offered a way of re-invoking the more heroic years around the beginning of the century (c. 500), the notion of Greek unity with Athenian dominance, as well as an instrument for defining relations between gods and men.

The Parthenon sculptures allude with great exactitude to the description of Athena's birth in the heroic hymns, clearly suggesting that the temple and the hymns represent a shared conception of the gods and the divine world. In a thorough and comprehensive analysis of the Parthenon pediments, Olga Palagia stresses the important role of the Homeric Hymn to Athena in the composition of the pediment on the eastern side.[30]

The world-picture of the Homeric Hymns can provide a pattern for my perception of the sculptural decoration. It can give an interpretive frame which is relevant to sixth and fifth-century Athens, and which connects the Hymns thematically with the sculptures through the 'Birth of Athena' theme as presented in the pediment space (always assuming that Pausanias' identification of the subject is correct).

The pattern provided by the Homeric Hymns arrange the sequence of the sculptures – pediments, metopes, frieze – in an hierarchical order as a scale indicating time, value, existence and accessibility. The pediments show beginnings, the gods come into being, live and exist in their own realm. The metopes are devoted to the heroic era. In the frieze the humans re-approach the gods, indirectly through the medium of vision and by way of rituals, invoking the presence of the gods.

In the relationship between the different worlds of the Parthenon sculptures I perceive not only a separation but also an overlapping, as though every level were reflecting the levels next to it. In seeking to get closer to the feeling of such a world view which this would seem to betoken I shall now turn to some passages from Plato for comparison.

In Plato I find a reflective consciousness very close in time to the Parthenon age. I cannot claim that Plato's thinking is representative of Athenians in general around 400 BC, or that it accords with that of the Parthenon artists. Nonetheless I do perceive significant similarities in the creative mental structures, in the way a hierarchical cosmos is established and the different levels in the world are then allowed to illuminate and penetrate one another. I am not setting up this comparison between Plato's texts and the Parthenon sculptures in order to try to 'fit' the artefacts to the philosophical texts, but simply to be able to observe correspondences or divergencies.

The Parthenon sculptures and Plato's philosophy resemble each other in the following ways: 1. the notion of a coming-into-being, of a gradual realisation, in contrast to states of being, 2. the tensions between impressions and knowing, in both cases as faculties involved in visual experience and visuality, and 3. the sense of reflection and interaction within a hierarchical system.

The evolution of Plato's philosophy belongs to a period some decades later than the building of the Parthenon. Owing to the disasters of war and Athens' crushing defeat in 404, life in the society which Plato knew was quite different from life under Pericles. However, Plato himself refers explicitly to the period immediately preceding his own, mainly by adopting Socrates as his chief player, and sometimes by letting Socrates and other people remember events which took place even further back in time. But he also challenges the systems of ideas which had been the great intellectual adventures of the Periclean age, namely the theories of Protagoras and Anaxagoras, as well as the earlier speculations of Heraclitus and Parmenides.

While Plato's philosophy sees the highest level of being as entirely

immaterial, the gods in the Parthenon appear in corporeal form. Plato proposes a metaphysic beyond traditional mythology and beyond any doubting of the gods: as an expression of the highest reality there seems to be little fundamental resemblance between the Olympian gods and Platonic Forms. Nonetheless Plato uses the idea of the Olympian gods as a simile for a reality which cannot be visualised directly and as part of the cosmogony he describes in the *Timaeus*. At a Panathenaic feast he lets the visitor Timaeus of Locri tell how a first creator, or Demiurge, gave shape to the immortal gods on the model of eternal Being, and how they then created the rest of physical reality, which encompasses time, change, cyclical movements and causal chains.[31] The gods, as the first creation, are imbued with life of a higher potency: the more potent such 'life', the closer it is to immutable Being. According to this story of the Creation, 'life' precedes any other coming-into-being, as the soul precedes the physical constituting of the human body. In the *Phaedo* it emerges from Socrates' conversation with his disciples a few hours before his execution, that the dimension of the Forms is pure life with no admixture of matter, which is subject to corruption. Thus in Plato's analytical structure and in the religious world view which might have been relevant to the Parthenon artists, the highest level constitutes in some sense a pure life force.

The lowest section in Plato's hierarchy of reality, the one facing towards the here and now of human life, consists of all impermanent combinations of qualities which are designated by the term 'Becoming'. The certainties available to men are generally beset by shifting sensory impressions, rhetorical caprice and forgetfulness. All search for knowledge is exposed to obstacles and obscurities. The 'sight' of pure knowledge is obscured (Plato speaks of apprehending pure knowledge 'visually' in the *Symposium*). Thus, characteristically, the visual image is charged with two opposing values. One is negative in the sense that there are obstacles (obliqueness, changes in viewpoint, the lack of clarity induced by distance); the other is positive, in metaphorical mode, referring to the highest insight – the final stage on the way towards the dimension of Forms, described in the *Symposium* as the beholding of overwhelming beauty (210 E – 12 A).[32]

Plato's sensible world and the human content of the frieze both invoke a sense of fluid visual impressions, a code which intimates a state of

tension in relation to a more perfect existence. However, Plato's ambivalent attitude towards the visual sense is not reflected in the frieze, whose pictorial invocation of the gods expresses confirmation rather than acknowledgement of obstacles – despite the distance between men and gods. Rather, the affinity with Plato's world view and his aesthetic consists in the perception that the making of 'pictures' admits to boundaries while also transgressing them.

It is often claimed that Plato's philosophy condemns pictorial art, and the *Republic* is called in evidence. Here Plato presents his programme for education in the ideal state, and includes a powerful albeit slightly ironical rejection of material images (I assume that he is referring mainly to paintings and drawings when he speaks of *skiagraphema*, *zographema* and *eidolon*), i.e. pictures claiming to reproduce sensory impressions.[33] Making these pictures is like holding up a mirror and then believing that one has created something: with the reflection of real things, it is possible to deceive those of little discernment that the actual objects are present.

Quite different aspects emerge if instead of focusing on material pictorial objects we consider 'pictorialness' (the actual picture-object relationship) in the highly intellectually charged concepts of 'likeness' or 'simile' (*eikon*) in Plato's philosophical world view. The value of a representation depends entirely on the nature of the model and the proximity or essential likeness between picture and model.

The 'picture' executed by the first divine creator, when he brought the immortal gods into being on the model of Eternity, bears the stamp of beauty, or so Timaeus (Plato) says in his account of the creation of the world.[34] The resemblance between picture and model is what constitutes the link between them. The more fundamental and essence-revealing the resemblance, the more enlightening and knowledge-generating the picture, if the model is something that exists in reality.

It is just this resemblance aspect which makes the 'picture' or the phenomenon of likeness interesting to Plato, as it provides a field or stage for philosophical reflections. Something which is related through resemblance to something else – an original – can never be identical with that original. If it were, there would not be a picture and a thing depicted;

150

there would be two originals.[35] Resemblance implies both closeness and separation.

Plato conceives a system of analogies in the structure of the world, which calls for a corresponding ascent through a hierarchy of image-reality relationships on the part of those seeking knowledge. As a philosopher Plato is ambivalent about the effective power of the visible image. On the one hand he acknowledges the philosopher's ability to arrive at direct knowledge of the truth by pure analytical thinking (*logos*). At the same time he always returns to the obstacles that occur so long as we, or our thoughts, are bound to the body. 'Pictorialness' is an expression of this obstacle, but it is also a sign of the fundamental human condition that is ours for good or ill: pictures and pictorialness set our thoughts in motion, arouse our desire to seek knowledge, activate our memories. He even goes so far in the specificity of his pictorial language as to denote the first abstract creator in *Timaeus* by the term used for craftsmen in general, namely *demiourgos*, i.e. one who makes an object (a statue, a vase, a shield etc) by the work of his hands.

'Resemblance' is one of the key grounds for man's conception of the world, and even the philosophical analysis of logical disputation is an approximation. Knowledge needs similes. Now and then stories or visionary narratives occur in the Platonic dialogues, used to explore or elaborate the argument.

It is not that philosophical dialectic and similes present alternative routes to the truth; rather, they complement one another. Even Kebes, the most philosophically sophisticated of those who remained with Socrates during his last hours, accepts that he has a child within him who needs reassuring when he feels afraid of *Mormolykeia*, the legendary witch.[36] Logical argument does not reach the 'child' in us: we have to perceive with our own minds the insights embedded in the relevant similes.

In the *Republic* Plato demonstrates the relations between the different levels of reality, illustrating his philosophical ideas in a variety of models and metaphors, among others the model of the Divided Line: the 'intelligible' world, about which we can acquire knowledge through pure cognitive activity, is separated by a clear boundary line from the material

world, which we perceive with our senses. On each side of this line there are two levels, making four subsystems in all (see table, below).

Plato's 'Divided line' (*Republic* 509–11).
(The symbols introduced are mine)

	The world	Knowledge
The intelligible world, attainable by reason; *noeton*. The form of the Good rules F + a1	F = Forms, represented or depicted by a1.	This is where *logos* or *nous* operates. The thinking person assumes *hypotheses* and is elevated, through *dialectics*, to the ultimate premises (511A).
	a1 = the 'concepts' (measurements and conceptual features of the things in a); a1 functions as 'pictures' of F, thus in the same relation to F as b to a.	This is where *dianoia* operates. The thinking person examines the geometrical principles of the things; conclusions are inferred from hypotheses.
The seen and felt world *horatón*. The sun rules a + b	a = men, animals, plants etc., represented by b.	
	b = pictures (*eikones*)- water reflections, mirrors, shadows.	This is where *aisthesis* works − sensual impressions and habits

Comment: a1 and a are equally long; they are parallel, but in different relations. The following relational analogy obtains:

$$\frac{F/a1}{a/b} \text{ is analogous to } \frac{\text{knowledge}}{\text{Doxa (= assumptions opinions)}}$$

152

Plato distinguishes between objects, e.g. houses or plants on the one hand, and shadows or reflections of them on the other; their relation lies in the lower half of the Divided Line which separates levels of reality; he then distinguishes the objects from the concepts, such as those of geometry, under which the objects *can* be subsumed; these concepts are in turn distinguished from some ultimate ideas under which all things are *necessarily* subsumed and in whose light alone they are fully understood. There are two crucial issues in the present context of the Parthenon: the levels of intelligibility or reality overlap and the final level is grasped only indirectly through images like that of the sun as an image of the Good.

The significant resemblances which I see between the Parthenon sculptures and Plato's philosophy are associated with the following: in the hierarchical order which is reality, there is a deep fissure (between the Forms and the sensible world, as between gods and men); on both sides of the Divided Line, relations become more intensive, projecting across the borderline in a kind of mirroring of likenesses, so that the same phenomenon can appear on one side or the other but in different modes or with different functions.

In analogy with the Divided Line model the Parthenon sculptures could be read as follows: close to the boundary that separates the heroic dimension from the human, the same kind of beings appear – enhanced at the higher level by contact with the divine world. Through the historical link, the causal chain, men retain something of the heroic and the divine. Reinterpreted as essential symbols of their kind and their society, the Athenian citizens can be projected as 'pictures' of the divine impulse that was once their origin.

Similarly the gods appear on both sides of the divide: as 'real' and as 'reflected' (or 'thought of', 'imagined'). The gods of the frieze are not picturing the gods of the pedimental world – but they must be comprehended as figures 'caused' by these 'real' gods.

A further resemblance between the sculptures and Plato's philosophy can perhaps be seen in the conception of the connections between the different levels of reality: the combination of a pictorial relation and a causal relation is what links the world together and guides understanding. The following is a cognitive pattern which could apply to the temple decoration: mortals are 'caused' by the gods and their link with this

creative power is maintained through the medium of pictures; Plato's philosophy claims that things in the sensible world are 'caused' by the Forms, and that through a system of pictorial images we can comprehend something at least of these connections.

What does this comparison do to help our understanding, apart from telling us that similar signifying structures occur at roughly the same time in roughly the same cultural area? The relation between the temple decoration and the pattern of ideas informing the Homeric Hymns seems to explain something about the religious motivation and power-political considerations. The analogy between Platonic philosophy and the sculptures, however, is of a different kind. It provides no explanation of the votive gift as such, but it helps one to experience the actual mechanism in the pictorial relationships — the mechanisms of an existential divide between picture and model and the thrill of the 'resemblance' in the area close to the border itself.

Common to both Plato's similes and the sculptures is the notion of the visible. This area — the realm of the frieze in the sculptures and the *horaton* (the seen) in Plato's system — has a double meaning and a double value: it is a secondary kind of reality, vulnerable and shifting like the life of man. And yet it holds within itself the traces of its causes; it sets us out on a search for another ultimate dimension, beyond the visible; it is the only means available to man for embarking on this endeavour, this quest for knowledge.

What can be said about the value of an effigy that looks exactly like a living being, but that is actually made of stone? What would Plato have said about works such as the pedimental sculptures? Would not they have caused much more trouble in moral terms, since they deceive us even more than two-dimensional images which imitate nothing but impressions? Plato's condemnation of pictures imitating impressions is really aimed at the model: such pictures are bad because their models are bad, and they deceive us. A three-dimensional figure derives from a less defective model and must be of a superior kind, despite the disappointment it may cause a beholder who takes the imitation for the 'real' thing.

The foundation of such evaluations in Plato's philosophy can be found in his ideas about the way things 'partake' in the Forms. For something to be essentially an element of the created multidimensional world, and to be represented without the fundamental features of that creation (or the 'thoughts' determining it), means that the thing concerned is being

deprived of its defining characteristics. Thus, full-scale three dimensional images alluding to living bodies pay greater tribute to the actual causes of living bodies than two-dimensional pictures: they 'show' more of the shaping Form in which the sculpture and the body can both be said to partake.[37]

There are paradoxes in Plato's philosophy: concepts and mathematical proportions can reflect the eternal Forms, although these Forms have neither quantity nor connections. We might wonder whether the 'pictures' can really resemble their models. But Plato reinforced the link between the sign and the thing signified by referring continually to signs which have a natural basis (they are not 'conventional', but are 'motivated', to use modern linguistic terms). Conversely, the representational system is a causal system. Plato is mainly concerned with the pictures which nature paints herself: shadows, reflections in the water, the glow of material colour – effects caused by natural phenomena.

The special emphasis on the creative power of natural light in picture-making is an effect of such a merging of signifying functions: cause combined with depiction. Plato returns time and again to nature's own capacity for making pictures. Is the effect of the sunlight on the Parthenon sculptures a similar bearer of meaning? After all, at the original location, light and shadow endowed these figures with form and expressive qualities. The Parthenon sculptures are no longer part of the temple, so I can only try to imagine the effects I have outlined above as elements in the expression of the pictorial world of the temple façades. I am referring now to the powerful impact which light and shadow must have had on the interaction between the different parts of the decoration. The effects must have been astonishing: the projecting elements in the pediment sculptures catching the light and throwing deep shadows; in the frieze the abrupt switches between direct light and reflected light in the chunks of shadow cast by the colonnade. The varying degrees of three-dimensionality probably affected the meaning of the figures, as the many optical adjustments certainly did. In all these cases the natural lighting would have added greatly to the effects.

THE PARADOXES OF ART

The explicit similes or myths in Plato's texts also tell me something about contemporary taste as regards the 'look of things'. Plato conjures up visual

images to encourage his listeners in their understanding of the philosophical stages which could lead them up through increasingly immaterial levels, and in so doing he provides a sample card of attractions in the physical world. This taste can no longer be clearly discerned or identified in Greek art as it has come down to us – damaged, displayed in museums, and surviving only as fragments. What we see among these remnants is hardly representative. But Plato must have been referring to pictorial perceptions which were widely experienced, or he would not have been able to claim that he was speaking to the 'child' in his listeners.

The description in the *Phaedo* of the world and of the underworld and all its rivers, is just such a powerfully pictorial simile, and it gives us some idea of how Plato and his contemporaries valued different sensory impressions or visual qualities.[38]

The earth (*ge*) is located in the middle of the sky; it is 'pure', round and in perfect equilibrium, surrounded by the 'ether', the finest and most transparent of the layers of air. We humans live like frogs and ants by a lake, close to the sea; we live under the surface of the water in the dips and crannies of the earth, and everything that we see is perceived by us through the refractions and reflections of the water.

The details of the simile are then painted in: to see the sun and the stars through the surface of the water, to live in the hollows and yet to believe that we live on the surface of the earth, to claim that our eyes are gazing directly upon the sun and the stars – all this is *as if* we lived on the surface of the earth and saw the sun and the stars and then believed that we knew the nature of the highest things (in the simile the ether symbolises the intelligible world).

As in the simile of the Divided Line, the 'normal' dimension of our knowledge – the perception of things, phenomena and connections in earthly life – appears in two versions in each half of the analogy: what is truth behind the error in the first state becomes the face of the error in the second. In order to shake the foundations of knowledge based on observation, Plato fills out his world-picture with the story of the underwater life and the real target of his philosophising – namely the Forms, symbolised by the transparent ether.

What, then, is so repugnant about this underwater life? The world of the deep is full of mud and filth; there is no plant life worth mentioning, for there is too little light; sensory impressions of all things above the

water are continually distorted by the surface; colours are not clear, but fractured and unstable. The world of the earth's surface, undistorted by the underwater view, appears from a distance like a leather ball, stitched together from motley scraps or fragments of coloured material. But the ethereal world consists of the colours themselves – that is, not just imperfect examples of colour.

This picture of the ethereal world is supposed to encourage us to envisage the beautiful, the true and the good in our imagination. So how does Plato go about persuading us to 'gaze like children' upon the highest things? The ether is everything that the underwater world is not: it has purity and clarity, its colours are more numerous, more beautiful and more distinct, and include even purple, gold and a whiteness surpassing that of chalk or snow; trees, flowers and fruits are more lovely here, and more diverse; mountains and rocks are smoother, more translucent, their colours more beautiful. Precious stones in our world are deceptive examples of the infinitely purer and clearer models of the highest world, where the ground is studded with jewels, silver and gold. There, such materials are not concealed in the rocks but are visible in all their multiplicity and abundance. The seasons are milder, health is better; sight, hearing and wisdom more sublime. In the holy places the gods are truly present and men can speak with them; the sun, the moon and the stars can be seen as they really are.

From this and other similes so vividly rehearsed by Plato, I derive a catalogue of valued visual qualities, testifying to a zest for life and fertility, to anything in fact which can be qualified by the Greek prefix *eu-* (roughly 'well-'), i.e. objects and appearances naturally expressing a happy disposition, a good character, a vital force; they partake of the Forms, not arbitrarily but by revealing the dimension of the Forms as a clear skin reveals health. It is just such self-evident natural expressive qualities which constitute the ideal picture. The description of the overflowing abundance of vegetation in the ethereal world is a typical example of this. Plant-life stands for genuineness; it conveys what is real rather than merely signifying it (a picture that actually extinguishes itself and merges with its own original). Like 'appearance' in a picture this quality reveals itself in many indications of naturalness: the ideal picture does not deceive us, it is not false; it is unambivalent and lucid; it is allied with the quality which Plato advocates for his ideal state under the designation *euetheia*, whereby

157

everyone does one thing, has one clear will and mission, and becomes identical with his own actions.[39] In the vision of the ether the idea of real gods in temples, in real confrontation with mortals, signifies this ideal.

Thus, as the chosen criteria of beauty, we have:

Multiplicity: paradoxically the lavish abundance of plants, stones etc in the highest world is the 'picture' chosen for the undifferentiated unity of the Forms.

Many colours – clear, distinct and intensely luminous.

Soft, smooth or transparent materials, whose shining surfaces are the primary signifiers.

Clarity and lucidity: no fractured perspectives, nothing ambivalent or obscured.

Are there traces of this aesthetic in the Parthenon decoration, perhaps more scattered and conceived in a more general way, and appealing to many beholders? The luminous material and strong colours are no longer visible, but were originally much in evidence. The smoothness of Helios's neck still offers a faint idea of the treatment and 'finish' of the surfaces. The oblique angles of vision and the partly obscured sections in the decoration seem to contradict the aesthetic ideal outlined above. For the ordinary visitor to the temple much of this brilliant pictorial world must have appeared elusive.

However, this judgment applies only to the exterior decoration. There must have been a dazzling contrast between these effects and the impact on the contemporary observer entering the cella or standing before its entrance, where the colossal statue would appear to be towering above him – impressive, clearly visible, yet shimmering in the semi-darkness of the room, a revelation (fig. 45).[40] Early in the morning, when the cella was filled with the first sunlight, the impression must have been one of blinding light.

The colossal statue is utterly remote not only from our perception (since it has vanished completely), but also from our understanding; it is just as foreign to us as the bright and colourful qualities Plato chose to symbolise the ethereal world were to the 'classically' trained taste of the romantic tradition, with its emphasis on pure form and the principle of contrast and synthesis.

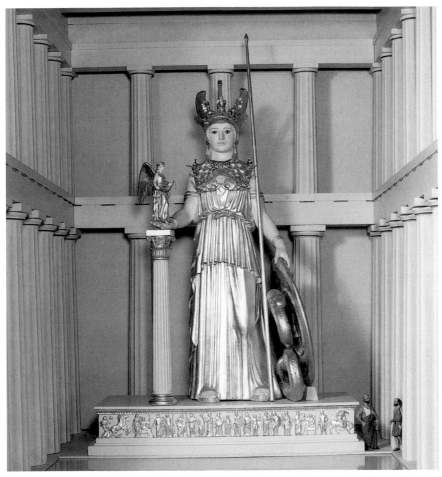

45. Reconstruction of the gold and ivory colossal statue. Toronto, the Royal Ontario
Museum.

Reconstructions and copies show me rather a stiff and stylised figure,
overloaded with the attributes of divinity. I simply do not understand it.
It is noticeably more ungainly than the other sculptures whose remains
I can still see. But to fifth-century Athenians this was the jewel in the
crown, the miracle-worker which induced amazement and rapture in all
beholders.

159

Let me nonetheless try to imagine something of its impact. This statue, too, must have been 'painted' by the natural light, particularly by the contrast between the sunlight outside and – once morning had advanced a little – the shadowy but shifting twilight in the cella. The surface of the water in the basin before the statue would reflect the shiny facets and details of the goddess's form in a sparkling display of rippling light. Here we find assembled just those qualities which Plato invokes as he paints in words the path to the supreme value: brightness, reflections from the natural play of light and shadow, luminosity, tiny points of transparency, strong distinct colours, the glitter of gold, a shining whiteness. The straightforward frontal stance and the candid display of symbols also seem to accord with the desire for clarity in both appearance and meaning: here is a goddess who does not deceive, who is identical with her own partisan actions and thus also with their effects. The goddess speaks 'clearly' and informatively through her attributes: in her right hand she bears a golden Nike holding the laurels of victory; she has griffins, deer, a sphinx and two pegasuses on her helmet and visor; the great victories (over giants, Amazons and centaurs) are depicted on her shield and tunic.[41]

Her size was prodigious, her radiance overwhelming. Enamel, gold, ivory and precious stones added to the splendour and perfection emanating from the technical virtuosity which had created her. She was the ultimate triumph of artistic skill. Those who beheld her must have thought: 'This is how the goddess looks – superhuman, immortal, just as she is described among the Olympian gods'.

The statue could be said to possess considerable realism, in its expression of the nature and exclusive 'apartness' of the gods. Even so, the Athenians knew that the goddess herself was not present in the colossal statue; she was in the old statue of olive wood. Thus it was not Athena's *ousia* or true being which the new statue signified. Or was it, as well as the other qualities? How did it all tie up?

Many myths have grown up around the idea that mortal eyes cannot endure the sight of the gods. Semele, mother of Dionysos, gazed upon Zeus and was scorched by his thunderbolts; Anchises almost lost his strength on meeting Aphrodite; Kreousa looked at Apollo's radiant face and was forced, against her will, to submit to his violent passion; when Teiresias happened to see Athena naked, she punished him with blind-

ness; and for the same crime Aktaion was transformed by Artemis into a deer and was torn to pieces by his own hunting dogs.[42]

However, the olive wood statue was apparently so insignificant and formless, resembling a natural object more than anything else, that the goddess could be present in it without any risk to mortal beholders: it contained Athena's being but did not reveal her appearance. A god's being is not as threatening to men as a true epiphany. As conceptual objects or facts in the structure of the world, the gods can be classified as principles or causes; as sensory perceptions they approach the existential boundary of the mortal realm. Close to this boundary, and within the dangerous zone where the border might inadvertently be crossed, the turbulence increases and the powerful forces become physically perceptible. In the imaginative world of the pediments these pressures on the barrier to the physical and perishable nature are sensed together with a recognition of restlessness, in the figures of the horses of the Sun and the Moon (plate IV).

If on the other hand the goddess's appearance is 'translated' into an object of art, then it becomes possible to approach and apprehend it. The divine appearance is never more than an approximation, a translation, or an image. At the cost of not being allowed to perceive Athena's essence through direct contact, mortals could come as close to the boundaries of her appearance as they had ever come before. Only as regularised legendary figures or artistic images could the gods once more be apprehended and touched by mortals.

According to the world view of the Homeric Hymns, which I shall now extend to apply to the Parthenon sculptures, man's inability to endure the sight of a god is the result of a separation. At the moment of the separation between gods and men, Zeus sent Pandora to 'punish' mankind, according to Hesiod's account. The name Pandora alludes to the fact that this woman was composed of gifts from all the gods. But, in particular, it was Hephaistos who formed her lovely body at Zeus' command, and Athena who endowed her with her handicraft skills and her beautiful raiment.

Pandora is the supreme symbol of the arts. She is a punishment, since she confirms the irreparable distance that has come between gods and mortals, but she also brings into our narrow and toilsome human lives

the allurements of beauty and a restless seeking. Since everything about her derives from the gods, she bears within herself traces of their essence; at the same time, however, she is ambivalent, and has something of the illusory quality of pictures which conceal while they reveal.

To Hesiod Pandora is also all living women, who were thus not created like 'mankind' at the beginning of time, but arrived as a secondary species at the time of the separation. According to this myth woman is not a real being; she is a construction. Indirectly this testifies to the way 'existing' women were rendered less visible than 'existing' men; their lives were determined as a product of social customs and traditions, which were subsumed under men's communication with each other and the regulation of male power. The very idea of 'woman' implied a structural duality, consisting of one visible and possibly illusory side and one unknowable and unarticulated.

Pandora is represented on the base of Athena's colossal statue, and the struggle against the Amazons appears on the outside of the goddess's shield. Other fundamental struggles, recognisable from the pictorial motifs of the metopes, reappear here as decoration on the statue. But now there is undeniably an accumulation of themes all revolving round the female identity. Who or what is this creature, known indirectly through symbols, who can be blamed for the sorrows of life, to whom one can turn for protection – is she enemy, ally, ornamental object, snare and/or a chance of happiness?

'Woman' is not being equated here with 'divine'. Nor have recollections of a prehistoric mother goddess become institutionalised. Rather, it is implied that women, like the gods, were beyond epistemological reach; they could only be understood through signs that were articulated with varying degrees of success. Since a female god was to be worshipped and represented in the temple, the two tracks of existential speculation cross one another here.

It could also be said that art itself is being apostrophised in the themes of the colossal statue, but according to Hesiod art and woman are the same thing. For anyone approaching the statue the Pandora scene would appear at eye level. Pandora recalled an acute situation: distance, punishment, the conflict between delight and fear, hard and dangerous conditions and the wretchedness of human life. But she also confirmed that her gift was a kind of compensation: skill, and particularly skill in

handling cloth, was a condition of survival largely in the hands of women: the warrior may defeat the enemy with his weapons, but he needs a cloak if he is not to freeze to death. Pandora had knowledge of handicrafts, a gift she received from Athena. Thus the art of manufacturing cloth is rendered symbolically no less than three times in the decoration: in the Athena statue itself, in the Pandora theme and in the mantle scene on the frieze.[43]

The colossal statue can be seen as an attempt to approach the goddess by depicting her appearance. However, bearing Plato's theory in mind, we know that however consummate the rendering may be, it can never be identical with its model. The closer the picture comes to the boundary that separates model and image from one another, the more powerfully the boundary imposes its presence. The statue, which claims to reproduce the goddess's form, should help to bridge the distance between mortals and gods, but instead confirms it. The epiphany remains a translation and is thus accessible to human perception, even after men have lost their closeness to the gods.

Has the direct link, then, not been re-established at all? Is the contact which once persisted in the olive wood statue – albeit less clearly articulated and less accessible to the probing curiosity that characterised the epistemological thinking of the time – still impossible?

I will let this question rest for the time being, and put a similar question to myself instead. Has any link or understanding been established in the course of my long reflections upon this remote and ancient period and its imagery? It has been an existential journey during which I have come to recognise that my possible moves in the game are conditioned by this pictorial world, at least as much as the participants in the frieze procession were conditioned by their gods. The task has aroused aggressions in me and feelings of compulsion. I identify a picture of the feminine as a contrasting force, working through silence, manipulation and ambiguity, and eroding the manifestations of the taken-for-granted sovereignty of the creative male subject.

But against the distress of this compulsion I have experienced a sense of release in confronting a quality of expression which evokes not repose and harmony, but continuing reflection – a process that has not yet ended but remains in a state of becoming. What is being formulated here is being formulated for the first time, complete with all the doubts which have

persisted throughout history like shadows cast by the sun. My own link with this ancient conceptual world is primarily one of conditioning, not of unmediated empathy or understanding. The causal mechanisms are still operating, and they are being 'idyllised' or obscured by the innumerable idealisations of harmony. Many scholarly interpretations of ancient works of art are guided by a desire to reveal what was there and to conceal or deny the beholder's own reactions. But even then – the impact of the impressions can still be felt in the analysis, elusive, partly beyond the reach of the reflecting mind. It seems to me that the quality of our knowledge of ancient art would gain from a rejection of this denial. My idea is not that we should give free rein to subjectivity, but that we should explore and analyse the 'beholder's share' in scholarly interpretations. The explicit questioning of the relation between the beholder's experiences and the experiences inherent in the work of art may be able to sharpen the contours of the 'lost' and 'alien' meanings of the image.

And so I return to the question of the link between Periclean Athens and the goddess Athena. It has been repeatedly claimed that the city, the community of Athens, was the real 'meaning' of the goddess; that the two were interfused by their shared essential qualities, and the association was thus given. And yet I perceive in this great temple building and its figural decoration a picture of confirmation and eager self-assertion, combined with a self-reflection which demanded the clear exposition of its conditions – conditions which included the separation between mortals and gods. The sculptures seem to be born of a great surge of creative power, as an invocation to the gods and an invitation to a renewal of the meeting between gods and men. The Athenians created this invocation exactly when it was needed (their empire was threatened), and while they still believed in the possibility of success (they were still masters of the Greek world).

The Athenians may have been putting their trust in the existence of natural ('motivated') signs. Such a belief would have been close to the spirit of Plato's 'visions'. Although always suspicious about the possibility of 'looking' at truth, Plato acknowledges valuable 'pictorial' relations, whereby the gods are 'pictures' of the Eternal being or the concepts are 'pictures' of the immutable Forms. If the colossal statue had been a natural sign, the boundary would have been close to breaking, the link almost re-established. But only almost.

The possibility remained of denoting just this goddess with the help of skilfully executed artefacts, while simultaneously claiming that the depiction did not constitute the being of the 'real' goddess. Athena's *time* – the area over which she held sway – was art and artistic skill. Thus to create a statue that surpassed all others by exploiting the artistic gift granted by the deity to her people, could be a way of reaching out once more to the very essence of her being, of demonstrating the realm in which man was truly able, without the risk of suffering, to regain eye contact with the divine.

NOTES

ABBREVIATIONS

AJA *American Journal of Archaeology*
ARV Beazley, J.D., *Attic Red-Figure Vase Painters*, 2nd edition, Oxford, 1963
BICS *Bulletin of the Institute of Classical Studies of the University of London*
JHS *Journal of Hellenic Studies*
Jd *Jahrbuch des Deutschen Archäologischen Instituts*
LCL Loeb Classical Library
LIMC *Lexicon Iconographicum Mythologiae Classicae*, Munich and Zürich, 1981–
RE *Realencyclopädie der classischen Altertumswissenschaft*, eds A. Pauly, G. Wissowa, W. Kroll et al., Stuttgart 1893–
TrGF *Tragicorum Graecorum Fragmenta*, ed. A Nauck, Leipzig 1889.

I APPROACH

1 These impressions are based on observations in the spring of 1993. When I returned to Athens the following spring, the horsemen frieze had been removed for examination and treatment as part of the conservation project.

 The dimensions of the sculptures are as follows (based on information from the British Museum, from Palagia, and Brommer):

 The frieze is 0.99m high and was 160m long, when it was on the temple, the width of the slabs varies.

 The east pediment: figure B (Helios' horse) is 0.89m high; figure D is 1.32m high, the approximate length is 1.80m; figure E is 1.21m high, figure F is 1.37m high; the seat of E + F is 1.41m in width; figures L + M are carved in one block, 2.33m in width (originally probably 2.50m), the maximum height is 1.24m; figure O (Selene's horse), total height is 0.62m, height above pediment base is 0.50m.

 The metopes are 1.32m in width and 1.33m in height, and the maximum depth of the relief is about 0.21 to 0.23m.

2 Thomas Bruce, 7th Lord of Elgin, was British ambassador to the 'sublime Porte of Selim III, Sultan of Turkey' from 1800. In 1816, having purchased the sculptures from the Turkish government, he submitted a petition to the House of Commons, requesting a Select Committee to investigate the terms of a sale of the sculptures to the Government. For further reading, see Cook, pp.53–70 and St Clair. For detailed information about Parliament's acquisition, see Smith and Rothenberg. There are fragments in some other museums, in the Louvre in Paris, in Vienna, Heidelberg, Palermo and Rome. There are casts showing some figures in a better preserved state, particularly in London, in Paris, in Athens and in Basel. For detailed information see Jenkins, 1994, Palagia, 1993, Brommer 1963, 1967 and 1977.

3 Some of the work on identifying motifs and the original appearance of the sculptures is supported by the relatively amateurish documentary drawings made in 1674, presumably by Jacques Carrey, for the Marquis de Nointel. The drawings belong to the Bibliothèque Nationale in Paris. The drawings document the condition of the sculptures before the explosion in 1687. See Bowie & Thimme (eds), 1971.

4 It is only possible to guess at the motifs here; the sole source of identification is Carrey's drawings. The figures on south metopes 19, 20 and 21 seem to be women; and a statue appears on south metope 21. Osborne, in Goldhill & Osborne (eds), 1994, pp.69–70 interprets the scenes as a Daidalos theme. Other interpretations have been suggested by Harrison, Simon and Castriota (see Castriota, 1992, pp.158–64 and pp.288–90); the interpretation suggests that the central part depicts the story of Ixion, Peirithoos' father, well known in Attic drama and vase painting. Ixion was motivated by strong desires – erotic and covetous; he represents violence against *sophrosyne*, the rules of *xenia* and violation of the social order.

5 In memory of their confrontation a feast was held on the 2nd Boedromion, but in literary form the myth is not recorded in any great detail. References in Herodotus, VIII, 55; Plato *Menexenus*, 237 D; Pausanias, I.XXVI.5 and I.XXVII.2. The relation between Athena and Poseidon was re-enforced in cult practice: the Eteobutadai tribe provided not only Athena's priestess but also a priest for Poseidon/Erechtheus. LIMC, IV, 1, 1988, p.923. As for the identification of the rest of the figures, there is general agreement that Attic heroes and their families are 'spectators'; figure B with a snake is identified by practically all scholars as Kekrops, the mythical hero king. A reference contemporary with the Parthenon (Xenophon, *Memorabilia*, III, 5, 9–10) mentions that 'Kekrops and his people' decided the victor in the fight between the two gods; a much later tradition connects this judging function with institutional restraints on women and the 'burdens' of marriage, since the women had outnumbered the men by one voice and had voted for Athena, and the men then stripped the women of their original rights in order to appease Poseidon's wrath (Varro, in Augustine, *City of*

God, XVIII, 9). These references are given in Castriota, 1992, p.146. Castriota sticks to his misogynous reading, associating it with the theme of the Amazon war, on the same side of the temple. Such an interpretation underlines the symbolism of the social institutions in the shaping of Athenian power, rather than the recurrence of the struggle pattern originating in the fight between the gods. This other line of interpretation (i.e. the ongoing rivalry) for the west pediment is adopted by Stanley Spaeth, 1991: she supposes that the figures on the left flank behind Athena are Athenians, including Kekrops and Erechtheus among others, while the ones on the right behind Poseidon are Eleusinians, including Eumolpos; the relevance of the story is attested by Euripides' play *Erechtheus* (fragment); the theme would still be the unity of the Athenian land, the *synoikismos* and the struggle for dominance as the condition for 'Athenas children'.

6 Robin Osborne, 'Framing the centaur: reading fifth-century architectural sculpture', in Goldhill & Osborne (eds), 1994, pp.52–84 (on the identity reflections, especially pp. 76–7).

 Castriota, in his analysis of the metopes, stresses that all the antagonists of the Greeks are definitely 'enemies', and that they all reflect the Persians. In identifying the central section of the south metopes (see note 4) as the story of Ixion, however, Castriota gives too little emphasis to the fact that Ixion, who is the genealogical cause of the Greek party (being Peirithoos' father) is also the genealogical cause of the Centaurs, since in his excessive sexual desire Ixion begat Centauros on the cloud-like Nephele, an artificial 'goddess' created by Zeus. Castriota, p.290 and note 74, referring to Simon, Knell, Berger and Gauer, who stress internal Greek conflicts and moral issues rather than sticking only to the Greek-Persian conflicts. Another point about Ixion, relevant to the Greek reconciliation theme, is that he was purified as a suppliant at the altar of Zeus from the guilt of having the blood of kinsmen on his hands.

7 Regarding the Trojan 'palladion' in Athenian culture – as manifest in vase painting – see J.B. Connelly, 'Narrative and Image in the Attic Vase Painting: Ajax and Kassandra at the Trojan Palladion', in Holliday (ed.), 1993, pp.88–129.

8 Herodotus I, 3; Thucydides I, III.

9 I. III. I. Translation Charles Forster Smith, LCL, 1991 (first published 1919).

10 In Herodotus' historical account the war against Troy is a precondition for many later conflicts and its events are certainly accepted as having occurred. The Trojan war is one of a series of causes with the common attribute of violence against women, including rape. Further, Herodotus (I.3 – I.5) saw the Trojan war as the principle cause of the enmity between Persians and Greeks, which accounted for the main heroic conflict of his own time.

11 Castriota, 1992, pp.138–43, shows that the Lapith-centaur theme as well as the wars against the Amazons and the Trojans are part of the established

iconography associated with the war against Persia, while the *gigantomachia* refers more explicitly to Athena, and beyond her to Zeus.

12 There are examples in Parthenon scholarship of evaluations expressing nineteenth- and twentieth-century taste and aesthetics, for instance an appreciation of figures satisfying the idea of a dialectic contrast developing into a synthesis, and there are examples of 'reading' nature metaphors into the expression of the sculptures. Cf. Chapter 2 notes 155 and 156.

13 The building foundations on the south side were widened in Archaic times. Tölle-Kastenbein, p.52.

14 In or near the old temple there were sacred areas for several gods, including Poseidon and the Attic king Erechtheus, hero of the Butadae tribe. Erechtheus is mentioned in the *Iliad* (II.546–51) as being reared by Athena, a son of the Earth, with a place of worship 'in' Athena's own temple; Homer also says that Erechtheus is still worshipped by young Athenian men and boys in the sacrifice of bulls and sheep. Erechtheus is mentioned by Xenophon (Mem.3.5.19) and by 'Plutarch' (Vit.X Or. 843E) as a son of Hephaistos and the Earth, Ge. According to one myth, Hephaistos ejaculated out of lust for Athena; the semen then either fell on the ground or was wiped away by Athena with a woollen cloth. This cloth then fell to the ground and produced a child of the soil. However, this child is called Erichthonios; he was reared and cared for by Athena. Erichthonios and Erechtheus are often confused (in modern scholarship and in the ancient texts), but some characteristics and actions do separate them even mythologically; see N. Robertson, 1985. The myth of Erichthonios is the *aition* for the Panathenaia. The Erichthonios myth also explains Athena's role as the protector of young warriors; she is the *kourotrophos*. Erichthonios is supposed to be the initiator of the Panathenaia (Theseus is also allotted this role). In Euripides' play *Ion*, the two names definitely denote different characters: Erichthonios is the first 'divine child', born of the soil, the origin of the Athenian race; Erechtheus is his descendant, a hero king, father of the play's protagonist Kreousa who gives birth to the next divine child, Ion – son of Kreousa, a daughter of the Athenian royal house, and of the god Apollon.

15 Pausanias, I. XXVI,6, tells us that the Athenians believed tha statue had fallen from heaven; it was the holiest object in the *polis*.

16 All that is visible now on the Acropolis cliff are some remains of the foundations of one archaic temple, near the present Erechtheion; it is commonly connected with the pediment fragments representing a *gigantomacchia* (now in the Acropolis museum). Apart from these pediment remains, which are late archaic, there are remains of a limestone construction, presumably from the period around Peisistratos' rise to power, 560–550, with pediments representing animal fights and a Herakles (now in the Acropolis museum), and the remains of some capitals (still on the ground). (An attempt at a

reconstruction has been made by Immo Beyer, see *Archäologischer Anzeiger*, Band 89, Berlin, 1974, pp.639–51 (Sitzungsbericht)). There is no agreement among archaeologists about the function or the original site of this lime-stone construction, i.e. whether it was located where the foundation ruins are still visible, or where the Parthenon now stands, or somewhere else alto-gether. The designation '*ho hekatompedos neos*' is applied in Late Antiquity to the eastern inner room of the Parthenon, the cella, which is 100 Attic feet in length, and by extension to the temple as a whole. On these points, see further Tölle-Kastenbein, 1993. See also Harris, 1995, pp.4–5; Harris, p.17 is convinced that '*hekatompedon*' has the same denotation as '*ho hekatompedos neos*' but Tölle-Kastenbein assumes that '*hekatompedon*' (in the neuter) desig-nates a sacred area (since the inscription containing the word mentions small houses *oikemata*, maybe treasure houses).

17 Its name alludes to Erechtheus; see note 14 above.

18 Tölle-Kastenbein, pp.61, 68, refers to Korres, in Berger (ed.), 1984, I, note 1. The 'Pre-Parthenon' was a hexastyle peripteral temple. The Parthenon is the only temple of its time that is octastyle and colossal, but without any specific cultic function. The proportions of the Parthenon recall those of an archaic Zeus-temple in Athens, according to Tölle-Kastenbein; this might seem to confirm Castriota's view of the Parthenon as Athena in her role as an emanation of Zeus.

19 Manolis Korres, 'The History of the Acropolis monuments', in Economakis (ed.), 1994, p.42. According to fourth-century texts there was a decision after the war that the monuments destroyed in 480 should not be rebuilt for 30 years; some of the ruins were inserted in a new wall to act as a reminder of the invasion and to be easily seen from the agora.

20 Nonetheless, according to Mansfield, 1985, p.232 note 19, a sacrificial table is mentioned in a fourth-century inventory, indicating that sacrificial cer-emonies were conducted at the temple. See Ridgway, in Neils (ed.), 1992, p.134, note 51.

21 *Polias* is a feminine flexion of the adjective *polieus*, applied to Zeus, 'pro-tector of the *polis*'.

22 On the names of the statues in relation to the names of the goddesses, see Herington, 1955. On the use of names in Late Antiquity, see Overbeck, 1868, 642: scholiast over Demosthenes, Against Androtion 13. On 'Athena Lemnia', see Wycherley, 1978, pp.138–9; Pausanias (I.28.2) and Lucianos (Eikones, IV). There is only one ancient source documenting the use of the name 'Athena promachos' (Overbeck, 1868, 642); however, the desig-nation is now used by modern scholars to refer to all Athena figures in a warrior position or wearing warrior dress. On the names and the figure types see also Ridgway, in Neils (ed.), 1992, pp.119–42, and Pinney, 1988.

23 According to C.J. Herrington (1955), the reason for the existence of two variants of the patron goddess at two temple sites is that they each stem

from different religious traditions, which may in turn have started in connection with different goddesses: one associated with the abundance of the earth and the cultivation of the olive, and the other with the image of the virgin warrior.

24 The term *ho neos* was used to denote either the cella together with the western chamber *parthenon/opisthodomos*, or the cella only.

25 Contr. Androtion XXII 13. 76.

26 On the rooms and their designations see Tölle-Kastenbein, pp.70–1; for 'Parthenon' referring to the whole temple, p.71, notes 88–90. On the western chamber of the Parthenon, see Ridgway, in Neils (ed.), 1992, p.126. Noel Robertson, 1985, pp.264–5, suggests that this room could have been the room where an oil lamp was kept burning in memory of Athena nursing the divine child, Erichthonios (Robertson refers to texts by Ovid and Nonnos and, particularly, to Pausanias, I.XXVI,6–7). But it is still uncertain whether this room was in the Parthenon or in the Erechtheion; even more uncertain is whether the event was somehow staged in the cultic ceremonies.

27 About dates, programme and arrangements for the festival, see Neils, in Neils (ed.), 1992, pp.14–17.

28 Our knowledge of the Athenian celebration of the goddess Athena is drawn predominantly from the following evidence: inscriptions with lists of prizes, financial reports of the democratic *polis*; regulations about state religion codified by Nikomachos (*Cambridge Ancient History*, 1992, pp.247–8) on tablets on the Agora by the end of the fifth century; regulations regarding sacrifices etc on the initiative of Lychurgos in 335 (responsible for finance). Literary sources include: 'Aristotle', *Ta Politeia Athenaion* and Athenian historians from the Hellenistic period, preserved by encyclopaedic writers in Rome and Byzantium; descriptions of sites and objects and customs by Pausanias and Strabo; lexiographical works from Late Antiquity (Harpokration – first or second century AD, Aelius Aristides – second century, Hesychios – fifth or sixth century, the work 'Suda' or 'Suidas' – tenth century). The prize amphoras also represent important documents.

29 1) The festival is held in memory of the goddess's birth. The view is the traditional one, appearing for instance in Deubner, 1932, Parke, 1977, and Simon, 1983.

2) The festival is in memory of the victory of the gods over the giants, and particularly of Athena's role in this triumph. Ferrari Pinney, 1988, and Ridgway, in Neils (ed.), 1992. In support of this thesis cf. Euripides'*Ion*, 205–19; 1529–31.

3) The festival was a new year feast, celebrating the 'fetching of the new fire' and the building of society. Only in Noel Robertson, 1985. This view is compatible with either of the others, since it refers only to the origin of the festival and the importance of Hephaistos.

30 Plutarch see *Pericles*, 12. See also e.g. Gauer, in Berger (ed.) 1984, Root, 1985, Schneider & Höcker, 1990, and Castriota, 1992.

31 See Thucydides II. XIII. 5, about the removable gold of the giant statue.

32 Castriota, 1992, pp.202–26, stresses in his analysis of the frieze in relation to archaic Greek friezes that an assembly of gods represents not the receiving of gifts but rather an apotheosis: the gods recognising and admitting the humans. Nonetheless, in the case of the Parthenon frieze, one cannot ignore the fact that the humans are carrying gifts and sacrificial objects.

II ANALYSIS

1 Gombrich in *Meditations on a Hobby Horse and other Essays on the Theory of Art*, London and New York, 1972, 2nd ed. (first published as a book 1963), pp.3–11; and in *Art and Illusion*, 1960, pp.114–31.

2 On the concept *rhythmos* and relevant Greek text sources, see Pollitt, 1972, pp.54–60, and 1974, pp.219–28.

3 It is the kind of vision treated in Roland Barthes *La chambre claire*, 1980, under the label 'punctum'.

4 In her seminal research Svetlana Alpers, for instance, has explained to us that classicism has influenced art history to such a degree as to make Dutch seventeenth-century painting inaccessible to theory; see her *The Art of Describing. Dutch Art in the Seventeenth Century*, 1983.

5 Aristotle, *Peri psyches*: 'For vision occurs when the sensitive faculty is acted upon.' (II.VII. 419a 15) and '. . . that sense is that which is receptive of the form of sensible objects without the matter, just as the wax receives the impression of the signet ring without the iron or the gold, . . .' (II.XII.424a 17–20) Translation by W.S. Hett, LCL. Cf Mitchell, 1986, pp.9–11, on the idea of a 'family resemblance between whatever is named an 'image': physical pictures (paintings, drawings . . .), optical (mirror projections etc), perceptual (sense data), mental ('ideas' or 'phantasies') and verbal. There are speculations on the sense of vision in Plato's *Timaeus* 45 B–E, where the creation of the body is described: here the eyes possess a light similar to daylight, a 'mild fire' that in fusion with daylight creates a stream-like substance sensitive to the motions of the surrounding objects. The idea of an impression is thus not relevant here, but rather the idea of a mechanical structure: movements transported by a substance.

6 X, 595–8.

7 235 DE. In this dialogue Plato lets the 'stranger from Elea'condemn 'likeness-making' as well as the 'appearance-making' parts of the art of 'imitation' (images in water, mirrors, paintings and sculptures, 239 D), because they do not contain 'truth', they do not deal with what 'is' (pretending to be things they are not); this argument resembles that in the *Republic* (X,

596–8); here the 'art' of making *eidola* (images) is also condemned because it does not take an 'art' to hold up a mirror and thus to 'create' things just to deceive feeble-minded persons (cf. *Sophist*, 234 B).

In the *Sophist* the dialogue on optical corrections runs as follows:

> Stranger: I see the likeness-making art as one part of imitation. This is met with, as a rule, whenever anyone produces the imitation by following the proportions of the original in length, breadth, and depth, and giving, besides, the appropriate colours to each part.
> Theatetus: Yes, but do not all imitators try to do this?
> Stranger: Not those who produce some large work of sculpture or painting. For if they produce the true proportions of beautiful forms, the upper parts, you know, would seem smaller and the lower parts larger than they ought, because we see the former from a distance, the latter from near at hand.
> (Transl. Harold North Fowler, LCL, 1987 (first 1921))

8　In the metope south 26, for example, the optical corrections are obvious; the raised leg of the lapith seems much too short (at least the thigh), when the relief is seen at right angles. This composition has often been considered as artistically weak (Brommer, 1967, Text, pp.116–19) in contrast to the favourite of all scholars – south 27 that seems to be composed for a gaze at right angles. As an optical correction I also judge the overdimensioned head of the lapith in south 31.

9　*Odyssey*, XI.

10　Manolis Korres in a lecture on the conservation of the Parthenon sculptures, at Stockholm University, 29 March 1995. Korres based his views on Dinsmoor's research and on technical investigations undertaken during the restoration project. Cf. Dinsmoor, 1954.

11　The technique of low and high relief varied considerably. The Parthenon frieze was largely fashioned with chisels, while the metopes were carved with the sculptor's instruments. See Casson, 1970, p.136.

12　According to the Liddle-Scott dictionary *to ektypoma* means 'a figure carved or chiselled in relief' (ex. Plato, *Timaeus*, 50 D, Philostratos, *Bios Apolloniou*, II, 33) and 'reflection of light'; *he ektyposis* means 'modelling in relief'; *ektypos* means 'worked in relief', 'distinct' and 'clear' (about 'phantasia'). *To typos* has a wider range of meanings; cf. note 35.

13　Jenkins, 1994, p.31 and notes.

14　John J. Winkler, 'The Ephebes' Song: Tragoidia and Polis', in Winkler & Zeitlin (eds), 1990, pp.20–62; on the ephebes' military drill at the Dionysos theatre (p.3); Winkler's thesis is that the tragedy chorus acted as the corps of the ephebes doing their military drill (esp. pp.23 and 50 with note 88).

15　Ferrari Pinney, 1988.

16　The scene with the mantle is then read either as an examination of the

newly woven garment before the procession sets out (Gauer, in Berger ed., 1984), or as the laying aside of the old mantle which is to be replaced by a new one (Robertson, 1975).

17 See *Odyssey*, XI, 72, on the use of the adverb *opithen*. Compare also in the *Odyssey*, I, 222, the adverb *opisso*, in the same structure of time and room.

18 See Boardman, 1979. This view appears in Pollitt, Ashmole, Brommer, Robertson and Stewart. In Deubner, Parke and Simon we find reconstructions of the course of the procession based on the figures of the frieze.

19 There have also been attempts to break away from the Panathenaic theme, while still retaining an identification of the subject matter with a variety of contemporary and ritual events: Wesenberg, 1995, reads a synthesis of two different Athena festivals into the central east scene.

20 See Boardman, 1977; Kardara, 1963 and 1964.

21 Connelly, 1996. The literary source for this story is Euripides' play *Erechtheus*, preserved in fragments only. The date of the play is supposed to be the late 420s, but it builds on ancient and well-known traditions in Athens and is staged and focused on the Acropolis and on the cults associated with it. In the play there is no explicit connection between Eumolpos and the Eleusinians; in Thucydides (II, 15.1) and in later sources, however, Eumolpos is always said to be leading the Eleusinians in the war. Sometimes control of the Mysteries at Eleusis is said to be the heart of the conflict, but in Euripides' play Eumolpos claims the territory for his father Poseidon, thus offering a clear parallel with the west pediment of the Parthenon. At the end of the play Athena establishes the cult of Erechtheus' daughters, known as the 'Hyacinthids' (saved from Hades and transmuted into heavenly signs) and the cult of Erechtheus/Poseidon; she also appoints Erechtheus' wife Praxithea as her own first priestess and the descendants of Eumolpos as priests attached to the Mysteries at Eleusis.

22 Cf. chapter 1, note 5.

23 Cf. chapter 1, note 14. The worship of Erechtheus seems originally to have been the cult of a god, not a hero. Poseidon and Erechtheus are opposed in the story but in the cult practice they were very close, even sometimes with superimposed identities.

24 In the play Erechtheus is killed by Poseidon's thunderbolt and hidden 'below the earth' and he is subsequently to receive sacrifices as 'Poseidon/Erechtheus'; see Euripides' *Erechtheus*, lines 59–60, 90–1, 92–4; see also Mikalson, 1991, p.32.

25 Aristophanes, *Knights*, the chorus (551–64). About Poseidon's connection with horse-taming and horses, see RE, 1953, article on Poseidon, section 18, p.482. In celebrating an aspect of the union of the powers of Athena and Poseidon, the frieze artists could invoke Athens' military excellence by referring both to the cavalry and to the fleet.

26 Mikalson, 1991, p.235; Hughes, 1991, p.187; Bonnechere, 1994, pp.74–82

(the cult of the Erechthids concerns initiation, patriotism and protection of warriors, not human sacrifice *per se*).

27 Vellacott, 1975.

28 Cf. chapter 1, note 14.

29 Neils, 1992, p.195, note 34 with reference to Hyginus, *Astronomica* 2. 13.

30 Brommer, 1977, text, p.13, stresses the function of this scene as a central focus of the frieze: it is well defined within the boundaries of the slab and it is set off against the surrounding scenes.

31 See E. Simon, 1983, p.64 and W. Gauer in Berger, ed. 1984, p.220.

32 On the dynamics of direction in art, see Arnheim, chapter entitled 'Balance', and *passim*.

33 According to Harrison, in Berger (ed.), 1984, the men are organised in ten sections with six men in each. In Jenkins' reconstruction, 1994, there is the same kind of division on the north side.

34 The number of people in the groups is decisive to its identification. Ashmole, 1972, p.142, supposes two groups containing four persons each – the 'reading' I find most convincing. The dominant theory at the Parthenon-Congress in 1982 was to interpret the groups as 'eponymous heroes'. Jenkins, 1985, supposes them to be nine archons: in the centre the *archon basileus* with the *peplos*, eight of the men forming a group of nine as the other archons and the ninth as a *grammateus* – a role confirmed by the sources. See also Jenkins, 1994, pp.33–4, where he takes another stand and loosely identifies them as 'officials'. Ridgway supposes that the figures represent Athenian citizens, walking and talking to one another in relaxed expectation before the procession starts (1981, p.79). Nagy, 1992, supposes them to be *athlothetai*, and counts E34, the man handling the mantle, as another of them. These officials had more responsibility for the Panathenaia than the archons; another argument is that Pericles had been one, and Nagy proposes the theory that E34 portrays him.

35 There were also in language distinctions pertaining to the differences between two-dimensional and three-dimensional, for instance in words such as *typoun* and *ektypoun* ('embossing', 'molding', 'modelling', but also carrying meanings such as 'making a plan or fulfilling a commission'). On the other hand, relief-work was also matched with the different techniques of drawing, through the use of the word *glymma* (for the product) and *glyphein* (for the artist's activity, referring to the actual motion of carving). But these words were more related to the various techniques, not so much to what was conveyed or the impression intended.

Pollitt, 1974, pp.272–92, gives 98 text references on the use of the word *typos*, and discusses whether the word used in the Epidauros inscription, IG, IV2, 102, denotes reliefs or forms (models).

On the words in the *mimeomai*-group, see Sörbom, 1966, pp.19–21 and *passim*.

36 Stewart, 1990, pp.45–9. Although the style of the classical sculptures convey the impressions of living and moving bodies, this quality does not entail the belief in the presence of the being depicted in the statue. On the contrary, according to Plato's 'Athenian' in the *Laws*, XI, 931 A, the gods were not really present in the statues created to celebrate them; rather, they were supposed to take pleasure in the fact that humans made sculptures in their honour, and to show benevolence in return (this is said when the 'Athenian' is in fact talking about the need to care for one's old parents, living but age-ridden humans, rather than cult figures).

37 *Memorabilia*, III, 10. Sörbom, 1987, 1988.

38 The sudden 'bursting-in' appearance of Helios seems to be associated with the figure's appearance also in literature, cf Euripides' *Ion*, line 41: *kyrei d'ham'hippeuontos heliou kyklo profetis* . . . (a priestess happened to be there just as the sun with his horses drove forth on his course . . .).

39 In Greek theory on painting and sculpture there is no word for cropped figures. In the case of a three-dimensional pedimental sculpture cropped by the boundaries of the pictorial space and whose position indicates strong movement, certain aspects of the concepts of '*rhythmos*' and '*eremia*' might be relevant. Pollitt, 1974, pp.222–5, refers to Eugen Petersens article 'Rhythmus', *Abhandlungen der Kön. Gesellschaft der Wissenschaften zu Göttingen, Phil.-Hist. Klasse*, N.F. 16, 1917, pp.1–104; Pollitt summarises (p.225): 'In motion *eremiai* were points at which fleeting movements came to a temporary halt, thus enabling a viewer to fasten his vision on a particular position that characterized the movement as a whole.'

40 In vase painting there is a figure of Helios cropped in the same way as in the pediment of the Parthenon: see ill. 327 in John Boardman, *Athenian red figure vases, the classical period*, 1989: Neapel 2883, from Ruvo; ARV 1338.

41 Brommer, 1963, p.143 supposes that the whole pediment is about the situation, the moment, following the birth of the goddess. The only basis for an iconographical interpretation of the east pediment comes from Pausanias' brief comment (I. XXIV.5) that the sculptures showed 'the birth of Athena'.

42 Powerful expositions on the conditions of human life appear in drama. For instance, in Aeschylus' *Prometheus bound*, 436–71, on the wretchedness and limitations of human life and the knowledge and inventions which Prometheus brought to men; in Sophocles' *Antigone*, 332–83, where instead mankind is praised as the wonder of the world and inventions, culture and technique are focused as well as the hardships of human life.

43 Palagia, 1993, p.21. Cf the analysis of the frieze in Mark, 1984, p.295, on the blood relations between Aphrodite and Eros and between Aphrodite and Artemis, expressed in their leaning upon one another.

44 On the theme of child-bearing, female initiation and citizenship as a genetic code, as meanings in the frieze, see Jenkins, 1994, pp.35–42.

45 Dentzer, 1982, has pointed out the consistency of the banquet motif, irrespective of where it appears, i.e. painted or carved on objects with different functions and referring to either mythology, rite, eschatological belief or real life events; Dentzer notes that the banquet motif is generally connected with images and themes concerning horses and often weapons and dogs; he interprets it as a visualisation of a lifestyle, originally royal and later aristocratic, which evoked heroic status in the Classical and Hellenistic periods. Thus the combination of horses and banqueting in the pediment corresponds to a deep-rooted imagery.

46 According to Brommer, 1977, text, p.19, it is possible to see W24, the young boy, as holding long reins for the horse (a proposition put forward by W. Passow, JdI, 1900, p.46, Abb. 3).

47 *Odyssey*, X, 230–73; 429–45.

48 *Odyssey*, X, 552–60; XI, 51–83.

49 Osborne, 1987, p.100.

50 The contact, if any, is in a few cases that of mistaken identity.

51 Such an identification of roles is based on the supposition that the scene depicts the protagonists of a human sacrifice, Erechtheus sacrificing his daughter and the queen Praxithea consenting, as described in Euripides' drama fragment; Connelly, 1996.

52 Burkert, 1985, p.56; Nilsson, 1967, p.147.

53 Connelly, 1996. Her interpretation is a radical break with a well established tradition of a documentary kind, identifying the events as ritual ceremony.

54 There is an aspect of guilt involved in animal sacrifice and the guilt is expressed in the 'comedy of innocence' of the sacrificial procession. See B.C. Dietrich, 'The instrument of sacrifice', in Hägg et al. (eds), 1988, p.36; Dietrich refers to Karl Meuli, 'Griechische Opferbräuche', *Phyllobolia. Festschrift P. von der Mühll*, Basel, 1946, pp.224–52. See also Nanno Marinatos, 'The Imagery of Sacrifice: Minoan and Greek', in Hägg et al. (eds), 1988, p.17, about the killing of domestic animals: 'if anything it caused guilt'.

55 Burkert, 1985, p.56. However, Marinatos, in Hägg et al. (eds), 1988, p.13, stresses the fact that women are seldom seen holding the knife; this is done by men.

56 *Theogonia*, 536–615. Aristophanes in *The Birds* makes the gods suffer and hunger from the loss of the sacrificial meat, when contact between men and gods is broken as a result of a seige. In Homer, *Iliad*, XX, 168–72, Zeus feels compassion for Hector because of all the sacrificial meat the young man has burnt at his altar. In the *Homeric hymn to Demeter*, 305–13, Demeter withholds growth from the earth, thus calling down death upon the human race; but her action is more of a strategic move directed at the Olympians, since the gods will no longer receive their usual sacrifices.

57 This can be compared with the sense of uncertainty, fear and even

bitterness that the mortals express in Euripides' plays, in reflecting on the unpredictable and often destructive reactions of the gods: only what the gods give by their own wish, willingly, can be a benefit to mankind (*Ion*, 380).

58 See *Iliad*, VI, 269–311, 382–9. Even the favourites of the gods could become victims of their punishment and wrath. See the interpretation of the relation between Athena and Odysseus in Clay, 1983.

59 Walter Burkert, 1985, p.8.

60 Burkert, 1985, p.57. Blood libation at the altar is frequent in all Greek cults; see Marinatos, in Hägg et al. (eds), 1988, p.14. About the women's screaming (the *ololyge*), see Nilsson, 1967, p.142; Burkert, 1985, p.56 (referring to Aeschylus' *Seven against Thebes*, 267–9, where Eteocles excites the women of the chorus to shout the sacrificial cry to enhance the war effort); Gould, 1980, p.50 (note 92).

 Herodotus, IV, 188, 189, writes about the origins in Libya of certain basic characteristics of the Greek cult: the *aegis* of Athena derived from the dress of Libyan women, and the ceremonial cry, the *ololyge*, was modelled on Libyan customs.

61 See Folkert van Straten, 'The God's Portion in Greek Sacrificial Representations: Is the Tail doing Nicely?', in Hägg et al. (eds), 1988, pp.51–68. Van Straten has examined which phase is depicted in representations of sacrifice: pre-kill, kill, post-kill, and he finds a significant dominance for pre-kill (55.5% in vase-painting; 99% in votive reliefs); representations of the actual killing are extremely rare (4.5% in vases; 0.5% (?) in votive reliefs).

62 Deubner, Parke, Simon and Neils all seem convinced of a detailed scheme for this procession.

63 I refer to Robin Osborne, 'Framing of the centaur: reading fifth-century architectural sculpture', in Goldhill & Osborne (eds), 1994, pp.52–84, to support my interpretation of the sculptures as profoundly identity-reflecting, and I have based the 'message' on a combination of his interpretation of the centaur theme and Clay's view of the Homerian hymns.

64 Spence, 1993, pp.xxxii–xxxiii, notes that among reliefs and vase paintings depicting cavalrymen, armour is the rule. He accordingly takes it for granted that weapons were depicted in the frieze, albeit painted or in the shape of bronze attachments. He refers to 'Aristotle', *Ta Politeia Athenaion*, 18.4, on the inclusion of weapons in the Panathenaic procession. (The author states that weapons did not belong to the procession in the sixth century, but were included by 'democratic' rule.)

 On the detail of the sword of W12, I refer to the observations of the conservators in Athens (confirmed by Christina Vlassopoulou in a letter to me dated 8 April 1997); see also Brommer, 1977 (text), pp.6, 7, 10 (Brommer claims that also W4 carried a sword); Wesenberg, 1995, p.174.

65 Cf. note 35.

66 *Poetics*, 1448a ch. II.1.

67 *Republic*, VII, 514–18.

68 *Phaedrus*, 246B–254E.

69 Aristotle, *Poetics*, I, 2–6, 1447a; II, 1448a.

70 Sörbom, 1987, 1988, and 'Xenophon's Socrates on the Greek Art Revolution', unpublished paper delivered to the Second International Conference on Greek Philosophy, Samos, Greece, 22–8 August, 1990.

71 Aristotle *Poetics*, IX; Plato *Timaeus*, 26 D–E for example.

72 Brommer, 1961.

73 *Iliad*, IV, 515; V 115, 733, 876–91.

74 There are also references to the myth in *Homeric Hymn to the Pythian Apollo*, 321–5, in Euripides' *Ion*, 454; in Apollodoros' *Biblioteca* (first century BC) there is a short encyclopaedic notice. A late description of the myth occurs in Philostratos' *Eikones*, II, 27 (probably 3rd century AD).

75 According to Euripides' account in *Ion*, lines 452–9, it was Prometheus who helped Zeus to bring forth Athena from his head. Apollodoros writes in the *Biblioteca* that Hephaistos or Prometheus helped at the birth event.

76 On this name, see *The Odyssey of Homer*, Books I–XII, ed. W.B. Stanford, 2nd ed., 1959, p.262 (first ed. 1947). In Euripides' *Ion*, 870–3 (Tritonis), and in Aeschylus' *Eumenides*, 292–3, the name refers to the water, the river or the lake. Cf Herodotus, IV, 188, about the Tritonian lake in Libya where Athena is worshipped.

77 Apollodoros also talks of a suit of armour in gold, while Philostratos, who describes a painting (real or fictive) talks of a dress in bright rainbow colours.

78 Philostratos, in his description of a painting (II. 27. 22–4), elaborates on the expression on the father's face: we can witness how the father, after his daughter's birth, breathes deeply, from happiness – 'like men who have undergone a great contest for a great prize'. (Translation Arthur Fairbanks, LCL, 1979, first printed 1931.)

79 Dionysos is mentioned on four occasions only in the *Iliad* and the *Odyssey*: *Odyssey*, XI, 325, XXIV, 74: *Iliad*, VI, 132, 135, XIV, 325.

80 The theme of the god who frightens those around him by showing his weapons and then softens his appearance by removing the weapons from his shoulders, is also to be found in the *Homeric Hymn to the Delian Apollo*, 1–9 (here the gods tremble before Apollo who is armed, until Leto removes the bow and quiver from his 'strong shoulders').

81 It is uncertain whether all the texts brought together under the name 'Hesiod' really were written by the same person; many scholars have called attention to the differences in style and quality between *Theogonia* and *Works and Days* (this last is considered much better). In any case I use the name 'Hesiod' here for both works.

82 Examples of the ways 'symbol' has been used:

1. As the equivalent of 'verbal expression' in linguistic and analytical philosophy (Nelson Goodman, John Hospers).
2. Denoting 'conventional' or 'arbitrary' signs (also in analytical philosophy). As such it also appeared before the Romantic era as a 'label' or 'identifying signal'.
3. Denoting a 'semi-conventional' sign. A symbol can represent something and this something symbolises a concept or an event, on a basis of essential shared properties (Monroe C. Beardsley).
4. The 'symbol' of Romanticism and Symbolism, suggesting contact with transcendental dimensions, through analogy or 'similarities' (Albert Aurier, for instance).
5. The Modernist symbol concept, according to which a 'symbol' cannot be detached from its meaning; the two are irrevocably connected with one another (Ernst Cassirer, Erwin Panofsky and Susan Langer).
6. Ch. S. Pierce's symbol concept, according to which a 'symbol' is distinguished from 'index' and 'icon' by the general or abstract foundation of the relation on both sides (between the sign and its referent).

83 There is literary and iconographical evidence that Athenian women were associated with the art of weaving, the main *techne* of the skills Athena gave her people. It is worth noting, though, that this art did not mean as much to the economic prosperity of the *polis* of the classical period as it had meant to the Bronze Age society. See Barber, in Neils (ed.), 1992, p.117. Weaving as an attribute of Athenian women had much the same character as her other traditional and ritual identity features.

 Athenian women were associated with the manufacture of the *peplos* for the goddess, the gift presented to her at the occasion of the Great Panathenaia. Deubner, 1959 (1932), pp.30–1, assumes that no mantle was manufactured for the annual feast. Mansfield, 1985, as well as Barber, in Neils (ed.), 1992, p.113, propose that a yearly *peplos* was made by Athenian women, whereas a *peplos* in colossal scale was produced every four years by professional men. Mansfield, 1985, p.443 (as quoted from Barber, note 11) assumes that the yearly *peplos* was draped on the old Athena statue. Barber assumes that both the yearly *peplos* and the large one (in sail size) were decorated with the gigantomacchia-motif; literary evidence (Euripides, *Hecuba*, 466–74, *Iphigenia in Tauris*, 222–4, and *Ion*, 196–7) manifests the custom of Athenian women to weave textiles with patterns showing myths. The decorated textiles belonged to the objects kept in the treasuries of the gods (the Athena-treasury of the Trojans in the *Iliad* (VI) being the most well known example; another reference is the Apollo treasury described in *Ion*, 1139–65, containing also oriental textiles taken as war booty).

84 Thucydides, II, XLV 2. Translation Charles Foster Smith, LCL. 1991 (first published 1919).

85 Mark, 1984, note 62, builds his argument on Harrison, 1982. Harrison states here, pp.86–7, that a slipping chithon revealing the right breast has erotic connotations, while an uncovered left breast refers to motherhood and child-rearing. Mark uses this analysis to prove his thesis about Artemis/Aphrodite in the frieze, but Harrison establishes the meaning on the evidence of the Parthenon sculptures: the slipping chithon of figure M means erotic love, *because* M, who is Aphrodite, is wearing it. The meaning is not thus established independently of the Parthenon case. Furthermore, the other examples of slipping chithons referred to by Harrison are Amazon dresses; it cannot be taken for granted that meanings connected with Amazons can be applied to goddesses, even though Amazons were part of the Artemis cult (in Ephesos).

86 Jenkins, 1994, and Osborne, 1994.

87 See section on 'The paradoxes of art' below.

88 Osborne's analysis of this complexity of meaning is made in connection with the Amazon battle in the Apollo temple at Bassae, where the fight against the Amazons (women as enemies) is directly associated with fight against the Centaurs (women in need of protection). But this association also applies to the Parthenon decoration.

89 Sappho is of course the great exception, but she did not live in the classical era. Scholars have looked for evidence of women philosophers in the Pythagorean circle; fragments of texts written by women authors have been preserved in compilations of later dates, but most of these writers from the classical period lived in Boiotia. See Snyder, pp.108–13 on Pythagorean philosophers, pp.40–63 on women writers from Boiotia and Peloponnesos.

There has also been discussions of the position of Aspasia, who lived with Pericles, as a 'free' intellectual and as a teacher of rhetoric, but her role in that respect is only described by Plato, perhaps ironically, in *Menexenus* (4. 236B; 4.237E–238B).

90 Fewer girls than boys were probably allowed to live. A child was not accepted into an *oikos* until the age of three; before that, the father decided on the child's life. Yet because of the wars, there were probably more women than men in classical Athens. Pomeroy, 1975, p.69.

91 The question of whether women attended the performances of drama has not yet been definitively solved. See Winkler, in Winkler & Zeitlin (eds), 1990, p.39 (especially note 58). Winkler assumes that women were generally present in the audience, but there can be no certainty about this. Winkler points out that the problem is not whether women attended the theatre or not; it is simply that the question is so hard to answer.

Keuls, 1993 (1985), pp.330–2, assumes that women were generally not accepted in the audience; a condition for the demonstration in the plays of the threats of conflict between the sexes.

92 During the winter months the Delphic sanctuaries belonged to Dionysos

and during the summer months to Apollo. Burkert, 1985, p.224 (ref. to Plutarch, *De E ap. Delph.*, 389 C). See also Nilsson, 1967, pp.569–70.

93 Cf. note 79.

94 Dionysos takes Ariadne, abandoned by Theseus, as his bride. According to Homer, however, Ariadne is killed on the island of Dia by Artemis on the initiative of Dionysos (*Odyssey*, XI, 321–5). But usually the marriage theme dominates. In any case no other woman is chosen by Dionysos as his partner, although he is surrounded by women. M.P. Nilsson interprets the variation between marriage and death as a fertility theme, 1967, pp.314–15.

95 A vase painting – red figure bell-krater (about 420, NY Metr. 25.78.66, ARV 2, 1172,8) – showing three men with monkey-faces and lyres and the inscription 'singers at the Panathenaia' is much discussed by scholars (see Neils, in Neils, ed., 1992, pp.15, 194, note 11, and Winkler, in Winkler & Zeitlin, eds, 1990, pp.49–53). In recent scholarship this vase painting is not regarded as evidence of dramatic contests at the Panathenaia.

96 *Eumenides* 657–66; *Peri zoon geneseos*, I. XIX–XX in particular 727b, 729a and XXI 729a–b. Aeschylus' 'view' in the play must be seen as filtered through the role of Apollo; the god wants to ensure that no part of the woman's body remains in the offspring so as to be able to release Orestes from his blood-guilt for murdering his mother.

97 Dean-Jones, 1994, pp.148–99 and passim.

98 Gould, 1980, p.53.

99 Pomeroy, 1975, p.57. On the connection between virginity and mother-hood – the protection of childbearing was the realm of virgin-goddesses, such as Artemis and Athena. Cf Euripides *Ion*, 465–71.

100 Sissa, 1990, pp.87–8: 'The *oikos* must not be deprived of a right essential to its preservation, namely, the right to expel a female *soma* that had been irretrievably corrupted (*diaphtheirein*) and thereby rendered unfit for matrimony. Rape or seduction without paternal consent undermined the father's sovereign authority over his daughter. In such a case, instead of *ekdosis* (the act of *giving* one's daughter to another man), the father could exercise his power by putting the girl up for sale.'

It was not the fact that the girl had had sexual intercourse which prevented her from being a *parthenos*, 'virgin', but the change of position within the structure of roles in the family relations of the *polis*: whether she became a bride or not, whether she contained a future citizen in her body or not. A widow and a *parthenos*, for example, occupied similar positions. Sissa, 1990, chs. 8, 9.

101 *Oikonomikos*, VII.10–VIII.13.

102 On the issue of women connected with the Panathenaia, see Mary R. Lefkowitz, 'Women in the Panathenaic and other Festivals', in Neils (ed.), 1996, pp.78–91.

103 Pomeroy, 1975, p.75. Cf Gould, 1980, p.50: women were priestesses for more than forty major cults, which must have entailed some influence on the system of society. On the influence and social status of women, connected with cult and religious praxis, see also Kron, 1996.

104 In her analysis of the *Odyssey*, 1983, Jenny Strauss Clay shows how Athena's 'wrath' is a crucial element in the relationship between herself and Odysseus; Athena as the master of *metis* (knowledge, especially the command of imprecise and 'floating' appearances) and *doulos* (cunning, tricks) is parallelled by Odysseus, who in his own dimension is the master of the same qualities among men. The goddess's wrath hits the Greeks (and especially Odysseus) as a result of their insolence in sacking Troy, and is again provoked by Odysseus' rivalling of her own character. Clay writes (p.209): 'To put it simply, if not too crudely, *Odysseus is too clever; his intelligence calls into question the superiority of the gods themselves*.' The whole book deals with this structure of their relationship, but the heart of the conflict is described on pp.25–53, 186–212.

105 Cf. line 542 in Euripides' *Ion*, where Xouthos, the non-Athenian ally and Kreousa's husband, ironically answers Ion's question about the identity of his mother, saying that the 'ground' does not produce any children. (Being a 'foreigner' he does not think like a regular Athenian; moreover, he uses the word *pedon* (ground) rather than *ge* when he talks about the impossibility of 'earth-born' children.

106 Pausanias, I. XXVII. 2–3. The *arrephoroi* (bearers of sacred things) live for one year on the Acropolis near the old temple, in the care of Athena's priestess. During the night before the Panathenaia they carry on their head secret things (about whose nature neither they nor the priestess know anything) through a subterranean passageway to the sacred precinct of Aphrodite in the Gardens; there they leave their burdens and receive others to take back; thereafter they are replaced by other girls. The *arrephoroi* are supposed to refer to Aglauros (or Agraulos), Herse, and Pandrosos, the daughters of Kekrops (born of the Earth and having a snake-shaped body).

 According to the best-known version of the myth the girls were trusted by Athena to receive a basket with the newborn Erichthonios (guarded by a snake/having a snake-shaped body), but they were not allowed to reveal the contents of the basket; two of them, Aglauros and Herse, did not obey and consequently went mad and threw themselves off the Acropolis cliff in despair. (There are variants of the myth; the oldest literary reference is Euripides' *Ion*, 18–26, 268–74, 1427–32.) LIMC, I, 1, 1981, pp.283–6. The cult of Aglauros and that of Pandrosos were very important on the Acropolis, probably of an ancient origin, in both cases closely connected with the initiation of the ephebes.

107 A similar situation is to be found among the participants in the bear rite in the Artemis cult. These girls, approximately the same age as the *arrephoroi*,

symbolised the tame and the wild aspects of female identity, and the rite was associated with female initiation. See Osborne, 1985, pp.165–72. On the virgin goddesses as protectors of the birth of sons, see Euripides' *Ion*, lines 465–71.

108 *Seven against Thebes*, 78–368.

109 See for instance, Plutarch, *Pericles*, ch. 34.

110 *Iliad*, VI, 407–32; XX, 476–515.

111 One example of how religion and the biological rhythm of women were symbolically connected is the Chalkeia festival when the loom for the great mantle was set up. This happened nine months before the Panathenaia, suggesting the length of a pregnancy.

112 Dean-Jones, 1994, p.29; Burkert, 1985, pp.78, 263; most important: Sissa, 1990.

113 Gould, cf. note 98.

114 *Theogonia*, 507–616.

115 LIMC, VI, 1992, pp.298–302; RE, 13, 1927, p.2298. The theme is recorded in the classical era in a drama fragment *Skyrioi* (TrGF, IV, 553–61).

116 *Iliad*, VI, 321–41.

117 LIMC, VII, 1, 1994, pp.45–6. There are fragments of satyr plays and comedies from the classical period which probably deal with this theme.

118 526–49.

119 For example Homer, *Odyssey*, XI, 319–20; Pindaros, Olympian ode, I, 68; Xenophon, *Symposion*, IV, 23, 5; Aristophanes, *Clouds*, 978.

120 Characteristically they refer to the rules of the old kinsmen associations, the *phratriai*, 655–6.

121 Cf. the possible function of the Ixion theme. If this is really what is depicted on the south metopes, it fits well with this meaning: the united Greeks can be cleansed of the blood of their kinsmen. The myth of Ixion is explictly referred to in the *Eumenides*, 717–18: Apollo states that Zeus freed Ixion from the guilt of murder, and that Ixion was the first being to whom this happened. Cf. chapter 1, note 4.

122 J.J. Pollitt, 1972.

123 J. Ober, 1989.

124 The concept of '*demos*' meaning a population, a group of inhabitants in a *polis*, should be distinguished from the administrative concept of '*demos*', but the same word is used in Greek. The word also refers to the 'people', as opposed to the 'few' or the 'noble' and as such is involved in the definition of the political system, with the distribution of power as its basic element.

125 The demes were in turn organised in larger units, in thirty *trittyes* distributed over the different types of area: town, coastal plain and inland. One *trittys* from each type of area was included in the ten supreme units, the tribes or *fylai*. Thus every tribe consisted of three *trittyes*, and its members

were consequently able to contribute experience of different parts of the region as a whole.

126 The names of these old tribes are given in the *Ion*, by Euripides, lines 1552–9: Geleos, Hopletes, Argades, Aigikores.

127 Stockton, 1990, pp.24–5.

128 Simon, 1983, pp.59–60, assumes that the men are an escort of *epheboi*; so does Jenkins, 1994, p.33, while Spence, 1993, pp.xxxii-xxxiii, 267–71, interprets the men in the cavalcade as cavalrymen in contemporary military outfit.

The military classification *ephebos* may not have been relevant in the fifth century; the sources are not clear on this point. The *epheboi* were young men between 18 and 20, who at least from 330 BC were in public military service (after the battle of Chaironeia in 338), but there is no evidence for this institution for the fifth century; see Simon Goldhill, 'The Great Dionysia and Civic Ideology', in Winkler, Zeitlin (eds), 1990, pp.124–5. In the same book, however, John J. Winkler suggests in 'The Ephebes' Song: Tragoidia and Polis' that the origin of tragedy lies specifically in the position of the *epheboi*, on the borderline between conflict among the tribes and loyalty to the community, between wildness and responsibility; however, he also stresses that the military organisation of the *epheboi* belongs to the fourth century and the following period. There is epigraphical evidence for military training in horsemanship for *epheboi* from the first century BC; see Spence, 1993, p.270, note 22. Bugh, 1988, pp.195–6, refers to documentation on competitive elements in connection with the cavalry in the Panathenaia for 166/165. Escorts of *epheboi* appeared at the major festivals, as the epigraphic sources attest; see Burkert, 1985, pp.263 and 449 note 30 with epigraphic references.

The public military training of the young men probably stems from a model in earlier aristocratic practice. The concept and the definition must have ancient roots; the *epheboi* took their oath of loyalty to the *polis* at the sanctuary of Aglauros and they brought offerings to Athena Polias, Ge Kourotrophos and to Pandrosos at the place of worship dedicated to Pandrosos; thus they had a prominent role in the ancient cults of Athens. See further LIMC, I, 1, 1981, p.284.

129 Deubner, 1959 (1932), p.28; Parke, 1977, p.44; Simon, 1983, p.63.

130 Stockton, 1990, p.62.

131 See note 83.

132 *Politika*, Book I, 5–7.

133 On this notion, see Aristotle, *Politika*, Book I, ch. 6, 1255a. For further reading: Garlan, 1988, p.124.

134 A.D. Godley, introduction pp.xv–xvi, in *Herodotus*, vol. 3 (Books V–VII), LCL, 1938 (first published 1922).

135 Raaflaub, 1988, pp.264, 283–99, 313–39.

136 Garlan, 1988, p.120.

137 *Ion*, 854–6. Nonetheless, the old servant deems it a harder lot for Kreousa to accept a slave woman's child into her house, as heir to her husband, than if, other things being equal, she had had to accept a freeborn woman's child (836–9). The reaction of revulsion is even stronger in Ion himself, in the same play, when he exclaims that if a slave girl were found to be his mother, it would have been better for him not to know anything about her (1382–3).

138 *Iliad*, VI, 407–65.

139 *Odyssey*, XI, 487–91.

140 *Odyssey*, XI, 620–2.

141 *Wasps*, 518–714.

142 The idea of the slave as a member of the owner's body is to be found in Aristotle, *Politika*, Book I, chapter 6, 1255b.

143 Bugh, 1988, p.64. Bugh assumes that the greater part of the classical Athenian cavalry amounting to 1,000 men, consisted of men in their twenties, but that some men of a more advanced age were probably also included.

144 Martin Robertson, 1975, commenting on WIV and WVIII, assumes that the bearded men are hipparchs. See also Bugh, 1988, p.78, note 135. On p.77 Bugh discusses the possibility that the frieze glorifies the cavalry of 1,000 men, but notes that it must have been planned before the revolts of Megara, Euboia and Boiotia in 447/6, which is the earliest possible date for the reorganisation of the cavalry. See also Spence, 1993, pp.9–17, on dates referring to the organisation of the Athenian cavalry.

145 Bugh 1988. This view can be compared to Andrewes, 1991 (first published 1967), pp.9, 166, where it is argued that cavalry in the fifth century had little or no importance in military terms.

146 Spence, 1993, p.xviii.

147 475–6. Translation Herbert Weir Smyth, LCL, 1988 (first published 1922).

148 Harrison, in Berger (ed.), 1984, demonstrates the tribal affiliation of the riders.

149 Spence, 1993, p.xxx and note 38, discusses the elements of Thracian dress in the imagery of horsemen in the classical period. He finds the Thracian element of some of the Parthenon frieze riders to be evidence of this dress habit within the Athenian culture, since these riders must be Athenians (their dress cannot, in other words, identify them as foreigners). The elements in question are the *alopekis-caps* worn by 12 men in the frieze. To make up a whole Thracian the image would have to show: alopekis-cap, long zeira (mantle) and a small beard. Spence refers to M.F. Vos, *Scythian Archers in Archaic Vase Painting*, Groningen, 1963.

150 Stockton, 1990, p.6.

151 Reproduced in Thucydides, II, xxxv–xlvi.

152 It is almost a commonplace in modern scholarship to connect this funeral

speech with the Parthenon frieze: Pollitt, 1972, pp.79, 87; J.D. Beazley, in *The Cambridge Ancient History* (eds J.D. Bury, S.A. Cook, F.E. Adcock), V, Cambridge, 1927, p.440; Stewart, 1990, p.156; Schneider & Höcker, 1990, p.152.

153 'Aristoteles', *Ta Politeia Athenaion*, chapter 42.1. If the candidate for citizenship was not accepted, if he did not meet the requirements, he risked being sold as a slave, in case he entered a process and lost his case.

154 *Uber naive und sentimentalische Dichtung*, 1795–6. Schiller gives several examples of 'naive' poetry and mentality, not only in classical Greece. For instance he mentions Ariosto, Dante, Tasso, Raphael, Dürer, Cervantes, Shakespeare, Fielding, Sterne, and among military leaders Caesar, Henry IV, Gustavus II Adolphus, Tsar Peter. But Homer and the classical Greek poets are the prototypes of the concept he wants to develop. See Schiller, ed. 1959, pp.709–11.

155 The aesthetic principle of opposing concepts and/or opposing energies culminating in a powerfully expressive synthesis is recurring in the evaluation of the Parthenon sculptures:

To Pollitt (1972) the 'classical' implies a dialectical relationship, whereby the tension is described in terms of both contrast and synthesis: part/whole, specific/generic, chaos/cosmos, subjectivity or mobility/the quantitavie or calculable (for instance pp.28, 69, 83, 90, 96). This figure of thought appears also in Ashmole, 1964, pp.18–19; Ridgway, 1981, p.51; and Jenkins, 1994, pp.7, 19, 31.

156 On significance referring to nature, and on 'natural' expressiveness, see for instance: Pollitt, 1972, pp.94–5 – K,L, and M of the east pediment are seen as 'the cascading of a waterfall over a mountainside' and D as 'a sun-lit hillside' which balances the 'watery shape' of K,L, and M. See also Pollitt, 1972, passim, on the quality 'Olympianism' as a natural or evident expression of the Parthenon style, conveying the experience of the time. See also Ashmole, 1972, p.115, on figure N of the west pediment as 'the spirit of the air' and on the self-evident meanings of E and F as 'solidity and sobriety' while M expresses 'luxurious indolence'.

157 Pliny, *Natural History*, XXXV. XXXVI. 73.

158 See for instance Robert Rosenblum. *Transformations in Late Eighteenth Century Art*, 1967, pp.31–46 and Anne Betty Weinshenker, *Falconet: His writings and his friend Diderot*, 1966, chapter I ('Emotion and Reason') especially p.13 and notes. The eighteenth-century debate on Timanthes' painting of Iphigenia and its aesthetic relevance was enforced in the 1760s and 1770s through Lessings writings on the Laocoon. The key issue concerned the expression of violent emotion in the visual arts.

159 See for instance Edmund Burke, *A Philosophical Enquiry into the Origin of our Ideas of the Sublime and the Beautiful*, 1759 (first published 1757), pp.89–90, where 'sublime' is associated with feelings of self-preservation and with the impenetrable and obscure. Also, Immanuel Kant, *Kritik der*

Urteilskraft, 1790, part II, where the 'sublime' is related to formlessness and the unbounded, and is associated more with nature than with art, although it is subject to aesthetic judgment.

160 The demand for wholeness and coherence as the result of an interpretation is particularly typical of the hermeneutic tradition in scholarship, as founded on the ideas presented in Hans-Georg Gadamer's *Wahrheit und Methode*, 1960 (there is an understanding of the meaning of a work of art, in so far as this meaning has been merged into the beliefs making up the 'horizon' of the thinking person). This tradition has its roots in Romanticism and Hegelianism. In theories with a 'holistic' bent, coherence and totality of meaning are especially important as grounds for the validation of an interpretation.

161 Jacques Derrida, *Of Grammatology*, Baltimore and London, 1976 (translation from the French original *De la Grammatologie*, 1967, by Gayatri Chakravorty Spivak), pp.141–64. See also: Staffan Carlshamre, *Language and time. An Attempt to Arrest the Thought of Jacques Derrida*, Gothenburg, 1986, pp.43–5.

III MEANING

1 Plutarch, *Pericles*, 5, 6. Plato, *Phaedrus*, 269E–70A.

2 Yunis, 1988, p.50, note 27.

3 The attack on the Olympian gods seems to have been initiated by Xenophanes in terms echoed later in Euripides' plays. See Guthrie, I, p.371, and III, p.227.

4 J.V. Muir, 'Religion and the new education: the challenge of the Sophists', in Easterling & Muir (eds), 1985, p.209.

5 Guthrie, III, chapter IX, 'Rationalist Theories of Religion: Agnosticism and Atheism', pp.226–49.

6 Guthrie, III, chapter IX; Burkert, 1985, pp.305–37.

7 This view is held by Kritias in the play *Sisyphos*; Guthrie, III, p.243.

8 *Laws*, 904A.

9 Mikalson, 1991, p.5.

10 Plutarch, *Nicias*, 23–6. Thucydides, book VI and VII; on the disastrous defeat VII, LXX–LXXV. See also C.A. Powell, 'Religion and the Sicilian Expedition', *Historia*, 28, 1979, pp.15–31.

11 Other instances in Herodotus, on obeying oracles in military actions: V, 79–80; VI, 112, 118.

12 Muir, in Easterling & Muir (eds), 1985, p.201; translation of the fragment by Guthrie.

13 *Pericles*, 8.

14 Herodotus, II. 53.

15 Burkert, 1985, p.312; Guthrie, III, p.227.

16 For Plato's norms on religion in relation to the factual religion of the *polis* (similarities and differences), see Yunis, 1988, chapters 2 and 3.

17 Yunis, 1988, p.164, note 46.

18 Mark, 1984.

19 Even the radical Xenophanes, who profoundly reinterpreted the gods, stresses the point that the gods *see* and *hear* much better than human beings (assuming that the text in late renderings does record Xenophanes' original statement). See Yunis, 1988, p.163, note 46. Clay, 1983, pp.14–15, on the sharp, wide-ranging sensations of the gods. Cf. also Aeschylus' *Eumenides*, 397–8, where Athena hears clearly from a great distance, and Plato, *Laws*, X, 901D, on the sharp senses of the gods. See also note 32 below.

20 Gould, 1985, p.22.

21 The accusations against Alcibiades, for impiety (mutilation of the *Hermai* and parodies of the Eleusinian mysteries), are examples of these tendencies in Athenian society just before the Sicilian expedition in 415. Plutarch, *Alcibiades*, 19–22. See also Plutarch, *Nicias*, 23, and *Pericles*, 32, on the charges of 'impiety' against Aspasia, on Diopeithes' 'decree' that impious persons should be denounced, and on the prosecutions of natural philosophers.

22 *Iliad*, XX, 9–24.

23 Homer, *The Iliad*, translation Robert Fagles, 1991 (Penguin), pp.541–2.

24 Gould, 1985, pp.27–8.

25 J.P. Vernant in Gordon (ed.), 1981; Clay, 1989.

26 Clay, 1989.

27 *Works and Days*, 42–105; *Theogonia*, 507–616.

28 Clay, 1989, assumes a date range between the eighth and sixth centuries.

29 Homeric subject matter, and especially the birth of Athena, appears frequently in sixth-century Athens, to judge from vase painting. See Brommer, 1961, and Conelly in Holliday (ed.), 1993, where it is associated with the tyrants' claims to power.

30 Palagia, 1993, pp.18–19.

31 *Timaeus* is generally considered to be a late work of Plato. The 'Timaeus' character recalls Plato's memories of Sicily and southern Italy; Timaeus is supposed to come from the Doric city state of Lokroi, an early Doric settlement in southern Italy, which was famous for its old constitution based on an oligarchic distribution of power and strong ethics; Plato had visited this place, where Pythagorean traditions of thought were also prevalent.

32 Plato probably draws here on the parallel in many languages between 'knowing' and 'seeing' (so even in Greek: compare *oida*, 'I know', with *eidon*, 'I saw'). On the sense of vision in Plato's philosophy, see Guthrie, IV, pp.252, 392, 507, 511. Plato often expands on vision, e.g. *Timaeus*, 47 A–C,

Republic, X, 508, *Phaedrus*, 250 D–E. Compare also Clay, 1983, introduction, pp.12–13; Clay also points out that seeing has epistemological dominance over hearing in Homer (she also refers to J. Beckert, 'Die Diathesen von *idein* und *horan* bei Homer', *Münchener Studien zur Sprachwissenschaft*, 6, München, 1964).

33 *Republic*, X, 596–601.

34 *Timaeus*, 28A.

35 *Cratylus*, 428C–440E.

36 *Phaedo*, 77E.

37 There is no clear-cut answer to the question of whether or not the theory of the Forms in Plato's philosophy can be explained as a theory of causes. See Guthrie, IV, p.358 (on the concept of 'Forms' as it appears in the *Phaedo*): Forms can be **in** things and are that **by** which the particulars are characterised; Forms can be looked upon as formal and final causes; it is by the **presence** in the particular that the form can act as a cause (pp. 351, 355).

38 *Phaedo*, 108E–114B.

39 *Republic*, II, 395, 396, 397E, 400.

40 Although there were probably restrictions on entering the cella, its interior must surely have been visible. There were hidden or forbidden parts of temples (*Ion*, 233) and rules about how to enter a temple (barefoot, *Ion*, 220–1). Further evidence comes from *Ion* (1258–60) on the conditions associated with sanctuaries: if a suppliant at the altar of a god was killed, there was blood-guilt on the killer; it was an offence against the god. Compare Aeschylus' *Eumenides*, where it is an offence against Apollo and Zeus to kill the murderer, Orestes, when he comes as a suppliant to the altar; and see Herodotus, V, 71, on the blood-guilt of the Alcmeonidae.

On the evidence of various restrictions for visitors to Greek temples (different for each site), see Hewitt, 1909, and Corbett, 1970.

41 Stewart, 1990, pp.157–8, gives a vivid description of the statue and its imagery. He stresses the point that the colossal statue probably exemplified a new idea about the representation of gods: it was a 'revelatory' image of the goddess, an image that displays, or shows concretely, her qualities and attributes.

42 About Kreousa and Apollo, see *Ion*, 886–96; 1550–1. The version of Aktaion's death that I have retold here comes from Kallimachos (310–238 BC), Hymn 5, 105–16; the story of Teiresias with an analogous narrative also occurs in the same hymn, 77. But the theme is in fact not only Hellenistic, since the origin is to be found in Pherekydes (fifth century BC), in the story of Teiresias whom Athena struck with blindness because he had seen her bathing naked at a spring.

43 Cf. note 83, Chp. 2 on the recurrence of the theme of weaving as an attribute of Athenian women.

Select Bibliography

'Aristotle' *The Athenian Constitution*, translation and introduction P.J. Rhodes, London, 1984

Andrewes, Antony, *Greek Society* (Penguin Books), London, 1991 (first published as *The Greeks* by Hutchinson 1967, in Pelican Books 1971)

Ashmole, Bernard, *Architect and Sculptor in Classical Greece*, London, 1972

Berger, Ernst, *Die Geburt der Athena im Ostgiebel des Parthenon*, Basel, 1974

Berger, Ernst (ed.), *Parthenon-Kongress Basel. Referate und Berichte 4. bis 8. April 1982*, Mainz, 1984

Boardman, John, 'The Parthenon Frieze – Another View', in Höckmann ed. 1977, pp.39–49

Boardman, John, 'Greek Art and Architecture', chapter 12 of John Boardman, Jasper Griffin, Oswyn Murray (eds), *The Oxford History of the Classical World*, Oxford and New York, 1986

Bonnechere, Pierre, *Le sacrifice humain en Grèce ancienne*, Athens Liège, 1994

Bowie, T. & Thimme, D. (eds), *The Carrey Drawings of the Parthenon Sculptures*, Bloomington, 19/1

Brommer, Frank, 'Die Geburt der Athena', *Jahrbuch des Römisch-Germanischen Zentralmuseums Mainz*, 8, 1961, Mainz, pp. 66–83, Taf. 20–37

Brommer, Frank, *Die Skulpturen der Parthenon-Giebel. Katalog und Untersuchung*, 1–2, Deutsches Archäologisches Institut, Mainz, 1963

Brommer, Frank, *Die Metopen des Parthenon. Katalog und Untersuchung*, 1–2, Deutsches Archäologisches Institut, Mainz, 1967

Brommer, Frank, *Der Parthenonfries. Katalog und Untersuchung*, 1–2, Deutsches Archäologisches Institut, Mainz, 1977

Brommer, Frank, *Festschrift* . . . see Höckmann, Ursula and Krug, Antje

Bugh, Glenn Richard, *The Horsemen of Athens*, Princeton, 1988

Burkert, Walter, *Greek Religion. Archaic and Classical*, translated from German by John Raffan, Cambridge (Mass.), 1985 (first published in German 1977)

Casson, Stanley, *The Technique of Early Greek Sculpture*, New York, 1970

191

Castriota, David, *Myth, Ethos and Actuality. Official Art in Fifth-Century B.C. Athens*, Madison (Wis.) London, 1992

Clay, Jenny Strauss, *The Wrath of Athena. Gods and Men in the Odyssey*, Princeton, 1983

Clay, Jenny Strauss, *The Politics of Olympus. Form and Meaning in the Major Homeric Hymns*, Princeton, 1989

Cook, B.F., *The Elgin Marbles*, London, 1984 (6th printing 1993)

Connelly, Joan B., 'Parthenon and Parthenoi: A Mythological Interpretation of the Parthenon Frieze', AJA, January 1996, pp. 53–80

Corbett, P.E., 'Greek Temples and Greek Worshippers: the Literary and Archaeological Evidence', BICS 17, pp. 149–58 (University of London, Institute of Classical Studies, Bulletin Number 16)

Davies, J.K., *Democracy and Classical Greece*, 2nd ed., London, 1993 (first published 1978)

Davies, J.K., *Wealth and Power of Wealth in Classical Athens*, Salem, N.H., 1984

Dean-Jones, Lesley, 'The Politics of Pleasure: Female Sexual Appetite in the Hippocratic Corpus', *Helios*, Spring 1992, 19:1/2, pp. 72–91

Dean-Jones, Lesley, *Women's Bodies in Classical Greek Science*, Oxford, 1994

Dentzer, Jean-Marie, *Le Motif du banquet couché dans le Proche-Orient et le monde grec du VIIe au IVe siècle avant J.-C.*, Ecole française de Rome, Palais Farnèse, Rome, 1982

Deubner, Ludwig, *Attische Feste*, Hildesheim, 1959 (reprint of the original edition of 1932)

Develin, Robert, *Athenian Officials 684–321*, Cambridge, 1989

Dinsmoor, William B., 'New Evidence for the Parthenon Frieze', AJA 1954, vol. 58, No. 2, pp. 144–5

Dover, K.J., *Greek Homosexuality*, Cambridge (Mass.), 1978

Easterling, P.E. & Muir, J.V. (eds), *Greek Religion and Society*, Cambridge, 1985

Economakis, Richard (ed.), *Acropolis Restoration*, London, 1994

Euripides, *Selected Fragmentary Plays*, ed. with introductions, translations and commentaries by C. Collard, J.M. Cropp and K.H. Lee, vol. 1, Warminster, 1995

Fehl, Philipp, 'Rocks on the Parthenon frieze', *Journal of the Warburg and Courtauld Institutes*, 1961, pp. 1–44

Ferrari Pinney, Gloria, 'Pallas and Panathenaea', *Proceedings of the 3rd Symposium on Ancient Greek and related Pottery*, Copenhagen, 1988, pp. 465–77

Franke, Ursula, *Kunst als Erkenntnis. Die Rolle der Sinnlichkeit in der Ästhetik des Alexander Gottlieb Baumgarten*, Wiesbaden, 1972

Garlan, Yvon, *Slavery in Ancient Greece*, translation from the French by Janet Lloyd, New York, 1988 (in French 1982)

Gauer, Werner, 'Was geschiet mit dem Peplos?', in Berger (ed.), 1984, pp. 220–9

Goldhill, Simon & Osborne, Robin (eds), *Art and Text in Ancient Greek Culture*, Cambridge 1994

Gould, John P., 'Law, Custom and Myth: Aspects of the Social Position of Women in Classical Athens', JHS, Vol. C, 1980, pp. 38–59

Gordon, R.L. (ed.), *Myth, Religion and Society*, Structuralist essays by M. Detienne, L. Gernet, J.-P. Vernant and P. Vidal-Naquet, Cambridge, 1981

Guthrie, W.K.C., *A History of Greek Philosophy*, Cambridge, I:1962, II:1965, III:1969, IV:1975, V:1978

Halperin, David M., *One Hundred Years of Homosexuality and Other Essays on Greek Love*, Routledge, New York, London, 1990

Halperin, David M. & Winkler, John J. & Zeitlin, Froma I. (eds), *Before Sexuality: The Construction of Erotic Experience in the Ancient Greek World*, Princeton 1989

Hansen, M.H., *The Athenian Assembly*, Oxford, 1987

Harris, Diane, *The Treasures of the Parthenon and Erechtheion*, Oxford Monographs on Classical Archaeology, Oxford, 1995

Harrison, Alick Robin Walsham, *The Law of Athens*, 1–2, Oxford, 1987

Harrison, Evelyn B. 'Athena and Athens in the East Pediment of the Parthenon', AJA, vol. 71, 1967, pp.27–58

Harrison, Evelyn B., 'Two Pheidian heads: Nike and Amazon', in Kurtz & Sparkes (eds), 1982, pp.53–88

Harrison, Evelyn B., 'Time in the Parthenon Frieze', in Berger (ed.), 1984, pp. 230–44

Haskell, Francis, *Rediscoveries in Art. Some Aspects of Taste, Fashion and Collecting in England and France*, London, 1976

Hausmann, Ulrich, *Griechische Weihreliefs*, Berlin, 1960

Herington, C. John, *Athena Parthenos and Athena Polias: a Study in the Religion of Periclean Athens*, Manchester, 1955

Hewitt, Joseph William, 'The Major Restrictions on Access to Greek Temples', *Transactions and Proceedings of the American Philological Association*, 1909, vol. XL, pp. 83–91

Holliday, Peter J. (ed.), *Narrative and Event in Ancient Art*, Cambridge 1993

The Homeric Hymns, ed. T.W. Allen, W.R. Halliday, E.E. Sikes, 2nd ed., Oxford, Amsterdam, 1963

Hughes, Dennis D., *Human Sacrifice in Ancient Greece*, London & New York, 1991

Hägg, Robin & Marinatos, Nanno & Nordquist, Gullög (eds), *Early Greek Cult Practice*, Stockholm, 1988

Höcker, Christoph, *see* Schneider

Höckmann, Ursula & Krug, Antje (eds), *Festschrift für Frank Brommer*, Mainz, 1977

Jahn, Otto & Michaelis, Adolf, *The Acropolis of Athens* (reprint of *Arx Athenarum*), Chicago, 1976

Jenkins, Ian, 'The Composition of the So-Called Eponymous Heroes on the East Frieze of the Parthenon', AJA, vol. 89, 1985, pp. 121–7

Jenkins, Ian, *'The Progress of Civilization'. The Acquisition and Arrangement of the Sculpture Collection of the British Museum 1802–1860*, (Diss.), London, 1990

Jenkins, Ian, *London – World City 1800–1840*, London, 1992

Jenkins, Ian, *The Parthenon Frieze*, London, 1994

Jenkins, Ian & Middleton, A.P., 'Paint on the Parthenon Sculptures', *The Annual of the British School at Athens*, 83, 1988, pp.183–207

Jones, A.H.M., *Athenian Democracy*, Baltimore, 1986 (first published 1957)

Kardara, Chrysoula, in *Archaiologiké Ephemerís*, 1963, pp. 185–202

Kardara, Chrysoula, 'Glaukopis, the archaic naos and the theme of the Parthenon frieze', (1961), published 1964 in *Archaiologiké Ephemerís*, pp. 61–158

Kessler, Herbert L. & Simpson, Marianna Shreve (eds), *Pictorial Narrative in Antiquity and the Middle Ages, Studies in the History of Art*, Vol. 16, National Gallery of Art, Washington, 1985

Kearns, Emily, *Heroes of Attica*, London, 1989 (BICS, Suppl. 57)

Keuls, Eva C., *The Reign of the Phallus. Sexual Politics in Ancient Athens*, Berkeley, Los Angeles, London, 1993 (first published 1985)

Knell, Heiner, *Perikleische Baukunst*, Darmstadt, 1979

Knell, Heiner, *Mythos und Polis*, Darmstadt, 1990

Kroll, John H. 'The Parthenon Frieze as a Votive Relief', AJA 83, 1979, pp. 349–52

Kron, Uta, 'Die Phylenheroen am Parthenonfries', in Berger (ed.), 1984, pp. 235–44

Kron, Uta, 'Priesthoods, dedications and euergetism. What part did religion play in the political and social status of Greek women?', *Religion and Power in the Ancient Greek World*, Proceedings of the Uppsala Symposium 1993, eds: Pontus Hellström and Brita Alroth, Uppsala, 1996, pp.139–82

Krug, Antje, *see* Höckmann

Kurtz, Donna & Sparkes, Brian (eds), *The Eye of Greece. Studies in the Arts of Athens*, (dedicated to M. Robertson), Cambridge, 1982

Kyle, Donald, G., *Athletics in Ancient Athens*, Leiden, 1987

Lagerlöf, Margaretha Rossholm, 'Some Remarks on Aesthetic Appearances', *Nordisk Estetisk Tidskrift*, 12, 1994, pp.53–61

Linfert, Andreas, 'Die Götterversammlung im Parthenon-Ostfries und das attische Kultsystem unter Perikles', *Mitteilungen des Deutschen Archäologischen Instituts. Athenische Abteilung*, Band 94, Berlin, 1979, pp.41–7

Loraux, Nicole, *The Children of Athena. Athenian Ideas about Citizenship and the Division between the Sexes*, transl. Caroline Levine, foreword by Froma I. Zeitlin, Princeton 1993 (first published 1984)

Loraux, Nicole, *The Invention of Athens: the Funeral Oration in the Classical City*, transl. from French by Alan Sheridan, Cambridge (Mass.), 1986 (first published in French 1981)

Mansfield, J.M., *The Robe of Athena and the Panathenaic Peplos* (Diss.), University of Californa, Berkeley, 1985

Mark, Ira S., 'The Gods on the East Frieze of the Parthenon', *Hesperia*, LIII, 1984, pp.290–342

Marinatos, Nanno, *see* Hägg

Michaelis, Adolf, *see* Jahn

Mikalson, Jon D., *Honor Thy Gods. Popular Religion in Greek Tragedy*, Chapel Hill, London, 1991

Muir, J.V., *see* Easterling

Nagy, Blaise, 'Athenian Officials on the Parthenon Frieze', AJA, 1992, pp.55–69

Neils, Jenifer (ed.), *Goddess and Polis. The Panathenaic Festival in Ancient Athens*, Jenifer Neils with contributions by E.J.W.

Neils, Jenifer (ed.), *Worshipping Athena. Panathenaia & Parthenon*, Wisconsin Studies in Classics, Madison, 1996

Nilsson, Martin P., *Geschichte der Griechischen Religion*, I. Band, München, 1967 = *Handbuch der Altertumswissenschaft*, Fünfte Abteilung. Zweiter Teil. Erster Band

Nordquist, Gullög, *see* Hägg

Ober, Josiah, *Mass and Elite in Democratic Athens. Retoric, Ideology, and the Power of the People*, Princeton, 1989

O'Connor-Visser, E.A.M.E., *Aspects of Human Sacrifice in the Tragedies of Euripides* (Diss.), Amsterdam, 1987

Osborne, Robin, 'The Erection and Mutilation of Hermai', *Proceedings of the Cambridge Philological Society*, 31, 1983, pp.47–73

Osborne, Robin, *Demos: the Discovery of Classical Attika*, Cambridge, London, New York, 1985

Osborne, Robin, 'The Viewing and Obscuring of the Parthenon Frieze', JHS, 1987, pp.98–105

Osborne, Robin, *see* Goldhill

Overbeck, Johannes Adolf, *Die antiken Schriftquellen zur Geschichte der bildenden Künste bei den Griechen*, Leipzig, 1868

Palagia, Olga, *The Pediments of the Parthenon*, Monumenta graeca et romana, VII, ed. H.F. Mussche, Leiden, New York, Köln, 1993

Parke, Herbert William, *Festivals of the Athenians*, London, 1977

Pemberton, Elizabeth G., 'The Gods of the East Frieze of the Parthenon', AJA 80, 1976, pp.113–24

Pindaros, *The Works of Pindar*, transl. with literary and critical commentaries by Lewis Richard Farnell, I–III, London, 1930

Pollitt, J.J., *Art and Experience in Classical Greece*, Cambridge, 1972

Pollitt, J.J., *The Ancient View of Greek Art, Criticism, History, and Terminology*, London and New Haven, 1974

Pomeroy, Sarah B., *Goddesses, Whores, Wives and Slaves. Women in Classical Antiquity*, New York, 1975

Raaflaub, Kurt, *Die Entdeckung der Freiheit. Zur historischen Semantik und Gesellschaftsgeschichte eines politischen Grundbegriff der Griechen*, VESTIGIA, Beiträge zur alten Gechichte, Band 37, München, 1985

Rasmussen, Tom & Spivey, Nigel, *Looking at Greek Vases*, Cambridge, 1991

Reeder, Ellen D. (ed.) *Pandora, Women in Classical Greece*, Princeton, New Jersey, 1995

Revett, Nicholas, *see* Stuart

Rhodes, P.J., *Commentary on the Aristotelian Athenaion Politeia*, 1981

Rhodes, P.J., *The Greek City States: a Source Book*, University of Oklahoma Press, 1986

Ridgway, Brunilde Sismondo, *Fifth Century Styles in Greek Sculpture*, Princeton, 1981

Robertson, Martin, *The Parthenon Frieze*, London, 1975

Robertson, Noel, 'The Origin of the Panathenaea', *Rheinishces Museum für Philologie*, Neue Folge, 128 Band, Heft 1, 1985, pp.231–95

Root, M.C., 'The Parthenon Frieze and the Apadana Reliefs at Persepolis: Reassessing a programmatic relationship', AJA 89, 1985, pp.103–20

Rothenberg, J., *Descensus ad terram: The Acquisition and Reception of the Elgin Marbles*, 2nd ed., London, New York, 1983

Scranton, Robert L., *Aesthetic Aspects of Ancient Art*, Chicago, 1964

Schaps, David M., *Economic Rights of Women in Ancient Greece*, Edinburgh, 1981 (first published 1979)

Schiller, Friedrich, *Sämtliche Werke*, Band 5: *Erzählungen, Theoretische Schriften*, eds: Gerhard Fricke, Herbert G. Göpfert, München, 1959

Schneider, Lambert & Höcker, Christoph, *Die Akropolis von Athen. Antikes Heiligtum und modernes Reiseziel*, Du Mont, Köln, 1990

Schäfer, Thomas, 'Diphroi und Peplos auf dem Ostfries des Parthenon: Zur Kultpraxis bei den Panathenäen in klassischer Zeit', *Mitteilungen des Deutschen archäologischen Instituts. Athenische Abteilung*, Band 102, Berlin, 1987, pp.185–212

Simon, Erika, *Festivals of Attica: an Archaelogical Commentary*, Madison, 1983

Sealey, Raphael, *Women and Law in Classical Greece*, Chapel Hill, London, 1990

Simpson, Marianna Shreve, *see* Kessler

Sissa, Giulia, *Greek Virginity*, transl. Arthur Goldhammer, *Revealing Antiquity*, 3, Cambridge (Mass.), London, 1990 (first published 1987)

Smidt, Horst-Michael, *Sinnlichkeit und Verstand. Zur philosophischen und poetologischen Begründung von Erfahrung und Urteil in der deutschen Aufklärung. Leibniz, Wolff, Gotsched, Bodmer und Breitinger, Baumgarten*, München, 1982

Smith, A.H., 'Lord Elgin and his Collection', JHS, 1916, pp.163–372

Snyder, Jane McIntosh, *The Woman and the Lyre: Women Writers in Classical Greece and Rome*, Bristol, 1989

Sparkes, Brian, *see* Kurtz, Donna

Spaeth, Barbette Stanley, 'Athenians and Eleusinians in the West Pediment of the Parthenon', *Hesperia*, vol. 60, no. 3, July–September, 1991, pp.332–62

Spence, I.G., *The Cavalry of Classical Greece. A Social and Military History with Particular Reference to Athens*, Oxford, 1993

Spivey, Nigel, *Understanding Greek Sculpture. Ancient Meanings, Modern Readings*, London, 1996

Spivey, Nigel, *see* Rasmussen

St Clair, William, *Lord Elgin and the Marbles*, 2nd ed., London, New York, 1983

Stewart, Andrew, *Greek Sculpture: an Exploration*, 1–2, New Haven and London, 1990

Stillwell, Richard, 'The Panathenaic Frieze', *Hesperia*, 38, 1969, pp.231–41

Stockton, David, *The Classical Athenian Democracy*, Oxford, 1990

Stuart, James & Revett, Nicholas, *The Antiquities of Athens*, Vol. I and II, London, 1752, 1787

Sörbom, Göran, *Mimesis and Art. Studies in the Origin and Early Development of an Aesthetic Vocabulary*, Stockholm, 1966

Sörbom, Göran, 'What is in the Mind of the Image-Maker', *Journal of Comparative Literature and Aesthetics*, 1987, pp.1–41

Sörbom, Göran, 'Imitations, Images and Similarity', *Aesthetic Distinction. Essays presented to Göran Hermerén on his 50th Birthday*, Lund, 1988

Thimme, D., *see* Bowie

Tölle Kastenbein, Renate, 'Das Hekatompedon auf der Acropolis', JdI, 1993, vol. 108, pp. 43–81

Tournikiotis, Panayotis, *The Parthenon and its Impact in Modern Times*, Athens, 1994

Vellacott, Philip, *Ironic drama*, London, 1975

Winkler, John J. & Zeitlin, Froma I., *Nothing to do with Dionysos? Athenian Drama in its Social Context*, Princeton, 1990

Winkler, John J., *The Constraint of Desire: The Anthropology of Sex and Gender in Ancient Greece*, Princeton, 1989

Winkler, Joh J., *see* Halperin

Wycherley, R.E., *The Stones of Athens*, Princeton, 1978

Yunis, Harvey, *A New Creed: Fundamental Religious Beliefs in the Athenian Polis and the Euripidean Drama*, Hypomnemata 91, Göttingen, 1988

Zeitlin, Froma I., *see* Halperin

Zeitlin, Froma I., *see* Winkler

PHOTOGRAPHIC CREDITS

The reproduction of the photographs has been kindly permitted by the following institutions and persons:

The Acropolis Museum, Athens 3,25–9
The British Museum, London 1,2,4–6,14,15,17–24,30–5,38–42,44 and plates III, IV, V, VI and VII; © The British Museum
Deutsches Archaologisches Institut, Athens 7–13,16,25–8,37,43; © Deutsches Archaologisches Institut
Claes Petersson plates I, II; © Claes Petersson
Royal Ontario Museum 45; © ROM

INDEX

Pelops 28
Pentelian marble 6
peplos 27, 28, 29, 70, 73, 121, 122, 180n.83
Pericles 6, 8, 9, 88, 101, 111, 113, 114,
 133, 134, 136, 138, 141, 145, 175.35,
 181n.89
Persians 111, 168n.10
Persian war 3, 6, 7, 169n.11
personification 79
Phidias, statue 7
phratriai 184n.120
physis 52, 135, 139, 142
Pindar 84
 Olympian Ode 82
Plato 2, 16, 79, 80, 119, 135, 141, 148–65,
 189nn.16,32
 Forms 80, 119, 149, 152, 153, 154, 155,
 156–7, 164, 190n.37
 immutable ideas 2
 Laws 135, 138, 176n.36, 189n.19
 Menexenus 167n.5
 Phaedo 149, 156
 Republic 16, 19, 138, 150, 151, 152, 172n.7
 Divided Line 151–3, 156
 Sophist 16, 172n.7
 Symposium 80, 140, 149
 Timaeus 91, 149, 151, 172n.5, 189nn.31,
 32
Pliny 129
Plutarch 8, 137, 138, 189n.21
polieus 170n.21
polis 28, 49, 71, 72, 95, 98, 104, 105, 106,
 110, 114, 134, 135, 136, 169n.15,
 170n.21, 171n.26, 180n.83, 182n.100
Pollitt, J.J. 100, 133, 138
Polykleitos 15
Polyphemos 80
pompeia 75
Poseidon 2, 3, 27, 28, 88, 110, 167–8n.5,
 169n.14, 174nn.21–5
Praxagora 98
Praxithea 27
procession 30, 44, 68, 69, 71, 73, 76, 88, 122,
 174n.18
Prometheus 74, 146–7, 176n.42, 179n.75
Protagoras 138, 148
Pytho 81

relief(s) 22, 24, 144, 173nn.11,12, 175n.35,
 178n.64
religion 139, 140, 141
Revett, Nicholas 115
Rhodes 84

rhythm 24
rhythmos 15, 172n.2, 176n.39
riders 29, 30, 31, 32–3, 35, 37, 39, 42, 43, 65,
 66, 69
rite 8, 72–7, 137, 143, 177n.45

sacrifice 143, 145, 171n.26, 177n.56,
 178nn.60–1
 animal 72–5, 169n.14, 177n.54
 human 27, 28, 29, 48, 72–3, 177n.51
 of Iphigenia 129
 of women 90–1, 93
Schegel, Friedrich 116–17
Schiller, Friedrich von 117
sculpture 48, 81
Selene 85
 horse 52, 166n.1
Semele 160
Simon, Erika 185n.128
Sky 83
slaves 90, 104–6, 113, 186n.137, 187n.153
Socrates 49, 80, 141, 148, 149, 151
Sophists 134, 141
Sophocles 90, 176n.42
sophrosyne 167n.4
Spaeth, Stanley 168n.5
Spartans 134
Spence, I.G. 109, 185n.128
story 69–70, 77, 79, 135, 136
Stuart, James 115
sun 51, 52, 57, 59, 81
supplement 130–1
synoikismos 168n.5

Teiresias 160
telos 20, 82
Theseus 167n. 169n.14
Thucydides 3, 137, 168n.8
Timanthes 129
time 24–6, 50–7, 69, 80, 143
tray-bearers 69
trittyes 184n.125
Trojans 74, 77, 142, 168nn.7 and 11
Troy 2, 3, 142, 145, 168n.10

Underworld 17, 80

Vernant, J.P. 145
virginity 92, 95, 96, 182nn.99–100
vision 16–20
visual narrative 60, 69, 72, 79

war 78, 79, 85, 86, 95, 96